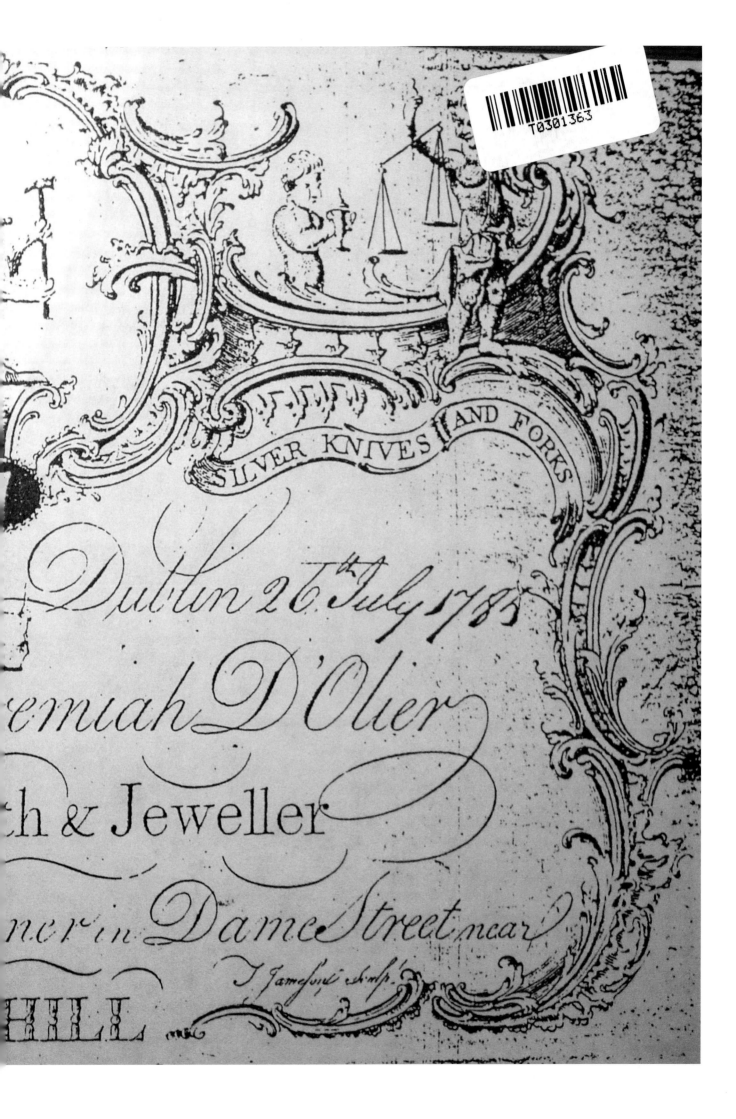

SILVER KNIVES AND FORKS

Dublin 26.th July 178...

...emiah D'Olier

...h & Jeweller

...ner in Dame Street near

J Jameson Sculp.

...HILL

Beyond the Border

HUGUENOT GOLDSMITHS IN NORTHERN EUROPE AND NORTH AMERICA

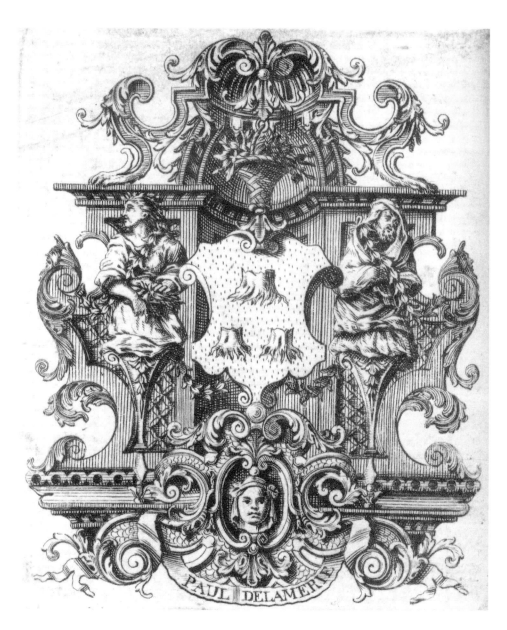

Bookplate of Paul de Lamerie,
circa 1728. © Royal Collection.

Beyond the Border

HUGUENOT GOLDSMITHS IN NORTHERN EUROPE AND NORTH AMERICA

Edited by

TESSA MURDOCH

sussex
ACADEMIC
PRESS

BRIGHTON • PORTLAND

2 4 6 8 10 9 7 5 3 1

First published 2008 in Great Britain by
SUSSEX ACADEMIC PRESS
PO Box 139
Eastbourne BN24 9BP

and in the United States of America by
SUSSEX ACADEMIC PRESS
920 NE 58th Avenue, Suite 300
Portland, Oregon 97213–3786

British Library Cataloguing in Publication Data
A CIP catalogue record for this book is available from the British Library.

Library of Congress Cataloging-in-Publication Data
Beyond the border : Huguenot goldsmiths in northern Europe and North America / edited by Tessa Murdoch.
 p. cm.
Includes bibliographical references and index.
ISBN 978-1-84519-262-4 (h/b : alk. paper)
1. Huguenot goldsmiths—Europe, Northern. 2. Huguenot goldsmiths—North America. I. Murdoch, T.V. (Tessa Violet)

NK7106.4.H84B49 2008
739.2′20882845—dc22 2008000116

Typeset and designed by Sussex Academic Press, Brighton & Eastbourne.
Printed by TJ International, Padstow, Cornwall.
This book is printed on acid-free paper.

Contents

List of Illustrations

Front and Back Cover

Paul Crespin (1694–1770), oil on canvas,
Artist unknown, British, *circa* 1725
© *Victoria and Albert Museum, London*

Paul Revere (1734–1818), John Singleton Copley, 1768
© *Museum of Fine Arts, Boston*

Frontispiece

Bookplate of Paul de Lamerie, *circa* 1728
© *Royal Collection*

Endpapers

Bill heading for Jeremiah D'Olier (1747–1816), goldsmith. One of the
founders of the Bank of Ireland, Dublin's D'Olier Street is named after
him. D'Olier made the new chain for the Lord Mayor of Dublin, 1784
© *Private Collection*

List of Colour Plates

List of Black and White Illustrations

Chapter 1

Chapter 2

Preface

We are delighted that the Paul and Elissa Cahn Foundation who generously sponsored the symposium held in honour of Paul Cahn at the Victoria and Albert Museum in January 2007 have also contributed to the costs of publishing these proceedings. We are also grateful to the Scouloudi Foundation in association with the Institute of Historical Research, University of London, and the Paul Mellon Centre for Studies in British Art for their financial support. This is the first serious study of the work of Huguenot goldsmiths from an international perspective. Distinguished colleagues from France, Holland, Germany, Ireland and North America, with our own leading experts here in Britain, have found time to share with us their new research.

This study appears against a background of recent publications which explore the pan-European and trans-Atlantic exchange in post-medieval material culture. Material objects provide revealing evidence for a culture which was obliged, under persecution, to be secretive. The welcome and acceptance that Huguenot craftsmen enjoyed beyond the French borders, where they enjoyed freedom of worship and diverse patronage, provides a common ground against which to access the exchanges between the different centres.

The strength of the January audience at the V&A demonstrates the interest that the study of silver and the Huguenot contribution attracts. The symposium coincided with the display of Paul de Lamerie silver in the Cahn Collection at the V&A which has subsequently travelled to Memphis, Tennessee; St. Louis, Missouri and is now at the Powerhouse, Sydney, Australia. Paul Cahn's personal history explains his motivation in building up the greatest collection of silver by the Huguenot Paul de Lamerie now in private hands.

Paul Cahn shared his personal experience with guests attending the opening of the display at the V&A in November 2006: 'Sixty-nine years ago my family left Mainz, Germany. My grandfather, a silversmith, was not permitted to take any silver out of Germany. Fellow silversmiths from Montreal, Henry Birks and Sons, then the greatest silversmiths in Canada whom my grandfather had supplied, sponsored our emigration. En route to Canada, we stopped in London for three days and my elder brother took me to the Victoria and Albert Museum where I saw marvellous silver on display. This raised from me the question, "Do you think we will ever have our own silver again?" That was the beginning of my ambitions to collect silver!'

We hope that the research made available will stimulate further discoveries of the work and lives of these talented Huguenots. New V&A displays of more Huguenot London-made silver and Berlin-made gold boxes from the Gilbert

Collection from June 2009 will provide the opportunity to share latest researches with our global audience. Perhaps these displays will in turn inspire future collectors and patrons of our rich cultural heritage.

MARK JONES
Director
Victoria and Albert Museum

Acknowledgements

The exhibition of silver by Paul de Lamerie and his contemporaries from the Cahn Collection held at the V&A in the winter 2006–7 provided the opportunity to host an international conference in honour of Paul Cahn. The support of the Cahn family, a publication grant from the Paul Mellon Centre for Studies in British Art and a grant from The Scouloudi Foundation in association with the Institute of Historical Research have made the publication of those conference papers possible. I would like to thank each of the speakers at that January conference for finding the time to provide a full text. It is a tribute to the calibre of the Cahn Collection that we were able to assemble such a galaxy of international expertise for the conference and a tribute to the speakers that they were able to contribute to this publication.

At the V&A, I would like to thank the Director, Mark Jones, and Dr Paul Williamson, Dr Glenn Adamson and Dr Carolyn Sargentson for supporting the applications for grant funding. Ethan Kalemjian and Caroline Rainey helped with administrative work. Particular thanks are due to Sabine Beneke at the Deutsches Historisches Museum for supplying on behalf of her Director, Dr Hans Ottomeyer, the text of his paper. In addition I would like to thank Ellenor Alcorn, Vanessa Brett, Editor of the *Silver Society Journal* and Dr Andrew Spicer, Editor of the *Huguenot Society Proceedings*, for their support and encouragement.

TESSA MURDOCH

Huguenot Goldsmiths in Northern Europe

Introduction

Christopher Hartop

The Huguenot contribution to silver made in England is justly revered. The Huguenots lent their name to a period in silver production, between the accession of James II in 1685 to the death of George I in 1727, that in the 20th century was held among silver collectors to be the golden age. Writers in the early part of the last century such as E. Alfred Jones and Joan Evans credited them with the introduction of a new, severely plain and massive style which was seen as a welcome contrast to the ornamental excesses of the Victorian era.

But who were the Huguenots, and just what did they do? Huguenot is the name – origin uncertain – given to French Protestants. In the late 16th century, these followers of the doctrines of John Calvin made up perhaps ten per cent of the total population of France. They left France in two waves, the first of which was at the end of the 16th century when many sought to escape the religious wars that were tearing France apart. When one of their leaders, Henry of Navarre, abjured his faith in order to become king of France, it was 'worth a mass'. As Henri IV he issued the famous Edict of Nantes in 1598 which granted the Huguenots freedom of worship in France. The mass emigration of families ceased, and the French protestants went back to their trades and crafts as Michèle Bimbenet Privat demonstrates in her introductory essay.

Eighty years later, however, the young Louis XIV felt himself secure enough on the throne to make France a totally Catholic country. Wholesale persecution began which resulted in the second wave of emigration. At first, those who left France were often able to take much of their property with them: the goldsmith Pierre Harache from Rouen arrived in England in 1683 with some of his finished stock. But when Louis revoked the Edict of Nantes in 1685, giving Huguenots the stark choice of embracing Catholicism or leaving France, what had been a trickle became a flood of refugees, most of them with little more than the clothes on their backs.

The diaspora they made extended throughout northern Europe and reached as far a field as North America and South Africa. But the greatest number came to England, and especially to London. England's king had no monopoly on patronage, as was the case in most European countries, and it was left to a large elite of landowners and those enriched by trade to assume the role of patrons. London was a boom town with a burgeoning population of prosperous merchants, tradesmen and craftsmen, and its consumer base was growing at a faster rate than in any other European city. For the most part, the Huguenots who came were what Daniel Defoe dubbed 'the middling sort', skilled in manufacturing and trades.

What was France's loss became the gain of other Northern European countries. The Huguenots brought with them the latest French designs as well as

knowledge of cutting-edge technology, both of which greatly facilitated the introduction of a French court style across northern Europe.

For English historians of the early 20th century, schooled in the Whig tradition that brought everything neatly towards a world run by white Anglo-Saxon protestants, the Huguenots were seen as part of the Good Guy team that was ranged against the Bad Guys – Louis XIV and the Catholics. With their industry and innovation they seemed to embody the protestant work ethic, appealing to the English professed love of fair play and supporting the underdog. In silver, moreover, the Huguenots were seem as the supreme example of the fact that all English art was the product of outside influences, as well as that particularly English self-deprecating attitude that held that any superb workmanship could not possibly be by a native English craftsman.

The Huguenot influx provided much needed talent – workers who were conversant with the latest designs and manufacturing techniques. But whether we should credit the Huguenots with the wholesale introduction of new styles and decoration is questionable. Plain silver, relying for effect on its reflective surfaces and geometric shapes, had been a constant theme in virtually all countries, England included, from the Middle Ages onwards, existing alongside elaborately decorated silver. The hazards of survival meant that plain silver was more likely to survive than ornate, and, ironically, these primarily utilitarian wares became the most highly prized by collectors in the twentieth century. Taste also influences scholarship, and only recently have surviving works with elaborate cast or chased decoration been studied as thoroughly as the plain ones. Moreover, while the Huguenots may have been experienced in techniques such as cut-card work (which became synonymous with their name) these innovations had reached London long before the revocation of the Edict of Nantes.

At the outset, the Huguenots' religion may have given them a certain affinity with native craftsmen. But it is easy to forget how quickly attitudes hardened towards the incomers. Pierre Harache had been welcomed into the London goldsmiths' company as 'lately arrived from France to avoid persecution'. A few years later, however, native goldsmiths presented a petition to the company complaining of the Huguenots' willingness to work longer hours for smaller wages. The anonymous author of a pamphlet inveighing against immigration called for a halt before these foreigners 'corrupt and impoverish the few that remain untainted by French ragouts and Italian effeminacy'.

The Huguenots were lucky indeed that they were French. Everyone with fashionable pretensions spoke French, ate French food, dressed in French fashions and surrounded themselves with French decorative arts. 'The English are for the most part boobies' declared Lord Chesterfield to his son, advising him to 'imitate the French in all things'.

In England, we have revised our image of the Huguenots somewhat during the past thirty years. In silver, we now know that the situation was a good deal more complex that that of individual craftsmen revolutionizing design. The Ruskinian image of the artist craftsman working in isolation on unique works of art does not apply to the seventeenth and eighteenth centuries. Moreover, the driving force in the adoption of new vessels and designs was not necessarily the

supplier, but the patron. And silver collectors have traditionally been obsessed with marks – which seemed to offer a guarantee of authenticity that was lacking in other decorative arts – but we now know that they are often a red herring. Behind the so-called maker's mark was an intricate web of specialists – designers, modellers, casters, chasers, hammermen, engravers and gilders – most of whom, Huguenot or not, are fated to remain anonymous. Tessa Murdoch paints a vivid picture of this community in Part II.

In England we recognize that the Huguenots were not the only outside influence on silver, although they were by far the largest group in terms of numbers. Other immigrants were highly influential. Christian van Vianen and others came from the Low Countries as a result of court patronage. Others also came not as religious but as economic immigrants, such as Jacob Bodendeich who came from Lüneberg in Germany, Wolfgang Howzer from Switzerland, Charles Kandler from Saxony, Nicholas Sprimont, a Catholic from Liège (who went from silversmithing to porcelain manufacturing), and Blaise Gentot, a French Catholic.

Silver studies in other European countries have also moved away from the tyranny of marks to the study of silver in the context of other decorative arts, as well as in the political, economic and social environment. But the story of the other Huguenots, those who settled in Germany, Scandinavia, the Netherlands and America, has seldom been told in England. In Part I of this volume Jet Pijzel-Dommisse and Hans Ottomeyer examine the influence of the Huguenots in the Netherlands and Germany, and how they were regarded by native craftsmen. Because of the tradition of the *wanderjaar* in continental Europe, it is tempting to think that they perhaps met with more toleration than they received from their English colleagues. But craft regulations were often much stricter in mainland Europe than they were in London, making absorption into the community much harder. Some no doubt were forced to work without contemporary personal recognition, making the job of the present day historian much more difficult.

CHAPTER **1**

Huguenot goldsmiths in France prior to the Revocation of the Edit de Nantes (1598–1685)

Michèle Bimbenet-Privat

'Under the jurisdiction of the Edit of Nantes' defines the period 1598 to the 1670s when the Huguenots were given freedom of faith in France. The Edict of Nantes, 1598, gave Protestants access to public offices and guild membership. From the 1670s repressive measures against the Huguenots culminated in the Revocation of the Edict of Nantes signed by Louis XIV at Fontainebleau in October 1685.

The apparently generous terms of the Edict of Nantes were in reality a demonstration of mere tolerance. The Huguenots, referred to as *'ceux de la religion prétendue réformée'* (those of the would-be Reformed religion) were restricted from 1597, when the Civil War was at its height, to worshipping in only one city in each of the hundred French *'bailliages'* (administrative districts). Their place of worship was confined to the suburbs so as not to interfere with the official Catholic rite. Huguenot congregations were thus conspicuous and easier to control.

Huguenot worship was strictly forbidden in the vicinity of any Catholic cathedral. In the Loire Valley, there were fewer Huguenots in the towns of Tours and Angers, as these were ruled by Catholic bishops, than in Blois, where there was neither a cathedral nor a bishop. Finally, the Edict of Nantes forbade Huguenot worship in the suburbs up to *'cinq lieues'* (twelve miles) around Paris. Huguenots organized weekly trips by horse-cart out of the metropolis to Charenton where they had built a temple. Huguenot worship in France was both curtailed and concentrated.

Settlements of Huguenot goldsmiths

Repressive as the measures were, Huguenot goldsmiths did not seem to have suffered too much from this religious concentration. In the 14th century, royal administration had regrouped all trades within strictly organized guilds. These guilds supported each other and were located near royal and aristocratic houses and wealthy abbeys in order to meet the demand for table wares, jewellery and church plate. Until the end of the 17th century, Huguenot goldsmiths were concentrated in the principle Huguenot centres; the Loire valley, Poitou, Saintonge, Aquitaine, Languedoc, Dauphiné and, of course, Paris. This essay will focus on the Huguenot goldsmiths who worked in Paris, in central France and on the west coast, as many of these goldsmiths migrated to England in the late 17th century.

In order to estimate the real impact of this migration on the French gold-smiths' trade, it has been necessary to establish the proportion of Huguenots in the Goldsmiths' guilds during the 17th century. In addition to 17th century Paris, scholars Cassan, Clarke de Dromantin, Jacob, and Pailloux have researched regional French goldsmiths' records. Although the academic survey of these guilds is not yet complete, much has already emerged. The city of Paris, where the guild recorded three hundred freemen, had an established reputation for being the centre of the goldsmiths' trade in France. Between thirty and forty per cent of the Paris goldsmiths were Huguenot.[1] That proportion is not as significant as the actual numbers: one hundred Huguenot goldsmiths' families were living in the French capital at the time. Although the number of regional guilds was lower than in Paris, the proportion of Huguenots within those guilds was much higher. There were eighteen Huguenot goldsmiths registered in Bordeaux out of the twenty-five freemen members of the guild.[2] In Poitou, there were more than fifty Huguenot goldsmiths. In La Rochelle, even after the defeat of the Huguenots and their exile in 1628,[3] up to sixteen out of eighteen freemen for the whole guild were Protestant, In Rouen, where there was no limit to the size of the guild, there were more than eighty Huguenot goldsmiths during the 17th century.[4] In Dieppe, where the Goldsmiths' Guild had only twenty freemen, records show that in 1677 most of them were Huguenot despite the parity required by royal laws.[5] In Blois, the goldsmiths' trade was almost exclusively Huguenot. Significantly, in 1680, the Blois Catholics sent a letter of grievance to the king denouncing the prejudice against two lonely Catholic goldsmiths in a guild totalling fifteen members.[6]

The work of Huguenot goldsmiths?

What was the impact of their religious faith on the Huguenot goldsmiths? How did it effect their output? Traditionally, goldsmiths provided churches and Catholic convents with sacred silver. By adopting the Huguenot faith, goldsmiths lost these regular customers and supplied civic institutions instead. This included silver for the dining table, candlesticks for domestic lighting, and for other specific uses including toilet services and writing sets, jewellery and gold watch-cases, but they also provided work in other metals including lead, bronze or brass, and in ivory; the latter was a speciality of the port of Dieppe, Normandy, as a result of trade with Africa. Records show that Huguenot workshops developed an excep-tional level of specialization, which was denounced by the Catholic clergy. In 1665, the bishop of Bayeux in Normandy wrote that '*Huguenots are so dominating in the goldsmiths' trade that clergymen cannot find any workshop to order the church plate they need*'.[7] A gilt brass holy water stoup, in a private collection, provides a strik-ing illustration of how Huguenot goldsmiths were making fun of Catholic church plate in the 1620s: although it was engraved with the inscription « *grave dans ton cœur le signe de Jonas* », (carve the sign of Jonas on your heart) and supported by two angels, it was dominated by a frightening whale's head with a monstrous open mouth (Plate I). Although anonymous, it may be attributed to the Huguenot goldsmith Denis Boutemie, well known in the 1630s as a designer of fanciful ornament.[8]

Few examples of 17th century regional Huguenot silver survive, as old French silver was melted down following royal orders by Louis XIV and Louis XV and also destroyed in the late 18th century during the Revolution. Although gold jewellery accounted for most of their output, the Huguenots did not mark gold, and it cannot therefore be identified. However, Huguenot goldsmiths played a crucial part in technical innovation and stylistic development in their chosen fields of excellence. Blois became the centre for watch-making because the Huguenot goldsmiths were supported by Gaston d'Orléans, the King's brother, whose court promoted trade in luxury goods. Fame and success were due to Huguenot families; the Bellangers, Cupers, Gribelins, Delagardes and Toutins.[9] The trade was brilliantly organized: in every family boys were trained as both goldsmiths and watchmakers. Watchmakers made the movements, and goldsmiths, endowed with the privilege of hammering gold, made watchcases. Abraham Gribelin (1589–1671) signed a watch movement set in a precious enamelled gold watchcase and displayed in a leather case decorated with nails (Plate II). Abraham was the grandfather of the engraver Simon Gribelin who took refuge in London in 1681. A leading clockmaker in Blois, Abraham Gribelin was appointed « valet de chambre » by King Louis XIII.[10] He worked with his brother Isaac, a famous goldsmith and enameller, who was trained in Blois in Jean Toutin's workshop and specialized in making gold and enamelled cases for his brother's watch movements.

The Toutins are the paradigm of these provincial Huguenot goldsmiths. Jean Toutin (1578–1644) was trained as a goldsmith in Châteaudun, and then travelled to Blois and eventually to Paris. On the first page of his earliest set of prints edited in 1619, designs for black champlevé enamels on a gold ground (Plate 1), he mentioned with pride his origins in Châteaudun.[11] All contemporary ornament prints for enamels and jewellery executed in France at that time were designed by Huguenots!

Not all the Blois Huguenots enjoyed such a reputation. Some simply needed to earn their living through ordinary work. In the Blois Museum, a lead sundial signed by the goldsmith Pierre Bellanger in 1658 demonstrates that goldsmiths sometimes resorted to working in base metals. In cities where Huguenot goldsmiths were less wealthy, some probably concealed their religion in order to retain their Catholic customers and protect their trade. For instance in Angers, a very Catholic bishopric, the Hardye family of goldsmiths remained Catholic to all appearances. They were recorded in the Catholic parish registers, although amazingly they retained their family Christian name Isaïe through successive generations which, in the 17th century, amounted to a Huguenot declaration of faith! It is probable that their Catholic allegiance was superficial and simply 'in line' with their commercial interests. Only one silver cast work by Isaïe the third Hardye, dated 1656, has survived, showing Saint Ann teaching her daughter Mary to read the Holy Bible: a very Catholic subject, quite unusual for a Huguenot goldsmith.[12]

Under the Edict of Nantes, French Huguenot goldsmiths could not completely escape religious harassment and financial problems. Their mobility is an exclusive characteristic, as they moved regularly between regional French cities and Paris.

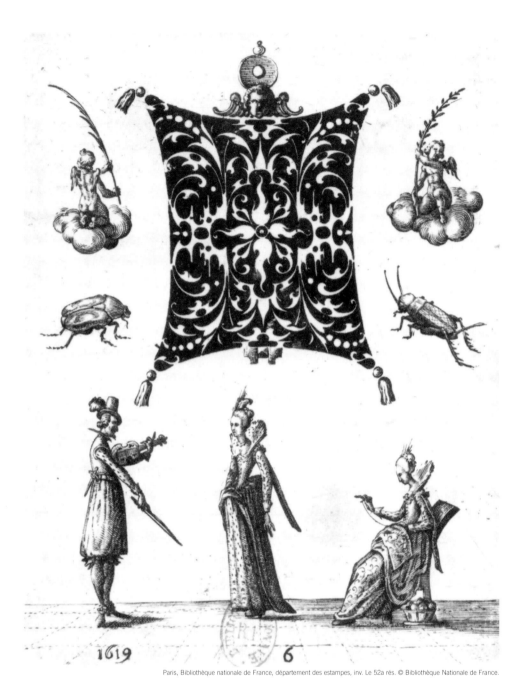

Plate 1 Design for a black and white enamel jewel, plate 6 from a set of 7, Jean Toutin, Châteaudun-Paris, 1619, 10.7 × 8 cm.

The situation in Paris

The Parisian market was much larger, and control of the Huguenots loosened. Migrations to Paris grew when the Edict of Nantes was signed in 1598, and did not diminish until the 1670s, when royal persecution increased. Did the Catholic goldsmiths in Paris become more tolerant towards their Huguenot colleagues?

Unfortunately not. The Paris guild was deeply Catholic and openly hostile to Huguenots. Yet, sometimes they were forced to compromise. Indeed, although significant in number (there were two hundred Catholic goldsmiths in the metropolis) they were hardly able to meet the demand for gorgeous plate, diplomatic gifts and valuable jewellery commissioned by the aristocratic and ambassa-

dorial houses. Huguenot goldsmiths seized an unexpected window of opportunity and took advantage of royal tolerance which reserved some places in Paris for newly arrived craftsmen.

In 1595, Henri IV built a new wing in the Louvre, the '*Grande Galerie*', bordering the river and extending from the old Louvre Palace to the Tuileries.[13] Ten years later, he decided to assign the lower levels to thirty workshops for painters, goldsmiths, watchmakers, gem cutters, and cabinet makers. It was an innovative decision because artists with different skills and from varying origins would work closely together, and influence each other. At that time, even if not Paris-trained, they could register as masters in the Paris guild free of taxes. Thus the '*Galerie du Louvre*' provided central accommodation for provincial Huguenot goldsmiths, who mostly specialized in jewellery and enamels. In Paris the goldsmiths' art was divided into two specialities: silver and gold. Every newly registered master had to opt for a speciality for life. It was then forbidden to change. From the 1630s on, every Parisian silversmith was Catholic and every goldsmith, Huguenot.

The earliest Huguenot goldsmiths who settled at the Galerie du Louvre came from different places in France, Germany and Geneva. Their training varied enormously and their previous work was so different that the experience of working together resulted in significant technical innovations. Jean Toutin, a regional goldsmith who gained admittance to the Paris guild in 1617,[14] discovered a new manner of painting with enamels upon gold which was developed in the Galerie du Louvre. His invention is generally dated to the 1630s, after his arrival in Paris.[15] The oldest surviving example of Jean Toutin's technique is in the British Museum. It was made in 1636 by his elder son, Henry Toutin (1614–1684), trained in Paris and registered as a master in 1634, who spent his whole life there. This gold portrait box is decorated with painted enamels: a naval battle with the Paris « tour de Nesle » after Jacques Callot as a background and mythological and classical scenes after Antonio Tempesta. The back enamel is signed '*Henry Toutin, maître orphèvre à Paris fecit. 1636*' (Plates 2 & 3).

As paintings on enamel improved, some Huguenot goldsmiths became specialist miniaturists. The celebrated Jean Petitot (1607–1691) and his brother-in-law Jacques Bordier (1616–1684) were trained in Geneva and mostly worked in Paris and even, in the 1630s, at the English court. Louis Du Guernier (1614–1659), trained as a goldsmith in Paris, also became famous for his portraits in miniature. He married Sébastien Bourdon's sister and copied Bourdon's paintings. Some other enamellers, such as Henri Toutin, remained in the goldsmiths' trade, producing work in gold decorated with painted enamels. Henry Toutin always seems to have signed his pieces, either to compensate for the lack of marks on gold, or more simply, as an expression of pride in artistic achievement. A graceful hand-mirror painted with the figures of Vertumnus and Pomona is in the Patek Philippe Museum, Geneva: it is discreetly signed with the monogram HT (Plate III). Although it has been suggested that Henry Toutin left France and went to England following Petitot's example,[16] there is no evidence to substantiate this. It is more likely that his established reputation in Paris attracted commissions from foreign courts. The presence of Toutin's work in England would explain a number of English connections with his work.[17]

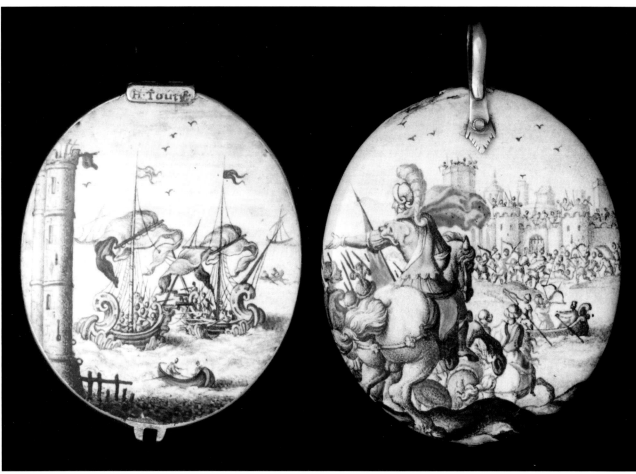

Plate 2 Portrait box with painted enamels, Henry Toutin, Paris, 1636, height 3.9 cm.

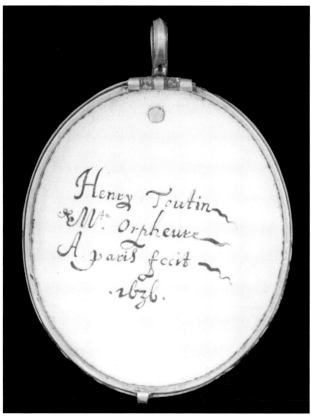

Plate 3 Back enamel of the portrait box Plate 2, Henry Toutin, Paris 1636.

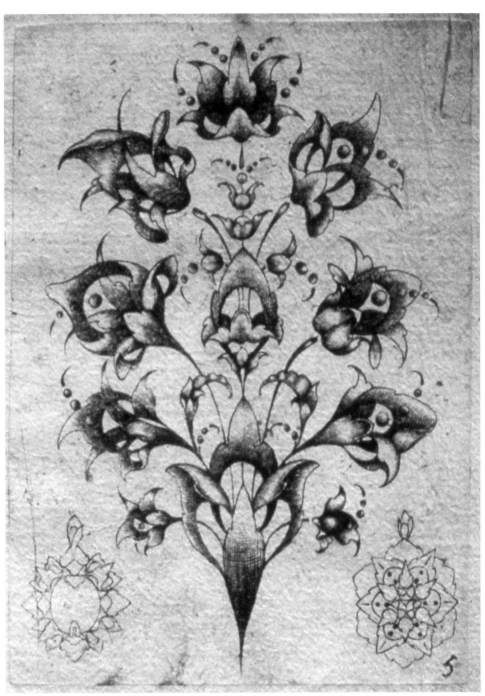

Plate 4 Design for a bunch of pea-pods, plate 5 from a set of 7, Gédéon Légaré, Paris *circa* 1630, 7.8 × 5.5 cm.

Wolfegg, Kunstsammlungen der Fürsten zu Waldburg-Wolfegg, Band 29, no. 542. © Peter Fuhring.

The second Huguenot innovation in the '*Galerie du Louvre*' was the creation of a very special style which is today called the 'Pea-pod style' referring to its botanical source (although this style is too abstract and fanciful to be explained in one word).[18] It was especially developed among the workshops that specialized in the setting of agate vases: the best examples are by François, Josias and Pierre Delabarre,[19] three brothers whose work has survived in the collections of the Louvre and the Prado museums. The Delabarres were born in Loudun in Poitou and reached Paris in 1617. Their gold settings were made of fanciful dragon and human forms mixed with sparkling jewellery and enamels (bright, opaque, painted) in use at the time (Plate IV).[20] Their pea-pod ornaments were

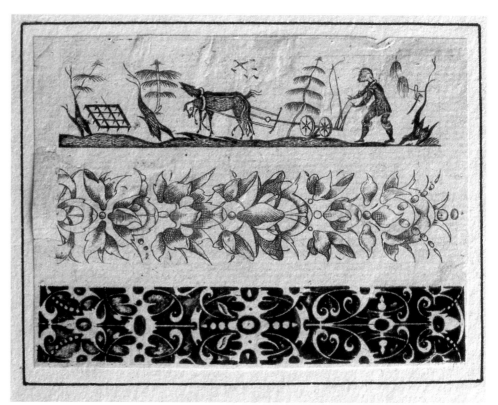

Plate 5 Three different bands of designs, plate 6 from a set of 7, Henry Toutin, Châteaudun 1628, 5.4 × 7.3 cm.

based on prints by three other Huguenot brothers, Gédéon, Gilles and Laurent Légaré,[21] whose Paris workshop was called '*Au Grand Moyse*' (Great Moses, Plate 4).

Records cite the network of friendship and family relationships that developed among these Huguenot artists and designers. For instance, Pierre Delabarre trained the son of Pierre Boulle, André Charles Boulle, the famous cabinet maker who worked in the Galerie du Louvre at this time. Jean Toutin's younger son, Jean Toutin the Second, was trained by Jacques Caillard. This goldsmith was born in Geneva where his father took refuge in 1572 at the time of the Massacre of Saint Bartholomew. Back in Paris, Caillard worked in the Galerie du Louvre and was registered a master in 1619.

Such a brilliant background accounts for the fact that so many Parisian goldsmiths were also active dealers and explains why some of them travelled to London from the 1630s onwards. It is possible that Queen Henrietta-Maria, Henri IV's daughter, married to Charles I of England, invited them to London and commissioned work from them. The names of three Huguenots from Paris are recorded in London at that time: Ulfrand Godart, born in Germany, Paul Boulle and Daniel Boursin, a jeweller. If their work has survived, it is not identifiable, but some of the jewels in the Cheapside Hoard are in the French style. The hoard, probably hidden in the period 1600–1630s, was dug up in 1912 under a demolished building in Cheapside, adjacent to St. Paul's Cathedral in the City of London. Most of these items are now displayed in the Museum of London. The perfume bottle[22] decorated with a line of peapod ornament inspired by Henry Toutin's designs printed in 1628 (Plate 5 and Plate V) is the epitome of the latest French fashion.

Paris, Bibliothèque nationale de France, département des estampes, inv. AA3. © Bibliothèque Nationale de France

Plate 6 Title plate of the '*Livre de feuillages et d'ouvrages d'or-fèvrerie inventées par T. Le Juge*', Thomas Lejuge, Paris, *circa* 1670, 14.5 × 12.5 cm.

French jewellery was much sought after in England. Recent research by David Mitchell in London and by this author in Paris confirms London's appetite for French work and French fashion at the time.[23] This commenced during the reign of Charles I and expanded after the Restoration of the Stuart monarchy in 1660 when a new wave of Paris goldsmiths reached London. They included the jeweller-goldsmith Samuel Loiseau. He was the brother-in-law of Thomas Lejuge,[24] with whom he had worked in Paris. In the 1670s, Lejuge designed a set of plates for jewellery which compare with Loiseau's work (Plate 6).

In France, the 1660s mark the beginning of persecution of the Huguenots which, as time went on, gradually worsened. For the first time, Huguenot gold-smiths were tempted to emigrate permanently. But, in 1669, Louis XIV, anticipating the danger, forbade them to leave France without permission. Yet, officially this prohibition did not apply to dealers '*who sometimes have to travel abroad for their trade*', and during the following months, the royal administration was forced to grant permission to those able to justify their need to travel. The first names mentioned in the French records indicate the trades which were attracted by the English market. First, there were the 'mercers' [dealers] coming from Rouen or Paris, such as Thomas Verbeck,[25] the son of a leading member of the mercers' guild who had supplied the French Crown. He may have been among those foreigners who sold magnificent French toilet services to English families, such as the Lennoxlove service, now in Edinburgh at the National Museum of Scotland.[26] Many professions were connected with French fashion or culture: wigmakers, tailors, tapestry-weavers, painters, musicians, mirror-makers, dancing-

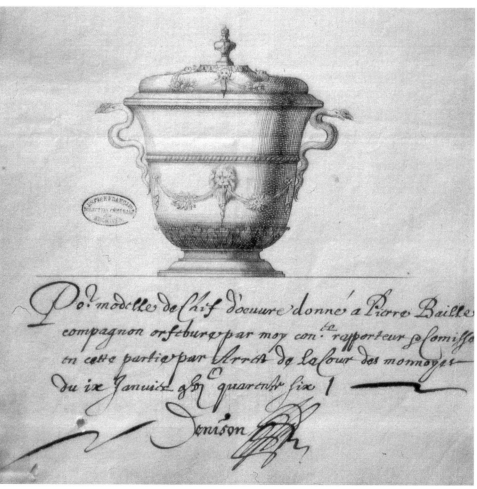

Plate 7 '*Coupe en forme de ciboire*' proposed as Pierre Baille's masterpiece in 1646.

masters, fencing-masters, rice-powder makers, and confectioners. There are no records of Paris goldsmiths in London (as Louis XIV would have objected), but there was a Huguenot gem-cutter, Isaac Maubert, and two jewellers, Jean Leroy and Pierre Tripier.[27] In London, in the Goldsmiths' Company records, David Mitchell has found Isaac Maubert's name on a list of sub-contractors of the London banker-goldsmith Backwell.[28] By travelling to England, these men certainly developed the new English taste for sophisticated French jewels.

The suffering endured by the few Huguenot silversmiths who remained in Paris after 1660 forms a stark contrast to the lives of those who emigrated. In some cases, Catholic silversmiths managed to exclude the Huguneots. In 1645, the Huguenot Pierre Baille tried to gain admittance to the Paris Goldsmiths' guild. His 'chef-d'œuvre' (masterpiece) was rejected and he was refused membership. He complained and finally went to court. He was eventually admitted in 1646.[29] Records prove that he had complied perfectly with the guild's requirements. There is no denying that his initial failure was simply due to the fact that he was a Huguenot, although the guild would never dare to admit that in writing. It is crystal clear: the design of his 'chef-d'œuvre' has been preserved (Plate 7). It was described as 'a covered cup in the shape of a ciborium', that is a secular object cleverly and wickedly described as sacred silver! Catholic prejudices against Huguenot goldsmiths had serious negative consequences. Regional Huguenot

goldsmiths could never gain admittance to the Paris Guild, to complete their training, acquire new skills or learn the latest in Paris design.

A recent discovery throws new light on leading first generation Huguenot goldsmith to settle in London, Pierre Harache. To date little was known about his life in France before his arrival in London in 1682. In 1668, when he was 28, Harache and his wife briefly stayed in Paris on the left bank of the Seine in the liberty of Saint-Jean-de-Latran, where companions and aliens were allowed to run their own workshops.[30] The presence of a young regional Huguenot goldsmith might have prejudiced Catholic interests, although there is no evidence for this. One day, all of a sudden, his workshop was inspected by police officers and, as his work bore no marks, all the square candlesticks, the forks and spoons, the toilet boxes he had made, were simply confiscated.[31] He was brutally thrown in jail on charges of '*rebellion*'. Once freed, he took French leave and went cheerfully back to Normandy. Had the hostility in Paris towards regional Huguenot goldsmiths not been so strong, they would have benefited from Paris fashions. The silver that Pierre Harache made in London in the 1680s would have reflected the latest fashions from the French metropolis.

FURTHER READING

Daniel Alcouffe, 'Le "maître aux dragons": les créations de l'orfèvre parisien Pierre Delabarre', *Revue de l'Art*, n° 81 (1988), pp. 47–56.

Michèle Bimbenet-Privat, *Les orfèvres et l'orfèvrerie de Paris au XVII^e siècle*, Paris, 2002, 2 vols.

Michèle Bimbenet-Privat, 'Pierre Fourfault and the Lennoxlove toilet service', *The Burlington Magazine*, vol. CXXXIX, n° 1126 (January 1997), pp. 12–16.

Michèle Bimbenet-Privat and David M. Mitchell, 'Words or images: descriptions of plate in England and France 1660–1700', *The Silver Society Journal*, 15 (2003), pp. 47–62.

Claude-Gérard Cassan, 'Les orfèvres de Rouen', *Art et curiosité* (janvier–février 1979), pp. 35–126.

Claude-Gérard Cassan, 'Les orfèvres de basse Normandie', *Art et Curiosité* (janvier–mars 1980), p. 14.

Jean et Jacques Clarke de Dromantin, *Les orfèvres de Bordeaux et la Marque du roy*, Suresnes, 1987.

Henri Clouzot, *La miniature sur émail en France*, Paris [1928].

Julian Cousins, 'Pierre Harache I and II. A challenge to current attributions', *The Journal of the Silver Society*, 19 (2005), pp. 71–77.

E. Develle, *Les horlogers blésois aux XVI^e et XVII^e siècles*, Blois, 1913 [réed. 1978]

Hazel Forsyth, *The Cheapside Hoard*, London, Museum of London, 2003

Thibaut Fourrier, *La minorité protestante de Blois de l'entourage de la cour au Refuge*, doctoral thesis, University of Tours, 1994

Peter Fuhring, 'Denis Boutemie. A Seventeenth-Century Virtuoso', *Print Quarterly*, IX (1992), pp. 46–55.

Peter Fuhring and Michèle Bimbenet-Privat, 'Le style "Cosses de pois": l'orfèvrerie et la gravure à Paris sous Louis XIII', *Gazette des Beaux-Arts*, vol. CXXXIX, n° 540 (Janvier 2002), p. 177.

Monique Jacob, *Les orfèvres d'Anjou et du bas Maine,* Paris, 1998.

Ronald Lightbown, 'Jean Petitot and Jacques Bordier at the English court', *The Connoisseur*, 168, n° 676 (June 1968), pp. 82–91.

David M. Mitchell, 'Innovation and the transfer of skill in the goldsmiths' trade in Restoration London', *Goldsmiths, Silversmiths and Bankers: innovation and the transfer of skill, 1550 to 1750*, London, 1995, pp. 5–22.

David M. Mitchell, ' "To Alderman Backwells for the candlsticks for Mr Coventry". The manufacture and sale of plate at the Unicorn, Lombard Street', *The Silver Society Journal*, 12 (2000), pp. 111–124.

Elie Pailloux, *Orfèvres et poinçons XVIIᵉ–XVIIIᵉ–XIXᵉs., Poitou, Angoumois, Aunis, Saintonge*, La Rochelle, 1962.

Philippe Verdier, 'An unknown masterpiece by Henri Toutin', *The Connoisseur*, 162 n° 651 (May 1966), pp. 2–7.

NOTES

I am very grateful to Madame Elisabeth Antoni who translated this essay into English.

1 Michèle Bimbenet-Privat, *Les orfèvres et l'orfèvrerie de Paris au XVIIᵉ siècle*, Paris, 2002, 2 vols.

2 Jean et Jacques Clarke de Dromantin, *Les orfèvres de Bordeaux et la Marque du roy*, Suresnes, 1987, pp. 39 et 46.

3 Elie Pailloux, *Orfèvres et poinçons XVIIᵉ–XVIIIᵉ–XIXᵉ s., Poitou, Angoumois, Aunis, Saintonge*, La Rochelle, 1962, p. 300.

4 Claude-Gérard Cassan, 'Les orfèvres de Rouen', *Art et curiosité* (janvier–février 1979), pp. 35–126.

5 Paris, Archives nationales, Z^{1B} 456; arrêt du 4 mars 1677.

6 Quoted in Colbert's letters: letter to Tubeuf, who was in charge of the 'intendance' of Tours (see Pierre Clément, *Lettres, instructions et mémoires de Colbert*, t. VI, 1869, pp. 131–132).

7 Quoted by Claude-Gérard Cassan, 'Les orfèvres de basse Normandie', *Art et Curiosité* (janvier–mars 1980), p. 14.

8 See Peter Fuhring, 'Denis Boutemie. A Seventeenth-Century Virtuoso', *Print Quarterly*, IX, 1992–I, pp. 46–55.

9 See E. Develle, *Les horlogers blésois aux XVIᵉ et XVIIᵉ siècles*, Blois, 1913 [réed. 1978]; Thibaut Fourrier, *La minorité protestante de Blois de l'entourage de la cour au Refuge*, doctoral thesis, University of Tours, 1994.

10 About the parish registers quoting the members of the Gribelin family, see Paris, Bibliothèque de la Société d'Histoire du Protestantisme français, Ms. 1701.

11 Peter Fuhring and Michèle Bimbenet-Privat, 'Le style "Cosses de pois": l'orfèvrerie et la gravure à Paris sous Louis XIII', *Gazette des Beaux-Arts*, CXXXIX (janvier 2002), n° 540, p. 177.

12 Monique Jacob, *Les orfèvres d'Anjou et du bas Maine,* Paris, 1998, n° 86, p. 376.

13 Michèle Bimbenet-Privat, *op. cit.*, 2002, t. I, pp. 93–103.

14 According to the records, Jean Toutin was made freeman during the last three months of 1617 (Paris, Archives nationales, T 1490¹⁴, fol. 133); in January 1634, when asked to serve as a witness in a trial of the Cour des monnaies, he told that he passed the 'chef-d'œuvre' exam in Paris twelve or thirteen years ago [' il y a XII ou XIII ans'] (Paris, Archives nationales, Z^{1B} 508).

15 Henri Clouzot, *La miniature sur émail en France*, Paris [1928], p. xxx.

16 Philippe Verdier, 'An unknown masterpiece by Henri Toutin', *The Connoisseur* (May 1966) vol. 162, n° 651, pp. 2–7.

17 See Ronald Lightbown, 'Jean Petitot and Jacques Bordier at the English court', *The Connoisseur*, vol. 168, n° 676 (June 1968), pp. 82–91.

18 See Peter Fuhring and Michèle Bimbenet-Privat, *op. cit.*, 2002, pp. 1–224.

19 Michèle Bimbenet-Privat, *op. cit.*, 2002, t. I, p. 298–301.

20 See Daniel Alcouffe, 'Le "maître aux dragons": les créations de l'orfèvre parisien Pierre Delabarre', *Revue de l'Art*, n° 81, 1988, pp. 47–56.

21 Michèle Bimbenet Privat, *op. cit.*, 2002, t. I, pp. 394–398; Peter Fuhring and Michèle Bimbenet-Privat, *op. cit.*, 2002, pp. 109–115.

22 Hazel Forsyth, *The Cheapside Hoard*, London, Museum of London, 2003, p. 48.

23 David M. Mitchell, 'Innovation and the transfer of skill in the goldsmiths' trade in Restoration London', *Goldsmiths, Silversmiths and Bankers: innovation and the transfer of skill, 1550 to 1750*, Londres, 1995, pp. 5–22; Michèle Bimbenet-Privat and David M. Mitchell, 'Words or images: descriptions of plate in England and France 1660–1700', *The Silver Society Journal*, n° 15 (2003), pp. 47–62.

24 Michèle Bimbenet-Privat, *op. cit.*, 2002, t. I, pp. 172–174.

25 Paris, Archives nationales, O¹ 14, fol. 55; 24 janvier 1670.

26 Michèle Bimbenet-Privat, 'Pierre Fourfault and the Lennoxlove toilet service', *The Burlington Magazine*, vol. CXXXIX, n° 1126, January 1997, pp. 12–16.

27 About this goldsmith, see Paris, Archives nationales, Z$^{1B}$ 517; 29 décembre 1666.

28 David M. Mitchell, ' "To Alderman Backwells for the candlsticks for Mr Coventry". The manufacture and sale of plate at the Unicorn, Lombard Street', *The Silver Society Journal*, n° 12 (2000), pp. 111–124.

29 Paris, Archives nationales, Z$^{1B}$ 649.

30 This part of Harache's life is not included in the most recent account of his life: Julian Cousins, 'Pierre Harache I and II. A challenge to current attributions', *The Journal of the Silver Society*, n° 19 (2005), pp. 71–77.

31 Here is the exact quotation of his works: '*un flambeau à pied et un au carré, un chandelier d'estude, deux petites salières basses, deux nœuds de flambeaux, une paire de petites boucles, une cuillère et une fourchette, un manche, un cadre brutte, un petit rond de boeste carré, cinq petites feuilles, une petite placque, trois petits ronds et deux petits cordons, un pied non encore soudé et une anse d'éguière, un morceau et neuf petits bouts de lingotz, le tout d'argent, trois manches de cousteaux, trois cuillers et trois fourchettes de vermeil doré*' (Paris, Archives nationales, Z$^{1B}$ 517; 7 mars 1668).

Huguenot goldsmiths and French influence in The Hague in the late 17th century

Jet Pijzel-Dommisse

Today The Hague is a major city but in the 17th and 18th centuries it was only a small town. In about 1630 its population was 18,000 compared to Amsterdam's 115,000 and by the end of the 17th century there were still only 30,000 people there. But The Hague was situated in Holland, the most important province in the Dutch Republic and its population was far wealthier than that of any other Dutch town. Goldsmiths and jewellers prospered there; in 1625 there were about forty and by 1690 there were approximately one hundred. The main reason for The Hague's wealth was the presence of the stadholder's court and the Republic's main decision-making body, the States General. These attracted a host of courtiers, provincial representatives, judges and lawyers. Amsterdam was the economic and financial heart of the Republic, but ever since 1588 – after the Northern Netherlands shrugged off Spanish rule – The Hague had been the centre of government. It was also an international city: the stadholders married foreign princesses and the town was alive with foreign guests, envoys and ambassadors, who were keen to show off their wealth and introduce the latest fashions from abroad.

Many foreign artisans were attracted to The Hague in the 17th century by religious freedom in the Protestant Republic, and the large potential market for luxury goods. Even in the 18th century The Hague welcomed foreign goldsmiths and jewellers without much opposition from the local guild. In the late 16th century, the foreign goldsmiths came mainly from the Southern Netherlands, which were still Catholic and under Spanish rule.[1] Between 1630 and 1650 there was a wave of goldsmiths from Augsburg and Nuremberg, who had lost their clients as a result of the Thirty Years War.[2] In the late 17th century there was an influx of Huguenots from France. This essay concentrates on French influences on the design and techniques of silver produced in Holland in this period, with particular emphasis on The Hague. The influx of Huguenot goldsmiths has been recognized as the main channel for that influence. But how many of them actually stayed permanently in The Netherlands? Was their work the only source of information about the latest stylistic developments in France? Who were the French goldsmiths who settled in Amsterdam and The Hague between 1680 and 1700 and what do we know about them?

Huguenot Goldsmiths in Amsterdam and The Hague

Between 35,000 and 50,000 Huguenots took refuge in the Northern Netherlands in the late 17th century. The *Dénombrement de tous les Protestants*

réfugiés de France à Amsterdam drawn up by Huguenots in Amsterdam between 1681 and 1684, lists their names and occupations.[3] This document probably includes less than half the Huguenot population of the city. Clearly most of the craftsmen listed were engaged in the textile trade: around ninety to ninety-five percent were *ouvrier de soie, passementier* or *rubanier*. Only five master goldsmiths (*Sieur Orfèvre*) – Pierre Poulain, Moise Bellanger, Louis Gontal, Moise Gallis and Pierre Langlois – and a single *Compagnon Orfèvre*, called Bestian, are included. Gontal and Bellanger are also described as engravers, while Gallis (or Gallois) is listed as an *orfèvre et ouvrier en soie*. Bellanger came from a large family in Blois, some of his family are recorded in Paris.[4] He was accompanied by his mother *la Veuve Bellanger* (Marie Feillet), who is also listed as an *orfèvre et graveure*. Bellanger and Langlois settled permanently in Amsterdam; their sons, grandsons or nephews were still working there in the 18th century, producing embossed and engraved gold watchcases and snuff boxes.[5] It is not known whether the other master gold-smiths remained in Amsterdam, or what they produced in the city. A few other goldsmiths of French birth moved to Amsterdam around 1680: Pierre Regnier from Paris and Theodore Badenhop from Caen made gold watchcases and snuff boxes.[6] Steven Des Rousseaux, a member of a family firm of merchants in luxury goods who were linked with the Paris-based protestant Marchand family of gold-smiths, jewellers and diamond dealers, also settled permanently in Amsterdam.[7]

Unfortunately there is no similar list of Huguenots for The Hague. Information has to be scraped together from various archives. The guilds in the Netherlands had to keep copper plates recording maker's marks but those for The Hague have not survived and there are few remaining guild records. There are municipal registers of new arrivals but until 1681 these do not contain systematic lists of the goldsmiths sworn in each year. And even after that, there are gaps. No oaths are recorded between 1691 and 1701, even though later records show new goldsmiths had in fact started work during that period. Fortunately the register of marriages sometimes records the origins of the bridegroom, although often merely as 'young man from France'. Huguenots sometimes came on to The Hague via other towns, such as Middelburg and Vlissingen, both in Zeeland. A French name is not sufficient in itself to prove Huguenot identity because crafts-men from French-speaking areas like the Southern Netherlands had already settled in The Hague in the past. For example, the Du Vignon family came from Brussels right at the beginning of the 17th century and were active in The Hague through to the 1740s. The famous silversmith Albert de Thomese, who worked from 1708–1753 and produced silver of very high quality in a French style for all the important families, cannot be called a Huguenot, as his family background is not recorded.[8]

Some of the small number of French silversmiths who settled in The Hague in the final decades of the 17th century can be identified. Jean Sonjé (or Sanjé) from Picardy married in The Hague in 1686; the only silver attributed to him is an altar cruet set and stand, made in 1712 and 1713 (Plate 8). The model and decoration are French; and the decorative border is inspired by engravings by Alexis Loir, published after 1689.[9] Louis Digues married in 1693 and is described in a legal document of 1697 as an 'orfèvre', but no work by him is recorded.[10]

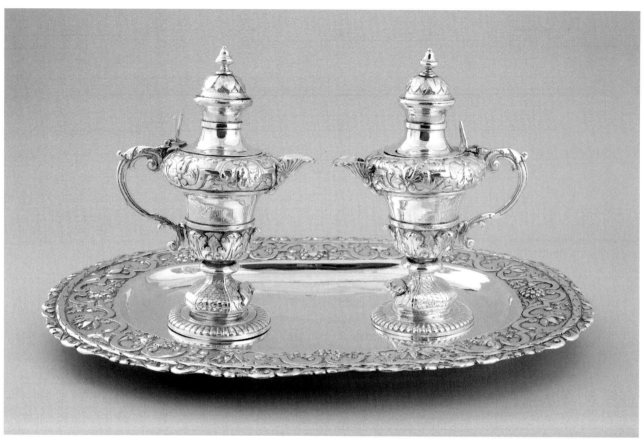

Plate 8 Altar cruet set, silver, attributed to Jean Sonjé, The Hague 1712, 1713; height of cruets, 18 cm., width of tray 40 cm.

Jacques Chevalier the Elder, a widower who remarried in 1699, is listed as a gold-smith. Silver attributed to him includes a bakers' guild cup of 1689 and a tea caddy in the Rijksmuseum Amsterdam, dating from 1695. Their cut-card decoration, combined with fine engraving, are French in style but it is unclear exactly where Chevalier came from.[11] Jacques Tuillier, married to Jeanne Sauvage, was made free in 1701, at the end of the decade in which no new admissions were recorded: it is possible that he had been active in The Hague for some time.[12] Likewise, Richard Musseau, who was sworn in in 1702, but married a Frenchwoman called Anna Paeck in The Hague in 1694. The kettle on stand in the Gemeentemuseum The Hague, attributed to him and dated 1707, is the finest example of 'Huguenot' silver, decorated with French inspired ornamental borders[13] (Plate 9). After Musseau's death, his widow remarried in 1711. Her new husband, Jean Rostang, also a goldsmith, was sworn in immediately after their marriage. His work includes a sconce for two candles dated 1713 and a covered christening basin for the Walloon Church in Delft.[14] Although their work was of good quality, none of these craftsmen had any lasting influence on the work of native goldsmiths; in contrast to the Huguenots goldsmiths who settled in London.

Silver in the French style

Although only a few French born silversmiths were active locally, there was strong French influence on the style of silver made in The Hague in the late 17th century. Dutch craftsmen absorbed French influences by working in France

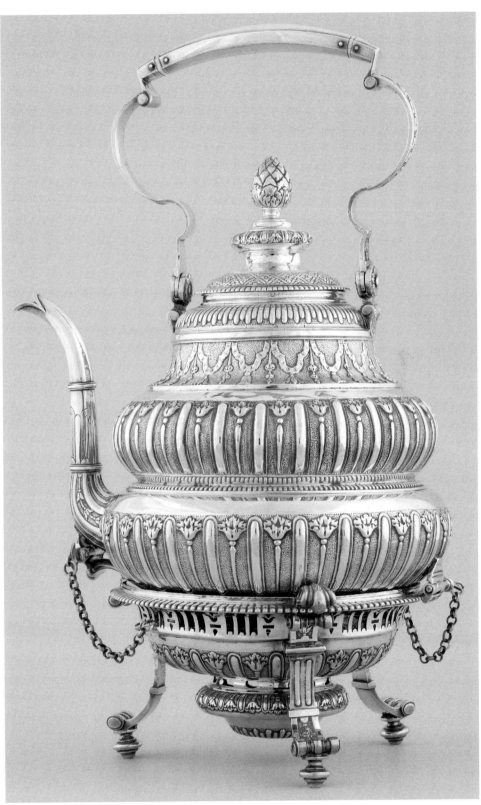

Plate 9 Kettle on stand, silver, attributed to Richard Musseau, The Hague 1707, height 39.4 cm.

© Gemeentemuseum, The Hague.

temporarily or by seeing French silver in The Hague, which they may have cleaned, repaired or copied. For example, in 1679, The Hague goldsmith Mattheus Loockemans had two candlesticks assayed, which were almost exact copies of candlesticks made by the Parisian silversmith Robert Collombe, even including the chased tendrils adorning the shafts (Plate 10). The Parisian candlesticks are

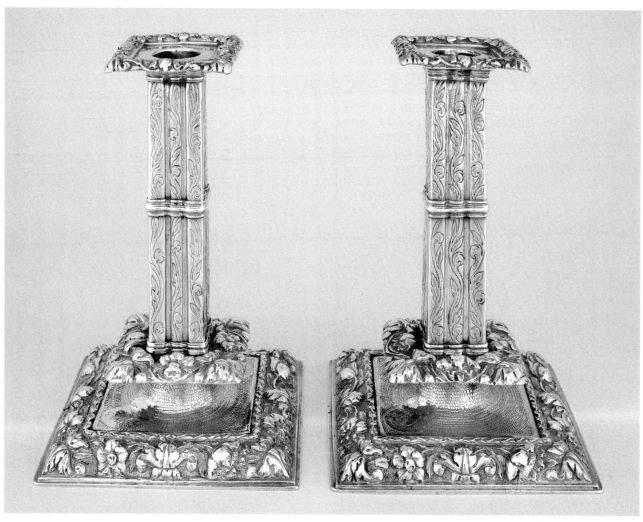

© Gemeentemuseum, The Hague.

Plate 10 Two candlesticks, silver, Mattheus Loockemans, The Hague 1679, height 18.5 cm.

part of the toilet set made for Princess Mary Stuart, now in the collection of the Duke of Devonshire at Chatsworth. The toilet set went with her to The Hague when she married Stadholder William, Prince of Orange, in 1677.[15] Three extra replica boxes for this toilet set were delivered to her from the workshop of Hans Coenraet Breghtel in 1678. There is an essential technical difference between the original boxes and the replicas: the French ones are cast, whereas the Hague copies are embossed.[16] French silver might also be given to silversmiths in payment or bought by them to sell to clients. For example, when he died in 1672, Hague silversmith Jeremias Micheel owned a ewer and basin decorated with the Four Seasons; described as French, it was the most valuable set in his possession.[17]

The Hague goldsmiths had easy access to published engravings of French designs through the many bookshops and publishers there and in Amsterdam. Books of architecture or sketches, drawings and prints of designs for modelling and embossing are listed among the possessions of the leading silversmiths. They certainly included the published work of the most celebrated Huguenot designer in the Netherlands, Daniel Marot. His designs were first published in The Hague in loose sheets in the 1690s, before being bound together in 1702 and 1712.[18] Hague-born silversmith Hermanus van Gulick must have encountered the French style at an early date. His 1682 'hansa' cup made for the use of the Delfland district

Plate 11 Fountain, with the initials of Czarina Anna Ivanovna; silver, Hermanus van Gulick, The Hague 1704, height 74 cm.

polder board at the Gemeenlandshuis in Maassluis already displays the entire French repertoire of ornamental borders and leaves, gadrooning and fluting.[19] His fountain, now at the Hermitage, is unusually large and imposing by Dutch standards; it was made in 1704, possibly for Prince Alexander Menshikov, who bought silver in Holland around that time[20] (Plate 11). It has many similarities with published designs for fountains and water jars by Daniel Marot, especially with his fountain design with its 'dripping water' ornament (Plate 12). Daniel Marot's influence was still perceptible in the Netherlands in the mid 18th century. One of the best examples of his later influence is an architectural Catholic tabernacle, made in 1720 by Jesaias van Engauw (Plate 13). Similar pilasters with crossbars can be seen in Marot's interiors, including the new Dining Room at Het Loo, Apeldoorn or the Trèveszaal in the Binnenhof, The Hague.[21]

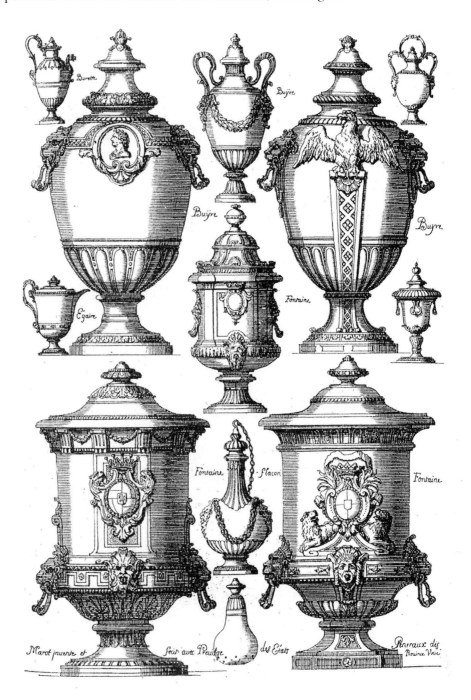

Plate 12 Design for fountains and buires from the series 'Nouveaux Liure d'Orfeurerie', Daniel Marot, The Hague 1689 1702, etching 27 × 18 cm.

Plate 13 Tabernacle, silver, Jesaias van Engauw, The Hague 1720, height 85.5 cm.

Adam Loofs, court silversmith to William III

The greatest boost to the French style was undoubtedly given by Stadholder William III and his wife Mary. In 1679 they ordered silverware in Paris and arranged for a Dutch silversmith working in Paris to come to The Hague as court silversmith: his name was Adam Loofs.

The term 'stadholder' originally meant a representative of the monarch. Under the Dutch Republic however the stadholder was subject to the States General and had an important role as leader of the army in time of war. The Orange family strove to establish the principle of hereditary succession, but this was not automatically accepted by the States. For this reason, the death of Stadholder William II in 1650 marked the start of a 22-year period in which there was no stadholder at all, partly because his son was born posthumously. William II and his wife Mary Stuart, daughter of Charles I of England, presided for only three years over a glittering court in The Hague, equal in magnificence to any other in Europe. It had been created by William's parents: Prince Frederik Hendrik and – more particularly – his wife Amalia van Solms. The Stadholderless Period that

followed the death of William II continued until the 'annus horribilis' of 1672, when the Netherlands were attacked by both France and England. At this point, William's son was appointed stadholder and head of the army, chiefly to bolster military morale. In 1677 William III married his cousin Mary Stuart, which led in 1689 to their becoming joint sovereigns of England as William III and Mary II.

William remained stadholder and kept up a considerable court in The Hague, though nowhere near as magnificent as that in London. His silver included some vast pieces his grandparents had ordered, for the table and the buffet and for lighting, but the silver that Mary had brought with her in 1677 was far more splendid and modern in appearance: a silver table with mirror, together weighing around 46 kilos, an eight-branched chandelier weighing around 21 kilos, furniture for the fireplace including silver andirons with shovel and tongs and her Parisian toilet set.[22] When she returned to England in 1689, she left this silver furniture in The Hague. In 1679 she acquired another two silver tables, from Paris, with matching mirrors and guéridons.

Adam Loofs, originally born in the Netherlands, was not a Huguenot but was more influential than the handful of documented Huguenot goldsmiths in bringing Paris design and techniques to The Hague. New biographical information and several recently discovered spectacular works shed new light on his importance.[23]

Adam Loofs was probably born in Amsterdam around 1645. The earliest mention of his presence in Paris is in the archives of the Dutch Embassy chapel, where he is listed as one of the chapel's two elders in 1670, 1672 and 1674.[24] His fellow elder was also a craftsman of Dutch origin and one of some distinction, the 'Konings cabinetwerker' or Ébéniste du Roi, Pierre Gole. As elders of the chapel, Loofs and Gole were responsible for its contents (there is mention of a pulpit, silver flagons and chalices, registers of baptisms and marriages, and alms for the poor). The chapel was closed down in 1674 following the war between France and the Republic and the ban on preaching in Protestant churches. Loofs and Gole were described by the embassy secretary Rumpf as 'very reliable and prosperous men'. The circle of acquaintances of Pierre Gole in which Loofs probably also moved in Paris or at any rate must have had contacts, contained many protestant goldsmiths and merchants, who served as witnesses at marriages or were family members, like the famous architect Jean Marot, Gole's brother-in-law and father of Daniel Marot, and Gole's son Corneille, later ébèniste to Queen Mary.[25] There is no mention of Loofs as a master orfèvre or indeed of him as a goldsmith actually working in Paris. Even so, he must have been one, because a legal document made in The Hague records a statement by one Estienne des Rousseaux, the Paris-born son of the merchant Jean des Rousseaux: Etienne had lived and worked with Loofs in Paris for six years as a journeyman after serving his apprenticeship until 1671 in Amsterdam.[26]

Loofs' professional connections are intriguing. Another legal document made in The Hague reveals that in 1706, four years after the death of his patron William III, Loofs had borrowed money from Baron Von Smettau, the representative of King Frederick I of Prussia, and that he was to pay the annual interest on the loan to one Hans Hendrick de Moor.[27] This is interesting, because Jean-Henri de

Moor, director of the mirror manufactory owned by the King of Prussia at Neustadt an der Dosse, was a former Paris goldsmith. In the same year, 1706, Loofs' only son Pieter married Catharina de Moor, also from Neustadt and no doubt a daughter of Jean-Henri. It is not impossible Loofs and Jean-Henri de Moor knew each other in Paris. They were about the same age, Jean-Henri too was born in the Northern Netherlands, in Arnhem, and was active in Paris from 1674 to about 1682. Like Loofs, he was not a master of the guild. Jean-Henri de Moor worked for his father-in-law the silversmith François Lebret and is known to have been in London about 1678. Between 1683 and 1696 he made silver furniture for King Christian V of Denmark, after which he apparently worked for Frederik I in Neustadt.[28]

There is equally telling information about Loofs' marriage. His wife Anne Frère may have been the daughter of another elder of the Dutch Embassy chapel in 1664–1668, Jean Frère.[29] He can probably be identified with the goldsmith of that name who came from Metz and was engaged in the export trade between Paris and Lorraine at the famous Paris market of Saint-Germain des Prés.[30] Could Loofs have been apprenticed to Frère in the 1660s and later married his daughter? It was a very common sequence of events. Jean Frère certainly had apprentices because a 1662 contract survives for the apprenticeship to him of the 15-year-old son Pierre of the goldsmith-jeweller Jean Leroy.[31] There is no further information on Jean Frère.

In September 1679 Loofs presented himself at the stadholder's court in The Hague to deliver from Paris two large tables, two large mirrors and four tall guéridons. The following January a francophile Dutchman, Philips Doublet, wrote to his brother-in-law Christiaen Huygens, the famous scientist who was then working at the Paris Academy of Sciences, mentioning Loofs and the furniture. Apparently it had made a great impression in The Hague because he writes about the 'superb silver furniture' that Loofs had himself helped to produce for the stadholder's wife Mary.[32] William van Nassau-Odijk, a relative of Stadholder William III and ambassador in Paris, is mentioned by Doublet as '*son patron*' and the intermediary between the court and Loofs. It appears from the letter that Loofs had worked on the pieces but that the main responsibility for the commission lay elsewhere. This is confirmed by a note made by Loofs in 1697 when he was drawing up an inventory of William III's gold and silverware: he wrote that the pieces delivered from Paris in September 1679 weigh '*volgens de memorie der silversmidh van Parijs*' (according to the memory of the Paris silversmith) a total of 1295 marc and 7 onces troois, approximately 319 kilos of silver.[33] The furniture was kept in the Stadholder's Quarters in the Binnenhof, where it was displayed in Mary's Presence Chamber. In the margin of the 1697 inventory there is a note revealing the artistic value attached to it: '*Dit moet gehauden worden, wijl te veul an fatsun saude verloren gaan*' (This must be kept or too much fashioning would be lost). After William's death therefore it was not sold off or melted down like almost all his other silverware, but inherited by his chosen heir in Holland, his cousin Johan Willem Friso of Nassau-Dietz, father of the later Stadholder William IV. The furniture survived for many years in the princely residence in Leeuwarden but disappeared in the late 18th century, probably looted by French troops and melted

down. Today its appearance can only be guessed at but it must have been as magnificent as similar tables at Versailles or later designs by Daniel Marot.

Van Nassau-Odijk's mediation and the impression made by the furniture led to Adam Loofs' appointment as both Ordinary Gold- and Silversmith and Keeper of the Plate at William's court in The Hague. A contract drawn up in May 1680 specifies a salary of 700 guilders a year (equivalent to around 70 pounds sterling) and describes his tasks and responsibilities. These included the storage, maintenance and repair of all the gold and silverware in William's palaces in the Netherlands. In addition, Loofs was to receive separate payment for any pieces he produced for the court. Loofs registered as a new resident of The Hague on 29 June 1680 but it was not until 16 May 1682 that he was sworn in as a gold- and silversmith and entered his mark.

Some objects made by Loofs

Loofs supplied William of Orange with gold mounts for ebony furniture and andirons, he made silver chandeliers, girandoles, sconces, fire-irons and mounts for a firepan. In 1680 he also supplied '*drie groote doorluchtige gedreven banketschotels op hoge voeten*' (three large gilded openwork cake stands), and in 1681 two '*buires*' or water jars. In fact Loofs supplied everything a stadholder married to an English princess might need to equip his apartments and sideboards in a manner befitting her and his position. After William and Mary ascended the English throne, Loofs

Plate 14 Christening basin, with the arms of Stadholder William III, silver, Adam Loofs, The Hague 1682, diameter 35.5 cm.

continued to work for William in the Netherlands, but made mainly small lighting items and tableware, needed for his larger retinue.[34] Spectacular new objects like fountains and matching coolers, ordered in London for the King and for all English ambassadors from 1695 onwards, were not, as far as is known, ordered for the stadholder's court in the Netherlands. On the evidence both of the inventory list and of payments made by the Nassau Domains Council it is also clear that Loofs was not the only person supplying the Dutch court. Other Hague goldsmiths and jewellers were involved, although none to the same extent as Loofs. And, so far as we know, none of the other goldsmiths had a French background.

Of approximately twenty objects marked by Loofs, a few can be linked to the stadholder or his courtiers. A covered 1682 christening basin and two communion beakers from the Walloon Church in The Hague, decorated with foliate cut-card ornament in a true French style, are the earliest works by Loofs assayed in The Hague (Plate 14). Since they bear the arms of William III, they may well have been donated by him to the French-speaking Eglise Wallonne, which met in his own court chapel and was attended by his family. The form of the standing beakers and the cover of the christening basin are unusual features for the time but set a local trend and became popular in The Hague in the 18th century.[35] In 1687 Loofs made the pair of candlesticks in the collection of the Rijksmuseum, possibly for princess Mary, as two years later she took with her to England two candlesticks 'met beeltjes' (with figures, Plate 15). The most striking and fashionable feature is the shaft in the form of a female figure supporting the

Plate 15 Pair of candlesticks, silver, Adam Loofs, The Hague 1687, height 28.6 cm.

© Rijksmuseum, Amsterdam.

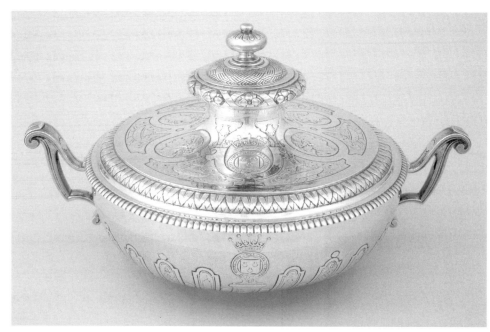

© Gemeentemuseum, The Hague.

Plate 16 Ecuelle or tureen, with the arms of Arnold Joost van Keppel, 1st Earl of Albemarle, silver, Adam Loofs, The Hague 1701, height 13.2 cm.

nozzle and wax pan, a popular feature in contemporary Paris designs; it is very similar to the shaft of a guéridon which the Parisian goldsmith Alexis Loir I published in around 1689.[36]

The famous two 1688 pilgrim bottles by Loofs bearing the arms of the 1st Duke of Devonshire, now at Chatsworth, may have been presented by William III to William Cavendish, 4th Earl of Devonshire, for his support in the Glorious Revolution or when Cavendish was created a Duke in 1694. The decoration is typical of Loofs: cut-card ornament, gadrooning around the foot, and large frowning masks.[37] Another present from William III to one of his courtiers, Arnold Joost

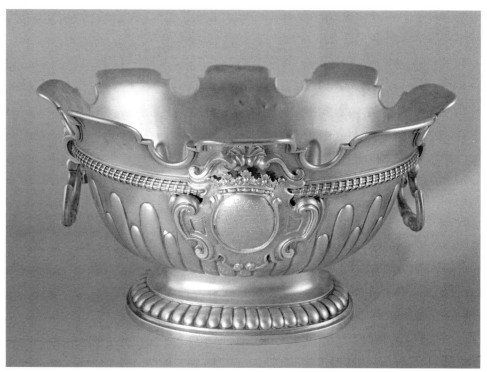

© Private collection.

Plate 17 Cooler, with the arms of the town of Den Brielle, silver, Adam Loofs, The Hague 1704, height 21 cm.

van Keppel, Earl of Albemarle, may have been the écuelle or small tureen in the Gemeentemuseum The Hague (Plate 16). The écuelle was made in 1701 when Keppel married Geertruida van der Duyn.[38] Loofs supplied other customers outside court circles, notably after the death of William III. In 1704 the town of Den Brielle commissioned a large monteith as a gift to a member of the town council, Arent baron van Wassenaer, and his wife Anna Margriet Bentinck, daughter of the Earl of Portland, following the birth of their first son. It is a large, sturdy cooler with Loofs' typical decoration confined to soft flutes, cartouches, and an ornamental ribbed border, traversed by ribbons (Plate 17).

Recent attributions to Loofs

Plate 18 Pair of vases, with the arms of Hans Willem Bentinck, 1st Earl of Portland, silver, Adam Loofs, The Hague probably 1693, height 43.4 cm.

Two pairs of impressive vases from the Portland collection at Welbeck Abbey have recently been attributed to Loofs and were included in the 2005 exhibition of Hague gold and silver at the Gemeentemuseum The Hague[39] (Plates 18 & 22). These vases deserve more attention. They perfectly illustrate the influence of

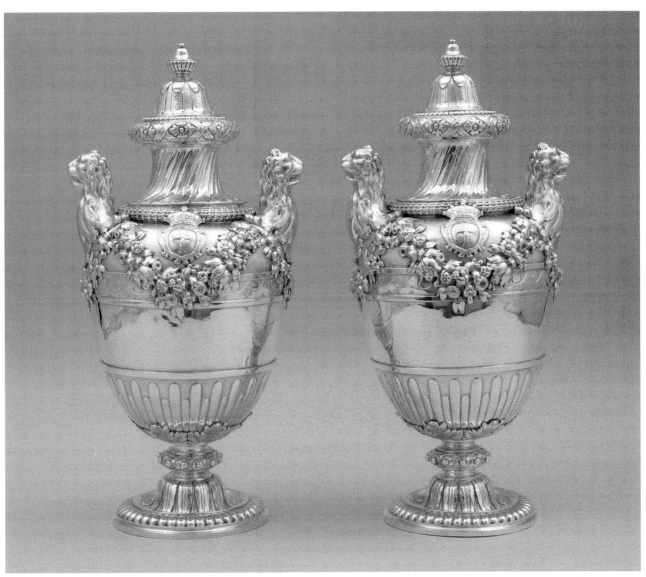

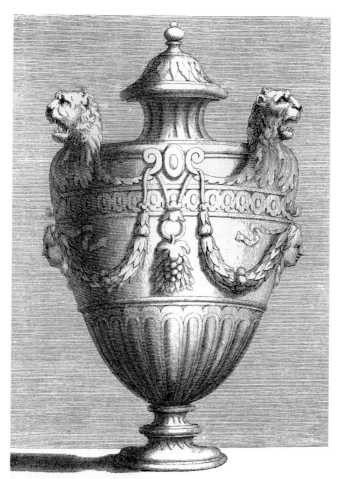

Plate 19 Design for a vase, Jacques Stella, Paris 1657–67, engraving 27 × 20 cm.

Plates 20 & 21 Candélabre composé par Michel-Ange Buonaroti d'après le concours ouvert entre Raphaël d'Urbino & lui par les Papes Jules II & Léon X, environ l'An 1518, published by Francois-Etienne Joubert, Paris 1803, after a drawing by Louis Prieur, Rome 1778. Etching and engraving, two parts, 45.3 × 30.7 cm. and 48.4 × 31 cm.

French classicism on taste at the stadholder's court in The Hague. Previously published by J. Starkie Gardner and E. Alfred Jones, their date has caused some controversy.[40]

The two smaller vases with the lions' heads bear the arms of Hans Willem Bentinck, as Earl of Portland, created in 1689 but before he was made a Knight of the Garter in 1697. Bentinck was William of Orange's page of honour, best friend and councillor; he became his Groom of the Stole and First Gentleman of the Bedchamber in England. He was a great military commander and a keen diplomat, best-known for being ambassador to Paris in 1698. He was regarded in the 17th century as the richest man in the Netherlands, apart from members of the House of Orange.[41] The two vases, with the maker's mark of Loofs and the date letter (most probably a T for 1693), may have been a gift from the king following the Battle of Landen in 1693, where Bentinck was wounded. The vases show, apart from the typical lions' heads on the shoulders, the bold flower festoons in relief and the spiral twisted collar, soft gadroons, leaves and ornamental borders known from other work by Loofs: the ribbed border with ribbons on the base of the collar is identical to the border on the 1704 monteith (Plate 17). The heads emerging from acanthus leaves on the shoulders are characteristic of French designs of the 1650s and 1660s. Designs by Jean Marot and Jacques Stella may have been amongst the prints mentioned in the inventory of Loofs' belongings after his death in 1710[42] (Plate 19). The French designs are based on 16th century

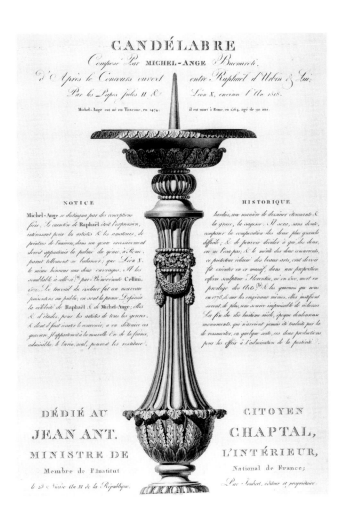

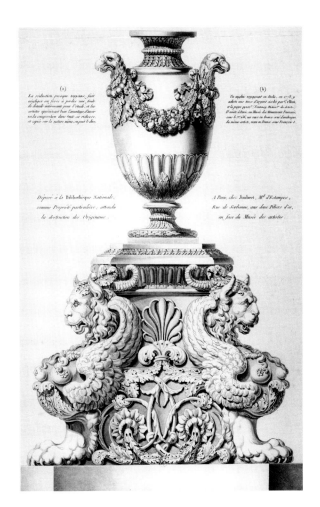

Italian designs including one by Augustino Veneziano 1530.[43] The combination of animal heads, festoons and flutes and acanthus leaves supporting the bowl is similar to the vase-shaped portion of a candlestick depicted in a large two-part engraving published in Paris in 1803, based on a drawing by Louis Prieur, made in Rome in 1778 (Plates 20 & 21). This overall design is typical of large bronze altar candlesticks used in Roman churches in the early 17th century which probably were also made in silver. Candlesticks like this, or drawings of them, may have been in circulation in Paris at the time when Loofs was working there.[44]

The two other large and highly unusual vases in the Portland collection at Welbeck are described as fountains. They are decorated with ornamental borders, acanthus leaves on the foot and shoulder, a spiral twisted collar, a large half-putto holding a dolphin spout, a cartouche with coat of arms in front and at the back a lion's mask with a handle (Plate 22). The most striking features are the unusual handles, enriched by cut-card leaves and terminating in grotesque monsters. The coat of arms of Robert Harley, 1st Earl of Oxford, reveal that the jars probably entered the Portland collection through the marriage in 1734 of Margaret Cavendish Holles, only daughter of Robert's son Edward Harley and Lady Henrietta Cavendish Holles, to William Bentinck, 2nd Duke of Portland.[45] The covers have been replaced and date from the time when the deer's head featured in the arms of the Cavendish family. 'Fountain' is not really the right word for these jars, because they have no taps. Water can be poured from the mouth of the

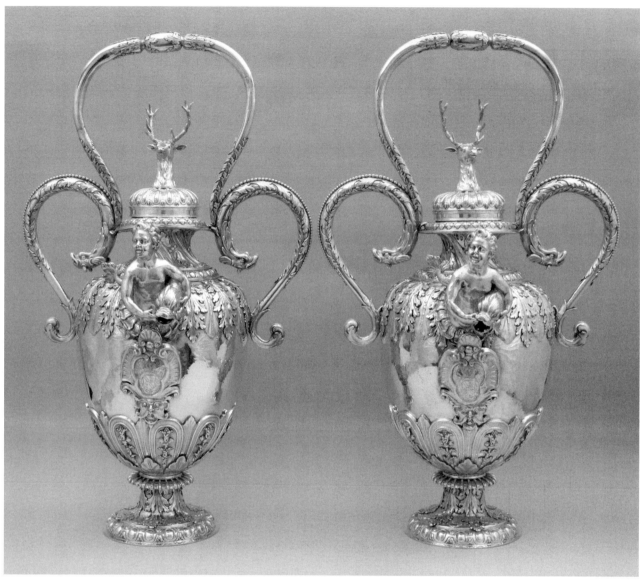

Plate 22 Pair of 'buires' or water jars, with the arms of Robert Harley, 1st Earl of Oxford, silver, attributed to Adam Loofs, probably The Hague 1681, height 85.1 cm.

dolphin although the operation requires three people: two to hold the vessel and one to raise the jar by the lion's mask handle on the back and tip it forward.

The inventory of William III's gold and silverware records that in November 1681 Adam Loofs had produced '*twee buires off hooge watterkruycken*' ('two buires or tall water jars'), with a combined weight of 121 marc 1 o 10 e, almost 30 kilos. The weight of the *buires* made for William III is almost identical to that of the Welbeck jars, although we don't know their exact original weight because their covers were replaced. The description 'buire or water jar' is highly appropriate to the Welbeck jars.[46] Daniel Marot makes a clear difference between *fontaines* and *buires* in his design, he even depicts a *buire* with a similar overarching handle (Plate 12). Based on this knowledge the Welbeck jars are here attributed to Adam Loofs. The complete absence of marks, including a maker's mark, is explicable if Adam Loofs made the jars in 1681, before he officially registered his mark in May 1682.[47] The technical construction of the jars and the finishing confirm that they are not made by a French or English goldsmith: the chasing is less refined than French work and the acanthus leaves have all been separately cast and then

Plate 23 'Buire' or 'Vase en argent' by Jacques Dutel, Paris 1669, after a design by Charles Le Brun; drawing of B. Drouot, after the tapestry Chateau du Louvre from the series Les Maisons Royales, published in J. Guiffrey, 'Inventaire général du Mobilier de la Couronne sous Louis XIV (1669–1705)', Paris 1885–96.

VASE EN ARGENT.

D'après la suite des Maisons Royales. (Château du Louvre.)

Plate 24 Kedleston fountain, silver, Jean Leroy, Paris 1661–63, altered by Phillips Garden, London 1758–62, height 65.2 cm.

attached to the foot and the body with pins before being soldered on, leaving the pins clearly visible on the inside. This is exactly how the acanthus leaves, festoons, lion's heads and Bentinck arms are attached to the two vases bearing Loofs' mark.

The unique and rather curious shape of the jars looks right for 1681. As Loofs was working in Paris in the 1670s he would have been aware of the two

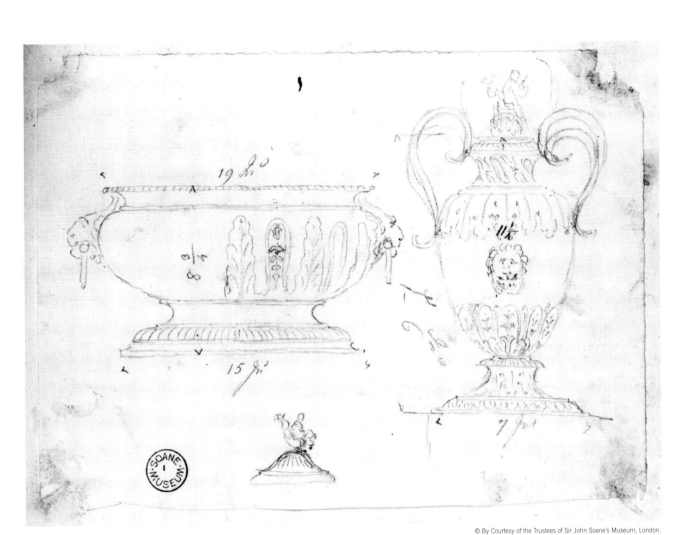

Plate 25 Sketch for the fountain, its lid and cistern, Robert Adam, London *circa* 1761, 14.5 × 20.2 cm.

pairs of enormous *buires* made for Louis XIV in 1669 by the goldsmiths Claude de Villers and Jacques Dutel after designs by Charles Lebrun. These huge ornamental vases are described in detail in the inventories and clearly depicted in tapestries.[48] A drawing of the swan's head *buire* by Dutel, based on a tapestry and published in the late 19th century, reveals a number of similarities to the Welbeck jars: the arrangement of handles at the top, the spiral twisted collar, the positioning of a rearing figure or head on the shoulder, and most especially the wreath of leaves around the figure (Plate 23). There are also close similarities between the Welbeck jars and the so called Kedleston fountain in the J. Paul Getty Museum (Plate 24). This fountain bears the maker's mark of the Parisian silversmith Jean Leroy, and the date letter R for 1661–1663.[49] Major changes were made to the fountain in 1758–1762 by Phillips Garden after designs by Robert Adam but an Adam sketch of the Kedleston fountain, made just before its modification, shows the old foot and double handles looking very like those on the Welbeck jars (Plate 25). Some details of the jars and the fountain, like the cartouche of the coat of arms and the lion's heads on the back are so similar that they actually look as if they are cast from the same mould (Plates 26 & 27). As mentioned earlier, in the 1660s Pierre Leroy, son of the goldsmith or jeweller Jean Leroy, had been apprenticed to Jean Frère, probably Loofs' father-in-law. If Loofs was also an apprentice of Frère and knew Pierre and his father Leroy, the attribution of the Welbeck jars to him becomes even more convincing. Looking at these vases from the Portland

Plate 26 Detail lion's head back of Kedleston fountain (Plate 24).

Plate 27 Detail lion's head back of buires Plate 22, attributed to Adam Loofs.

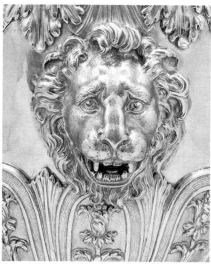

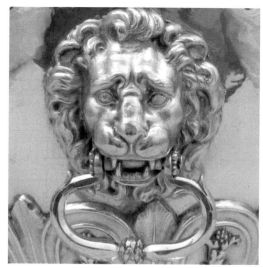

© The J. Paul Getty Museum, Malibu, Los Angeles. © Private Collection.

collection it is clear the work of Loofs at court must have been far more influential in The Hague than the work of the few Huguenot goldsmiths who are recorded there at that time.

FURTHER READING

Reinier Baarsen et al., *Rococo in Nederland*, exhib. cat., Rijksmuseum, Amsterdam, 2001.

M. Bencard, *Silver Furniture*, Rosenborg, Copenhagen, 1992.

D. J. Biemond, 'Kandelaar', *Bulletin van de Vereniging Rembrandt*, 16 (2006), no. 2, pp. 13–15.

M. Bimbenet-Privat, *Les orfèvres et l'orfèvrerie de Paris au XVIIe siècle*, 2 vols, Paris, 2002.

F. Buckland, 'Gobelins tapestries and paintings as a source of information about the silver furniture of Louis XIV', *The Burlington Magazine,* 125 (May 1983), pp. 271–83.

K. A. Citroen, *Amsterdamse zilversmeden en hun merken*, Amsterdam, 1975.

Courts and Colonies. The William and Mary style in Holland, England, and America, exhib. cat., Cooper Hewitt-Museum New York; Carnegie Museum of Art, Pittsburgh, 1988–89.

S. W. A. Drossaers, Th.H. Lunsingh Scheurleer, *Inventarissen van de inboedels in de verblijven van de Oranjes en daarmede gelijk te stellen stukken 1567–1795,* 3 vols, The Hague, 1974–1976.

P. Fuhring, *Ornament prints in the Rijksmuseum II: the seventeenth century*, 3 vols, Amsterdam, 2004.

Haags zilver uit vijf eeuwen, exhib. cat., Gemeentemuseum, The Hague, 1967.

C. Huygens, *Oeuvres complètes publiées par la Société Hollandaise des Sciences*, 22 vols, The Hague, 1888–1950.

E. A. Jones, *Catalogue of plate belonging to the Duke of Portland, K.G., G.C.V.O. at Welbeck Abbey*, London, 1935.

L. A. van Langeraad, *De Nederlandsche Ambassade kapel te Parijs*, II, The Hague, 1894.

Th.H. Lunsingh Scheurleer, 'Silver furniture in Holland', *Opuscula in honorem C. Hernmark*, 27-12-1966 (Nationalskrift serie 15) Stockholm, 1 XXXXX (1966), pp. 141–58.

Th.H. Lunsingh Scheurleer, *Pierre Gole ébéniste de Louis XIV*, Dijon, 2005.

G. Mabille, 'Le grand buffet d'argenterie de Louis XIV et la tenture des Maisons Royales', *Objets d'art. Mélanges en l'honneur de Daniel Alcouffe*, Dijon, 2004, pp. 181–191.

E. Miller, *16th century Italian ornament prints in the Victoria and Albert Museum*, London, 1999.

J. R. ter Molen, 'Adam Loofs, zilversmid van de koning-stadhouder en enkele nieuwe aspecten van zijn leven en werk', *Antiek,* 22 (1987/8), pp. 518–19.

S. Netzer, 'Was grosses Aufsehn macht. Brandenburgische Gläser im Rahmen höfischer Repräsentation', in Chr. Keisch, S. Netzer, *'Herrliche Künste und Manufacturen'. Fayence, Glas und Tapisserien aus der Frühzeit Brandenburg-Preussens 1680–1720*, exhib. cat., Kunstgewerbemuseum, Berlin, 2001.

L. van Nierop, 'Gegevens betreffende de nijverheid der refugiés te Amsterdam', I: *Economisch Historisch Jaarboek* 7 (1921), pp. 147–195, II: *Economisch Historisch Jaarboek* 9 (1923), pp. 157–213.

H. W. Onnekink, *The Anglo-Dutch favourite: the career of Hans Willem Bentinck, 1st Earl of Portland (1649–1709)*, Ashgate, 2007

Jet Pijzel-Dommisse, *Haags goud en zilver. Edelsmeedkunst uit de hofstad*, Zwolle, The Hague, 2005

J. Starkie Gardner, 'Charles II silver at Welbeck', *The Burlington Magazine*, 7, 1905, pp. 106.

E. Voet, H. E. van Gelder, *Merken van Haagsche goud- en zilversmeden. Haagsche goud- en zilversmeden uit de XVIe, XVIIe en XVIIIe eeuw*, The Hague, 1941.

H. Vreeken, A. den Dekker, *Goud en zilver met Amsterdamse keuren. De verzameling van het Amsterdams Historisch Museum*, Amsterdam, Zwolle, 2003

G. Wilson, 'The Kedleston fountain. Its development from a seventeenth-century vase', *The J. Paul Getty Museum Journal*, 11 (1983), 1–12.

M. Winterbottom, '"Such massy pieces of plate", Silver furnishings in the English royal palaces 1660–1702', *Apollo*, 156 (August 2002), p. 23.

NOTES

1 For instance Hans Bouwens van der Houven and Theodoor or Dirck Loockemans: Loockemans came from Den Bosch in Brabant when he married in The Hague in 1609. He had also spent some time in Paris about 1597 and afterwards possibly in London. In 1611, he married for the second time in The Hague, a girl from London. He founded a dynasty of leading goldsmiths, supplying the court, the Provinces and the States General. E. Voet, H.E. van Gelder, *Merken van Haagsche goud- en zilversmeden. Haagsche goud- en zilversmeden uit de XVIe, XVIIe en XVIIIe eeuw*, The Hague 1941 (hereafter Voet, Van Gelder), p. 40, pp. 82–83; Jet Pijzel-Dommisse, *Haags goud en zilver. Edelsmeedkunst uit de hofstad*, The Hague/ Zwolle 2005 (hereafter Pijzel-Dommisse), pp. 18–21, 35, figs 6–8, 32.

2 Among the arrivals from Nuremberg were Matthias Muller and Hans Coenraet Breghtel. Both became major purveyors to the court. In 1641 Breghtel presented himself to the court of the Winter Queen, Elizabeth of Bohemia with a large cup almost 80 cm high, which Elizabeth presented to the city of Leiden in gratitude for the education of her children. Breghtel almost immediately became a leading Hague goldsmith, renowned in foreign courts. From Augsburg came the Micheel brothers, Hans Jacob Beer and, via Amsterdam, one of the Grill brothers: Andries Grill. See Voet, Van Gelder (as note 1), pp. 90, 41, 86–87, 34, 57; Pijzel-Dommisse (as note 1), pp. 22, 30; figs 2, 12, 15–16, 19, 107, 109, 123, 124, 181, 191; nos 22, 139, 259.

3 L. van Nierop, 'Gegevens betreffende de nijverheid der refugiés te Amsterdam', I: *Economisch Historisch Jaarboek* no 7 1921, pp. 147–195, II: *Economisch Historisch Jaarboek*, no. 9, 1923, pp. 157–213.

4 M. Bimbenet-Privat, *Les orfèvres et l'orfèvrerie de Paris au XVIIe siècle*, 2 vols, Paris, 2002 (hereafter Bimbenet-Privat), vol. I, p. 202.

5 K. A. Citroen, *Amsterdamse zilversmeden en hun merken*, Amsterdam 1975 (hereafter Citroen), nos 673, 749. Reinier Baarsen et al., *Rococo in Nederland*, exhib. cat., Rijksmuseum Amsterdam, 2001, no. 7; H. Vreeken and A. den Dekker, *Goud en zilver met Amsterdamse keuren. De verzameling van het Amsterdams Historisch Museum*, Amsterdam, Zwolle, 2003 (hereafter Vreeken, Den Dekker), nos 348, 349, p. 417.

6 Citroen (as note 5), nos 762, 849.

7 Steven was born in Paris about 1654 and trained in Amsterdam in 1672, registered as resident in Amsterdam in 1681, married in 1682 and became a craftsman and assayer; see R. E. Roskam and D. J. Biemond, 'Biografieën', in Vreeken, Den Dekker (as note 5), pp.

466–67. He might have been the same person as Estienne des Rousseaux, son of Jean des Rousseaux (born in Hanau) and Jeanne Baron, who trained in Amsterdam with Michiel Esselbeeck before 1671, afterwards worked in Paris and The Hague with Adam Loofs and settled in Amsterdam again in the 1680s.; see J. R. ter Molen, 'Adam Loofs, zilversmid van de koning-stadhouder en enkele nieuwe aspecten van zijn leven en werk', *Antiek* 22 (1987/8, hereafter Ter Molen), pp. 518–19.

8 Voet, Van Gelder (as note 1), pp. 121–23, 115, 116.

9 Voet, Van Gelder (as note 1), p. 104. For Alexis Loir see his *Dessins de divers Ornements et Moulures*, published in C.A. Jombert, *Répertoire des artistes*, 2 vols, Paris 1764, vol. II, *Décoration*, fig. 35.

10 Voet, Van Gelder (as note 1), p. 46.

11 Pijzel-Dommisse (as note 1), p. 79, fig. 64, p. 301, fig. 219 (wrongly ascribed to jr); *Courts and Colonies. The William and Mary style in Holland, England, and America*, exhib. cat., Cooper Hewitt-Museum New York, Carnegie Museum of Art Pittsburgh, 1988–89 (hereafter Courts and Colonies), no. 210.

12 Voet, Van Gelder (as note 1), p. 117; Pijzel-Dommisse (as note 1), nos 34, 149, 220, 237.

13 Voet, Van Gelder (as note 1), p. 91; Pijzel-Dommisse (as note 1), no. 171; Courts and Colonies (as note 11), no. 62.

14 Voet, Van Gelder (as note 1), p. 103; Pijzel-Dommisse (as note 1), no. 221; *Haags zilver uit vijf eeuwen*, exhib. cat, Gemeentemuseum Den Haag 1967, no. 126.

15 Pijzel-Dommisse (as note 1), no. 218; Bimbenet-Privat (as note 4), vol. II, no. 22.

16 Bimbenet-Privat (as note 4), no. 22, pp. 90, 91.

17 Pijzel-Dommisse (as note 1), p. 198, note 14.

18 P. Fuhring, *Ornament prints in the Rijksmuseum II: the seventeenth century*, 3 vols, Amsterdam, 2004, e.g. vol. I, nos 1440–45, nos 2089–94.

19 Pijzel-Dommisse (as note 1), fig. 77.

20 Pijzel-Dommisse (as note 1), p. 31, fig. 20; M. Lopato, 'Bringing Dutch silver to Russia', *Hermitage Magazine*, no. 4, 2004–5, pp. 52, 54. The fountain was in the possession of the Russian imperial family by 1730, showing the initials of Czarina Anna Ivanovna. It may have come into their possession after Menshikov was arrested and his belongings were confiscated.

21 *Courts and Colonies* (as note 11), no. 35.

22 M. Winterbottom, ' "Such massy pieces of plate". Silver furnishings in the English royal palaces 1660–1702', *Apollo* 156 (August 2002), p. 23; S. W. A. Drossaers, Th.H. Lunsingh Scheurleer, *Inventarissen van de inboedels in de verblijven van de Oranjes en daarmede gelijk te stellen stukken 1567–1795,* 3 vols, The Hague, 1974–1976 (hereafter Drossaers, Lunsingh Scheurleer), vol. I, p. 421, nos 198–99; p. 415, no. 71; p. 417, no. 107.

23 Th.H. Lunsingh Scheurleer, 'Silver furniture in Holland', *Opuscula in honorem C. Hernmark*, 27-12-1966 (Nationalskrift serie 15) Stockholm (1966), p. 150; Drossaers, Lunsingh Scheurleer (as note 22), vol. I, p. 411; Ter Molen (as note 7), pp. 518–26.

24 L.A. van Langeraad, *De Nederlandsche Ambassade kapel te Parijs* , II, Den Haag, 1894 (hereafter Van Langeraad), pp. 4, 39, 110.

25 Th.H. Lunsingh Scheurleer, *Pierre Gole ébéniste de Louis XIV*, Dijon 2005, pp. 40, 37, note 9; names of protestant *marchand orfèvres*: Paul en Jacques Belliart, Claude Roussel, Charles Erondelle, Cottard, Jean Girard (*orfèvre de Monsieur le prince de Condé*), Jean Thibaut.

26 Ter Molen (as note 7), pp. 518, 519: Municipal Archives The Hague, Not. Arch. No. 626, pp. 615–16.

27 Municipal Archives The Hague, Not. Arch. no. 1805, no fol. (Not. S. de Raijes, 18 December 1709).

28 Bimbenet-Privat (as note 4), vol. I, pp. 316, 389, 390; S. Netzer, 'Was grosses Aufsehn macht. Brandenburgische Gläser im Rahmen höfischer Repräsentation', in Chr. Keisch and S. Netzer, '*Herrliche Künste und Manufacturen*'. *Fayence, Glas und Tapisserien aus der Frühzeit Brandenburg-Preussens 1680–1720,* exhib. cat., Kunstgewerbemuseum Berlijn, 2001, p. 64; M. Bencard, *Silver Furniture*, Rosenborg, 1992, nos 13–20; I am grateful to Morgens Bencard en Jørgen Hein for sharing their knowledge of the manufacture of mirrors in Kopenhagen.

29 Van Langeraad (as note 24), pp. 158, 190.

30 Bimbenet-Privat (as note 4), vol. I, p. 194.

31 David Mitchell has drawn my attention to a catholic jeweller Jean or John Leroy, married to Jeanne de la Roche, who was living in London during the 1660s and a protestant goldsmith by the same name, married to Denise Barbotte and Jeanne Barbier, who was working in Paris in this period: it is still unclear which Leroy, the catholic or the protestant, was the father of Pierre. Michelle Bimbenet holds the view John and Jean Leroy are the same person, Bimbenet-Privat (as note 4), vol. I, pp. 206, 410.

32 Chr. Huygens, *Oeuvres complètes publiées par la Société Hollandaise des Sciences*, 22 vols, Den Haag, 1888–1950; vol. VIII, p. 261: '*le Sieur Loofs qui estant venu ici ses superbes meubles d'argent pour Madame la Princesse, qu'il avoit travailler luy même en partie.*'

33 Drossaers, Lunsingh Scheurleer (as note 22), vol. I, p. 421, no. 200.

34 In the 1697 inventory (Drossaers, Lunsingh Scheurleer (as note 22), vol. I, pp. 411–25), he noted his name against these pieces. The *Ordonnantieboeken* of the Nassau Domains Council (National Archives The Hague) mention payments to Loofs, but only large not specified amounts; there are no bills left.

35 Pijzel-Dommisse (as note 1), figs 111, 112.

36 D.J. Biemond, 'Kandelaar', *Bulletin van de Vereniging Rembrandt*, 16, 2006, no. 2, pp. 13–15; Pijzel-Dommisse (as note 1), p. 369, fig. 229; *Courts and Colonies* (as note 11), no. 67.

37 G. Jackson-Stops et al., *The treasure houses of Britain*, exhib. cat., National Gallery of Art Washington 1985–86, no. 116.

38 Pijzel-Dommisse (as note 1), no. 33. It also may have been a private purchase from Keppel, meant as a 'morning after the wedding' present to his wife.

39 Charles Truman and Tim Schroder identified the maker's mark of Loofs with assay marks from The Hague on the base of the smaller vases; there are no marks on the larger ones.

40 J. Starkie Gardner, 'Charles II silver at Welbeck', *The Burlington Magazine,* 7 (1905), pp. 106, 107, no. 8, 10; E. A. Jones, *Catalogue of plate belonging to the Duke of Portland, K.G., G.C.V.O. at Welbeck Abbey*, London 1935, pp. 85, 130, pl. XI.

41 H. W. Onnekink, *The Anglo-Dutch favourite: the career of Hans Willem Bentinck, 1st Earl of Portland (1649–1709),* Ashgate, 2007. K. Zandvliet, *De 250 rijksten van de Gouden Eeuw*, Amsterdam 2006, no. 2.

42 Municipal Archives The Hague, Not. Arch. No. 1805, no. 39 (not. S. des Raijes, d.d. 30 November 1709).

43 E. Miller, *16th century Italian ornament prints in the Victoria and Albert Museum*, London (1999) cat. 66a, pl. 1.

44 According to the inscription on the engraving the candlestick was designed by Michelangelo Buonarroti, in competition with Raphael, for Popes Julius II and Leo X in about 1518; the famous Cellini was to execute the winning design in solid gold. This story seems too good to be true, Cellini was simply too young at that time. There is no surviving example of a candlestick exactly like the one in the engraving, but the bronze Strozzi candlestick in the church of San Andrea della Valle in Rome is quiet alike: J. Montagu, *Roman baroque sculpture. The industry of art*, New Haven/London, 1989, pp. 49–50, fig. 53. I am grateful to Jennifer Montagu sharing her thoughts with me.

45 Robert Harley, 1st Earl of Oxford, was Member of Parliament during William's reign, and during Queen Anne's reign, Speaker of the House of Commons, Secretary of State 1704–1708 and Lord Treasurer 1711–1714. On the death of the queen he fell from power. The jars may have been given to Harley by Queen Anne as a personal gift or perquisite, possibly when he was installed as a Knight of the Garter in 1713, but I have found nothing relating to the jars in the Jewel House administrative records. I am very grateful to Derek Adlam and Philippa and Gordon Glanville for help and advice.

46 I am grateful to Paul Micio for the discussion on possible differences in model and use between 'vase', 'buire' and 'fontaine'.

47 In the Netherlands objects ordered by the stadholders normally were assayed, the assay-office in The Hague was located in the Binnenhof. It took nearly two years for Loofs to register, perhaps he wasn't immediately accepted by the guild.

48 Like the series *Les Maisons Royales* or *Les Mois*: in Le Chateau de Madrid or March on the left the buire by De Villers with the eagle and in Le Louvre or January on the right Dutel's buire with the swan's head, see F. Buckland, 'Gobelins tapestries and paintings as

a source of information about the silver furniture of Louis XIV', *The Burlington Magazine* 125 (May 1983), pp. 271–83, notably p. 275; G. Mabille, 'Le grand buffet d'argenterie de Louis XIV et la tenture des Maisons Royales', *Objets d'art. Mélanges en l'honneur de Daniel Alcouffe*, Dijon 2004, pp. 181–191, figs 10–11.

49 Bimbenet-Privat (as note 4) vol. II, no. 66, notes that the date letter is not reliable, see also vol. I, p. 206; G. Wilson, 'The Kedleston fountain. Its development from a seventeenth-century vase', *The J. Paul Getty Museum Journal*, 11 (1983), pp. 1–12.

CHAPTER **3**

Huguenot goldsmiths in Berlin and Cassel in the 17th and 18th centuries

Hans Ottomeyer

The notion of an absolute monarchy, a centralized state with a 'state religion', reached its apex under Louis XIV of France. Those who did not want to submit to the Roman Catholic religion espoused by the king and the state had no other choice but to emigrate (Plate VI). The revocation of the Edict of Nantes in 1685, which had granted tolerance to the Protestants, brought about a massive exodus of human manpower, knowledge and craft skills.

Against the will of the king, approximately 150,000 French Reformed Protestants left their homeland. Of these, about 40,000 settled in German territories that would accept them, forming the third largest contingent of French immigrants, after Great Britain and the Netherlands. For the most part they entered the territory of the Holy Roman Empire through Switzerland and then on up the Rhine, the main refugee route.

The Huguenot refugees were taken in by the Reformed states and some of the Lutheran territories, whose rulers encouraged them to settle there due to the skills they brought with them (Plate VI). The loss of one third of the population and the economic consequences of the Thirty Years' War, which had ended with the Peace of Westphalia in 1648, could still be felt at the end of the 17th century. Moreover, there was increased interest in producing export goods as a result of the prevailing economic theory of mercantilism. In keeping with mercantilist thinking, the ruling princes hoped to achieve a marked economic upswing. The highly qualified Huguenot craftsmen were in a position to deliver top-quality products and had the latest technological knowledge at their disposal.

For the most part the Huguenots who settled in the cities met with bitter resistance by the indigenous citizens and municipal corporations, guilds and other privileged groups. With a limited market, they were not willing to lose individual customers and meagre resources forty years after the Peace of Westphalia to competitive immigrants who enjoyed privileges of the rulers. For, unlike other workers who had immigrated individually, the Huguenots were organized in groups and were in a position to negotiate favourable conditions with the German authorities willing to take them in. 'Colonies' marked by a special status and with their own jurisdiction and permission to establish French Reformed parishes became the centres of the refuge. This legal situation distinguished the German immigration territories from other Protestant states such as the Netherlands or England. In addition, the Huguenots were given further economic privileges to induce them to settle there.

The main German territories to accept the settlers were Brandenburg–Prussia, which took in approximately 18,000 refugees, and Hesse–Cassel, where around 3,800 Huguenots found a new home. Some 3,400 came to the Rhine–Main area, while the Palatinate with Zweibrücken took in another 3,400, Franken 3,200 and Württemberg 3,000. Smaller groups settled in the Hanseatic cities, towns in Lower Saxony and the smaller German principalities.

Huguenot goldsmiths achieved highest esteem at the courts of the two main migration territories Brandenburg–Prussia and Hesse–Cassel. Here they created works of an artistic quality far above that of the local craftsmen.

Cassel

Cassel, which had about 7,500 inhabitants in 1681, attracted silversmiths. Enjoying greater privileges than their indigenous colleagues, they were able to work there without being forced to join guilds or apply again for master status. Most of the Huguenots who settled in Cassel came from Metz – in particular a large number of the silversmiths.

Silver was used less for articles of personal and individual luxury than for special objects that were produced for social or communal groups – be they families, princely houses, corporations, guilds, magistrates or ecclesiastical parishes. These silver objects were made in a long, generation-encompassing, identity-building tradition that found expression in explicit signs and inscriptions: these included heraldic emblems of the noble men or cities, names and monograms, dedications, and symbols of unity and peace.

The production of communion chalices and jugs for holy wine remained one of the main outputs for the goldsmith in Germany. Unlike the Catholic communities, the Protestant parishes had greater need of these jugs, because all the men and women who came to the church service took part in communion, so they needed larger cups and more of them for communion wine.

The Huguenot goldsmiths – drawing on French fashion – introduced new forms of these vessels for Calvinist ritual in Cassel. Since the 16th century large wine vessels were commonly made for use at the Protestant communion (Plate 28). The two jugs shown here, manufactured in 1662 in Cassel, belonged to one of the poorer parishes. They correspond in their simplicity to typical communion vessels used by the Calvinist church in the landgrave's domain.

Pierre Beaucair (1696–1775), a Huguenot silversmith from Metz, created a communion jug for the Reformed community in Cassel which had all of the characteristics of the so-called Cassel 'Huguenot style' (Plate 29). Beaucair, who was trained in Metz, went to Hanau and is documented as living in Cassel from 1720, where he became the most important Huguenot goldsmith. The pear-shaped vessel with its stepped base reflects southern German forms. Silhouette and proportions conform to the *'style à l'antique'* that was prevalent in France in the last quarter of the 17th century. The simplicity and unobtrusive use of ornament underline the effect of beautifully balanced proportions and the harmonious appearance of the individual parts. The stepped lid with its baluster knob echoes the formal design of the ring at the base.

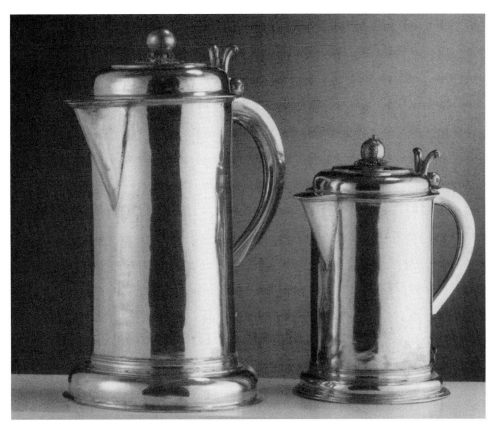

Evangelische Kirchengemeinde, Kassel, Germany. © Michael Wiedermann

Plate 28 Communion jugs, silver-gilt, Antonius Winther, Cassel 1662, height 29 cm × 16.4 cm.

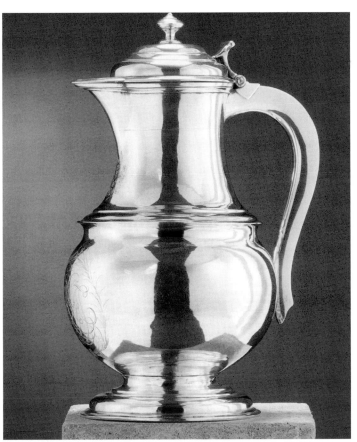

Plate 29 Communion jug, silver, Pierre Beaucair, Cassel 1733, height 26 cm.

Stadtmuseum Kassel (on loan from Oberneustädter evangelischen Kirchengemeinde), Germany. © Michael Wiedermann.

In addition to use in German churches, silver tableware was an exclusive privilege of princes and patricians and used at public banquets. Found at state occasions and in municipal councils, silver was used at official dinners when delegates came together to confirm their association or to engage in new contracts, which were celebrated with a banquet. The silver, closely connected with the history of the association, was prominently placed on the dining table and the adjacent buffet.

Another outstanding example of a secular Huguenot silver vessel is the *pot d'oille* that Pierre Beaucair produced around 1740 for Georg Moritz Wolff von Gudenberg (1684–1772) (Plate 30). Gudenberg was a lieutenant general and for a time the highest-ranking officer in the Hessian army and governor of the Cassel fortress. The round soup tureen, gilt on the inside, captures the eye through its simplicity of form and design. The finial echoes in miniature the form of the vessel. The lack of ornament emphasises the austerity of the form. This late Baroque vessel draws its elegance from balanced proportions. However, it lacks the engraving of the patron's coat-of-arms usually found on Cassel silver.

Still, the Cassel *pot d'oille* not only refers back to the traditional French form, but also bears witness to *'service à la française'* which was introduced in the late 17th century. In this form of dining, the *pot d'oille*, soup tureens, ragout dishes and small plates were placed in the centre of the banquet for the first course of the meal. Two handled soup tureens with lids and finials stood on dishes in the centre of the courtly table.

A soap globe and a sponge globe, also by Pierre Beaucair, reflect French forms. They were made as part of a personal toilet set in around 1752. The lids are

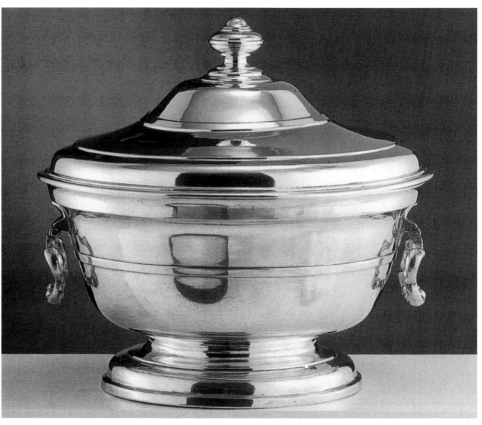

Plate 30 Pot d'oille, silver, gilt interior. Pierre Beaucair, Cassel 1740, height 23.5 cm.

connected to the bowls by hinges. The reinforced edges form a bulging rim around the middle. In their lack of ornament, the dome-like lids balance their bases. The circular bulge in the middle provides a central harmonious belt to the spherical body. It is probable that Beaucair introduced this characteristic form to Cassel from his native city of Metz.

Upon arrival in Cassel, Beaucair worked for Louis Rollin (1674–1731), another goldsmith from Metz, and completed his masterpiece whilst in Rollin's workshop. It is not known where Rollin served his apprenticeship. He married a local woman, the daughter of a goldsmith, in 1699. In the same year his name was entered in the Cassel goldsmiths' guild as a master. Rollin did not make use of the privilege granted by the landgrave, but qualified as master through acceptance of his masterpiece. In this way Rollin overcame the barrier between the German goldsmiths, who were all members of the guild, and the Huguenot craftsmen, who were not forced to become guild members. He thus created the decisive social conditions for establishing the dominant influence exerted by Huguenot types, forms and decoration on Cassel silverware throughout the 18th century.

Louis Rollin designed a pot for hot chocolate, made before 1725, a further example of the importation of standard French forms to Cassel that cemented the stylistic influence of the Huguenot goldsmiths. In the trend-setting countries of France and the Netherlands, chocolate, coffee and tea, the new hot beverages, had already become popular before they caught on – belatedly – in the Holy Roman Empire. The plain forms of Rollin's functional pot achieved their effect through balanced proportions. Unlike other pot designers of this period, Rollin did not add any engraved ornament and applied decoration.

The production of pairs of coffee and hot milk pots was unique to Cassel. It is not certain whether these matching jugs, made in the French style, were first introduced by the Huguenot craftsmen or by their patrons at court. Coffee and hot milk were poured at the same time in the proportion of 2 : 1, a habit still found in parts of Europe. Isaak Beaucair, the son of Pierre Beaucair, made a pair of pots in about 1780 (Plate 31). Their design bears traces of animated form associated with the outgoing Rococo style, but is not predominantly Rococo. The serene and harmonious balance of the forms places the pots in the Huguenot tradition of Cassel silverware.

The silver illustrated was brought from France to Cassel by Huguenot craftsmen. The deliberately austere forms of sacred silver vessels, were, like their religious belief, willingly accepted by the landgrave's Reformed community in Cassel. Secular silverware reflected the new forms and fashions of French courtly table culture which were gaining a foothold in Germany and thus promoted the triumph of the French style. Fostered by the local court, which oriented its fashion on France, Huguenot goldsmiths achieved a breakthrough after successfully positioning themselves in the guilds so that Cassel goldsmiths could no longer ignore the Huguenot stylistic influence. Up to the middle of the 18th century almost all of the German guild members worked in the style of the Huguenots. It was only at the end of that century, three generations later, that this specific influence began to recede.

It remains open to debate whether fundamental Puritanical principles of design were a traditional legacy of Metz that was carried on by the immigrants in

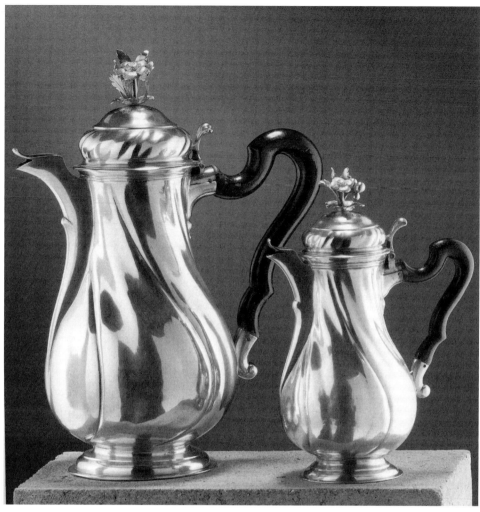

Plate 31 Pair of pots, silver, the smaller pot with gilt interior, ebony. Isaak Beaucair, Cassel 1780, height 28.5 × 21 cm.

© Museumslandschaft Hessen Kassel, Sammlung Angewandte Kunst.

Cassel or whether these principles corresponded to the Huguenot ethic. How did Huguenot goldsmiths working in London, North America and Northern Europe arrive at similar design principles? Were there direct connections between them or did they have examples in common to which they referred, or did their shared principles of belief lead them to similar forms and design solutions? It is surely significant that Baroque architecture in Cassel, designed by Huguenot architect Charles Du Ry (born in Cassel 1692 and died there in1757), was also dominated by the plain, simple design of the façade with a minimal architectural ornament.

Berlin

A minimalist approach to city planning and architecture is also found in Berlin. Here many Huguenots found living quarters in the newly built Baroque municipal districts Dorotheenstadt and Friedrichstadt. Friedrich Wilhelm, the Great Elector (1620–1688), married to Louise Henriette of Orange and himself Calvinist, issued the Edict of Potsdam on 29 October 1685. The edict invited Huguenots fleeing from France to settle in his territories. This invitation was inspired by the great economic problems in Brandenburg–Prussia following the devastations of the Thirty Years' War, which were still very much in evidence. The

Edict of Potsdam was not aimed merely at increasing the population, but specifically at introducing economic innovations such as new craft skills and manufacturing techniques brought by the new settlers. In response to the State Allegory of Louis XIV, Johann Jakob Thurneysen created his *Tribute to Friedrich Wilhelm Elector of Brandenburg for Taking in the Religious Refugees* (Plate 32). The etching, published in a small edition, apparently served as a gift for the Elector's aristocratic friends. The etching shows the Elector accompanied by the Christian cardinal virtues, Faith, Hope and Charity, and the virtues associated with good rulers,

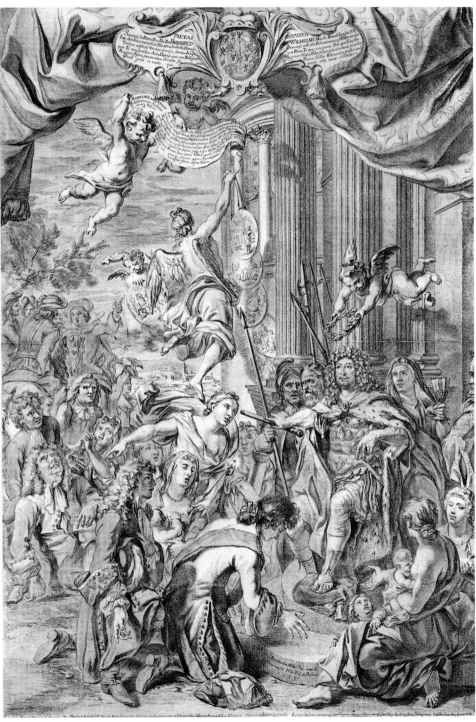

Plate 32 Homage to Friedrich Wilhelm Kurfürst von Brandenburg, etching, Johann Jakob Thurneysen, 1689.

Strength and Wisdom. A personification of Providence leads the Huguenots to the Elector.

An amazing number of highly trained Huguenots came to Berlin. Gardeners, pastry cooks, chefs and silk weavers brought French culture and craft skills with them and breathed new life into the production of arts and crafts in Berlin. The Huguenots even introduced the cultivation of tobacco in Brandenburg. The incoming refugees included an astonishing number of goldsmiths. The list of immigrants for 1700 contained the names of 42 goldsmiths. They were allowed to join the goldsmiths' guild or to work as independent masters. In 1713 the independent French goldsmiths' association in Berlin and the indigenous Berlin goldsmiths' guild were united, forming a trade guild in which each of the two nationalities provided a Master until the end of the 18th century.

Although the government had a vested interest in encouraging Huguenot goldsmiths to settle in Berlin, there is no record of court commissions until Friedrich II (Frederick the Great, 1712–1786) acceded to the throne. Elector Friedrich III (later King Frederick I, 1657–1713) and Friedrich Wilhelm I (1688–1740) continued to commission work from goldsmiths in Augsburg and from German court goldsmiths in Berlin. Thus the highly decorative silver made for the court buffet display in Berlin was completed in 1698 by Augsburg goldsmiths. There was no demand for new communion silver, so Huguenot specialists were not called upon to make ecclesiastical silver with its simpler forms. The Huguenot style of silverware did not develop in Berlin as it had in Cassel.

Although Huguenot goldsmiths became quite successful in Berlin, the real upturn occurred on the accession of Frederick the Great in 1740 for the specialist *orfèvres-bijoutiers*, who made gold jewellery, and *orfèvres-joailliers*, who set diamonds and precious stones. Many of these specialists were Paris trained and employed in turn specialist engravers, chasers, stone cutters and enamel workers. Frederick the Great's passion for collecting snuffboxes led to numerous commissions. His mother, Queen Sophie Dorothea, had already ordered numerous precious boxes for powder for the dressing table and for sweets.

The change from smoking tobacco to taking tobacco as snuff developed in France in the 17th century; in the 18th century Berlin followed the Paris example. Parisian jewellers took the lead in manufacturing precious boxes in which snuff was kept. These boxes became highly fashionable at court and in aristocratic society and their manufacture became a specialist business in about 1740. Many Berlin jewellers maintained trade relations with Paris and imported boxes from there. But Frederick the Great put a stop to these imports and became the Berlin craftsmen's best customer, encouraging them to manufacture the boxes themselves. Through the patronage of the king over a period of several decades – he lived until 1786 – jewellery made in Berlin achieved a quality that easily matched the Parisian products.

Daniel Baudesson (1716–1785), who came from a refugee family originally from Metz, created the few brand-name snuff boxes that were produced in Berlin. His work is representative of the Berlin snuff-box makers. A gold box designed in about 1755, was made and chased by Baudesson and decorated by the Berlin enamel painter Daniel Chodowiecki (1726–1801), also of Huguenot descent on

his mother's side (Plate VII). In Berlin the leading specialist enamel painters were also of French origin. Chodowiecki had learned the art of enamel painting from his relatives. His painting for the box lid is taken from François Boucher's *The Rape of Europa*.

The stone box pictured here, made around 1765 out of agate, again by Daniel Baudesson, may well have belonged to Frederick the Great (Plate VIII). His collection included not only gold boxes, but also hard stone snuff boxes mounted in precious metal. The simplicity of this stone box is unique in Frederick the Great's collection, as he preferred snuff boxes adorned with precious stones and diamonds.

Baudesson's austere box forms correspond to Parisian examples from the 1750s, when the Neo-classical style was beginning to take hold. Frederick the Great, however, retained a fondness for Rococo forms. Boxes embodying the perfect expression of this preference were made in Berlin exclusively for his personal use (Plate IX). In about 1755 Jean Guillaume George Krüger made a gold box with raw and cut diamonds; the lid set with an enamel portrait of Frederick himself. The king honoured deserving subjects with the personal gift of such boxes. Krüger, who described himself as a chaser, engraver and enamel painter, was born in London in 1728 and died in Berlin in 1791, was good at anticipating the taste of the king, who loved extravagant display of technique and decoration.

The opportunities offered by Frederick the Great for goldsmiths and jewellers specializing in the manufacture of snuff boxes in Berlin attracted, besides Krüger, another Huguenot to Berlin. Jean Reclam, born in Dublin as the son of Balthasar Reclam (1666–1744), who had come to Ireland from Geneva and later settled in Bremen, came to Berlin via Magdeburg. Reclam became the king's court jeweller. International family ties and a market-oriented mentality, in addition to his skill as a craftsman, led to his extraordinary success. After his death in 1754 his son Jean François continued the business. One of his 'très belles boëtes' was sold for 20,000 thalers.

The portrait of the Reclam family, painted after 1776, attests to the close family network. As Huguenots, they originally settled in Switzerland before 1685 and then moved to join colonies of refugees in the Holy Roman Empire (Plate X). The portrait shows the various branches of the family: merchants, craftsmen and preachers, with their wives. The three members of the family of court jeweller Jean François Reclam are shown on the right.

The exhibition 'Cassel Silver' organized by the State Museums in Cassel in 1998, brought together numerous examples of the work of Huguenot goldsmiths.[21] In 2005/2006 the Deutsches Historisches Museum showed a great number of works by Berlin Huguenot goldsmiths within the framework of an exhibition on The Huguenots. Essays in both catalogues delved more deeply into the subject matter. Research captured in these two exhibitions has led to the conclusion that there is no 'Huguenot Style' as such. The French immigrants, however, brought with them new French forms of silver and technical skills superior to those of the German craftsmen.

The design of those objects produced by Huguenot refugee craftsmen in Cassel and Berlin were influenced by the ideas and patronage fostered by local society. In Cassel the Huguenots came to occupy leading positions through

working in their own simple, sober style. In Berlin the production of luxury goods for the king determined the design of the objects and commercial success of the goldsmiths. The death of Frederick the Great in 1786 marked the diminishing influence of the 'Huguenotic'. After three generations, in Berlin as in Cassel, the formal and technical differences between 'German' and 'French' goldsmiths could no longer be distinguished.

FURTHER READING

Winfried Baer, 'Hugenottische Goldschmiede und die hohe Kunst der Bijouterie unter den Refugies in Berlin' in *Zuwanderungsland Deutschland – Die Hugenotten*, edited by Sabine Beneke and Hans Ottomeyer, exhibition catalogue Deutsches Historisches Museum, Berlin 2005, pp. 91–100.

Daniel Chodowiecki (1726–1801). Ein hugenottischer Künstler und Menschenfreund, edited by Ursula Fuhrich-Grubert, exhibition catalogue Hugenottenmuseum, Bad Karlshafen, 2001.

Barbara Dölemeyer, 'Aufnahme und Integration der Hugenotten im europäischen Refuge. Rechtliche Rahmenbedingungen', in *Zuwanderungsland Deutschland – Die Hugenotten*, edited by Sabine Beneke and Hans Ottomeyer, exhibition catalogue Deutsches Historisches Museum, Berlin, 2005.

Kasseler Silber, edited by Reiner Neuhaus and Ekkehard Schmidberger, exhibition catalogue Staatliche Museen Kassel, Cassel, 1998.

Tessa Murdoch, 'Hugenottische Goldschmiede aus Metz in London und Kassel', in Beneke and Ottomeyer, 2005, pp. 101–112.

Tessa Murdoch, 'Autour des Willaume, orfèvres originaires de Metz établis à Londres et Cassel; Des Orfèvres Messin à Cassel', in *Huguenots de la Moselle à Berlin, Les Chemins de L'exil*, Metz, 2006, p. 140.

Reiner Neuhaus, 'Kasseler Silber: Gibt es einen 'hugenottischen Stil'? in Kasseler Silber, pp. 72–81.

Andreas Reinke, 'Opposition et Protestations contre l'implantations des Huguenots dans les Etats Allemands', in *Huguenots de la Moselle à Berlin, Les Chemins de L'exil*, Metz, 2006, pp. 207–222.

Lorenz Seelig, *Silver and Gold, Courtly Splendour from Augsburg*, Munich, 1995, illustrated, figure 15.

Charles Truman, *The Gilbert Collection of Gold Boxes*, Los Angeles, 1991.

Huguenot Goldsmiths
in the English–Speaking World

Introduction

Philippa Glanville

For a hundred and fifty years silver scholars have evaluated surviving objects in gold, silver and even pewter, and the marks on them, to draw conclusions about authorship, and to attempt to pinpoint specific Huguenot attributes. We are fortunate that these material evidences offer so rich a source; they have great value as a trigger for speculation about Huguenot influences, even if what has survived for analysis is a tiny and perhaps unrepresentative sample of what was made. As Beth Wees points out, neither silver nor jewellery is known from the workshop of the Huguenot jeweller James Boyer, despite his long and successful career in Boston. In Dublin, as Thomas Sinsteden has shown in *The Journal of the Silver Society* (2005), some two thousand sword hilts had passed through the assay office between 1697 and the 1720s, but not a single one has survived.

Recent advances in silver research have deepened and enriched our understanding of regional production in the Atlantic community of the late seventeenth and early eighteenth century. In North America, as in Ireland (as well as Scotland and the West Indies), the passionate enthusiasm of collectors, antiquaries, curators and dealers has brought an almost unwieldy volume and diversity of evidence into print. Design historians have debated the significance of fashion, what the American historian John Marshall Phillips described fifty years ago as 'The Baroque of the William and Mary style'. The transmission of designs and the sharing of skills are taken seriously. Economic historians now include goldsmiths' work in their studies of consumption, and the role of the patron, both in demanding goods 'in the latest fashion' and in valuing traditional forms, is now emphasized.

John Bowen, Beth Carver Wees and David Barquist each offer rich and specific case studies in considering the careers of Huguenots in County Cork, Ireland and in contrasting regions of North America. Local patriotism has conditioned the historiography of silver as much as any other aspect of the decorative arts, indeed more so because of the relative richness of regional records, even in County Cork, and the particularity of local marks. David Barquist's comparison between Philadelphia and New York, for example, escapes from older attitudes, demonstrating the shared careers and styles of their Huguenot silversmiths. In an illuminating discussion of Boston and Charleston, Beth Wees brings out the contradictions encountered when chasing Huguenots; Apollos Rivoire (1702–54), father of Paul Revere, Jr. (1734–1818), was born in southwestern France. At the age of thirteen he was sent to the island of Guernsey; sailing to New England, he was apprenticed to the leading Boston goldsmith John Coney (1655/6–1722). In 1729 Rivoire married a woman of English descent, Deborah Hichborn, joined the Congregational Church and anglicized his name to Paul Revere. He effectively disappeared into the melting pot, and his son was to become the archetype of the American patriot-goldsmith (front cover). If we accept the influence of

heredity, his reputation, like that of de Lamerie's, may rest as much on his skill as an entrepreneur as on his manual dexterity.

Assemblages of objects are naturally, as always, at the core of these contributors' research, since they incorporate personal identifiers, initials and dates, and evidence of family descent. In addition, there is the physical evidence for techniques of the silversmith, chaser or engraver contained within most objects, such as sharing of casting patterns, distinctive soldering techniques or graphic idiosyncracies, as on the 1750 Leddel tankard (Plate 43).

Given that the patron was paying, he (or more rarely she) might be drawn either to some long-popular regional form, such as the brandywine bowls of New York, or the porringers of Boston (Plate 39), or for more ceremonious objects such as two-handled cups, to a recognizably Anglo-Dutch-French style. Is the harp-handle in Cork, for example, really evidence of a particularly Huguenot influence in that community, or merely a cliché of Anglo-French taste considered appropriate for grand display plate?

One factor which is not considered in these essays, focused as they are on the prevailing theme of the V&A symposium (see the Preface by Mark Jones), is the prestige of imported plate within the mercantile communities of Ireland and North America .The Huguenots discussed here were a small part of a market with a pronounced taste for metropolitan silver, as the account books of Joseph Richardson of Philadelphia reveal. Advertising in American newspapers, new arrivals emphasized their familiarity with the latest London styles, and the elite sent orders for plate via agents in Bristol, Dublin and London. Discussions of style-transmission benefit from insights into the impact of these objects, and of imported sheets of ornament, trade cards and journeymen's sketch books, to which these authors make reference.

Their characters, dispersed over a massive triangle across the north Atlantic, its southern tip in Charleston, the richest community on the mainland of North America, its northern extreme in Boston and to the east, the trading community of Cork, include the son of a London distiller, James Boyer, confidently advertising his arrival in a Boston newspaper in 1722. But these Huguenot entrepreneurs were, as Beth Wees and David Barquist both emphasize, a tiny proportion, perhaps 2,000 out of the quarter of a million emigrants to North America before 1750. So to isolate their distinctive influence, one needs to assess their work against the far larger volume of London-made plate flowing into Philadelphia, Boston or Charleston.

These studies have exploited the unique combination offered by archival sources alongside the objects themselves. Simplistic associations between styles and the birth origin or faith group of the presumed maker are no longer acceptable, as the true complexity of workshop organization is better understood. A more subtle and nuanced understanding of the terms 'silversmith', 'maker' and even 'Huguenot' has led to various reinterpretations of longstanding stereotypes, which are considered here in Part II.

FURTHER READING

John Marshall Phillips, *American Silver*, New York, 1959.

Thomas Sinsteden, Four Selected Assay Records of the Dublin Goldsmiths' Company, *Journal of the Silver Society*, 11 (1999), pp. 143–157; Surviving Dublin assay records, *Journal of the Silver Society*, 16 (2004), pp. 87–102.

Huguenot silversmiths in colonial New York and Philadelphia, 1680–1750

David L. Barquist

Focusing on the careers of Huguenot silversmiths working in New York and Philadelphia offers both an occasion to review some outstanding American work in precious metals as well as an opportunity to reconsider what kind of intra-colonial network or connections existed between members of this specific ethnic-religious group in these two cities. For much of the 20th century, scholarship in colonial American decorative arts was object-based, concerned with identifying the European origins of American forms and styles and defining aspects that were distinct from European precedent as well as from one regional centre to another. As one early scholar of Philadelphia silver expressed it, 'Early New England artificers followed the style of the Mother County; New York craftsmen produced silver after the Netherlandish fashion; the Philadelphia silversmiths developed a type of their own.' The desire to categorize silversmiths and their work into specific regional categories tended to obscure intra-colonial exchanges between different centres.[1]

The Huguenot silversmiths who settled in New York, and, to a significantly lesser extent, Philadelphia, were very different from their counterparts in England. They were not part of a cohesive community, even on the local level. As Jon Butler has demonstrated, the Huguenots in North America came in relatively small numbers and primarily were individuals seeking personal advancement. As such, their identification with a specific religious sect was unstable, and they tended to assimilate quickly into the local culture. Although how Americans identified themselves (and others) as 'Huguenot' is difficult to establish, the professional connections that existed between craftsmen offers useful evidence for some sense of community.[2]

The Huguenot populations of New York City and Philadelphia were different. New York had a French church and one of the largest Huguenot populations in the North American colonies, although this was nevertheless a negligible group in the larger context of New York society. Philadelphia, despite its growth during the 18th century into the largest city in the English colonies, had relatively few Huguenots, and the population did not support a French church. Not surprisingly, the relationship between the two centres seems to have been a one-way of migration from New York to Philadelphia, with the stylistic influences following the same direction. As another city with religious toleration, Philadelphia naturally attracted Huguenot silversmiths from New York, particularly as its rapid growth may have offered opportunities not available in the overcrowded craft community in New York.

Plate 33 Caster, silver, Bartholomew LeRoux I, New York City, 1700–10, height 20.3 cm.

In the earliest years of migration to North America, Huguenot silversmiths, like all immigrant craftsmen, offered their customers a first-hand knowledge of European styles. Bartholomew LeRoux I (*c.* 1665–1713) must have been fully-trained when he settled in New York City, as in 1687 he was made a Freeman, a privilege available only to master craftsmen. Nothing, however, is known of his apprenticeship, although when LeRoux married in New York one year later, he was recorded as a 'young man from London'. It is possible that he trained in that city, although he could also have used London only as a point of embarkation.[3]

LeRoux found a vibrant city and craft community in New York. Settled for over half a century, there was already an established silversmithing tradition from its days as a Dutch colony. As the first silversmith of non-Dutch ancestry to work in the city, LeRoux seems to have capitalized on his ability to bring a sophisticated, international Baroque style to New Yorkers in place of the local provincial Dutch style. LeRoux's caster of 1700–10 (Yale University Art Gallery, Plate 33), with its elegant form, gadrooned borders, cast swags, and delicate piercing, resembled French prototypes such as one made *circa* 1695 in Arras.[4]

At the same time, LeRoux's shop was also able to supply objects to suit traditional local preference for a provincial Dutch style. LeRoux's brandywine bowl of *circa* 1696 (Yale University Art Gallery) was made for Joseph and Sarah Wardel of Shrewsbury, New Jersey, married in 1696. American versions of the Dutch *brandewijnskom* were made almost exclusively in New York, based on models from Groningen and Friesland. Other than the absence of chased ornament, LeRoux's bowl is similar to such examples as that made *circa* 1685 by Cornelius Vander Burch (*c.* 1653–1699), who was born in New York City and trained with Jurian Blanck Jr. (1645–*c.* 1715). The bowl (private collection) was made for a member of the De Peyster family. LeRoux presumably learned this style after his arrival, although it is possible that he trained in the Netherlands before coming to London. He also may have employed a locally trained craftsman to produce such objects.[5]

The significance of LeRoux's arrival in New York can be measured by its contrast to the career of his Philadelphia contemporary, Cesar Ghiselin (*c.* 1663–1733). The earliest Huguenot silversmith working in the mid-Atlantic region, Ghiselin was born in Rouen and probably immigrated as a teenager to England, where, like LeRoux, he may have trained. He arrived in Chester, Pennsylvania, in October 1681, and one year later moved to the new settlement of Philadelphia as its first silversmith. Most of Ghiselin's work showed little influence of Continental European forms or fashions, but instead was in the austere style of mid-17th century English silver. This could be evidence of an English apprenticeship, but it may also have reflected the taste of his Anglo-Quaker clients. His porringer (Philadelphia Museum of Art) engraved with the initials of Anthony and Mary (Jones) Morris is the earliest datable piece of Philadelphia silver, presumably made prior to Mary Morris's death in 1688. The porringer was a typical version of form found throughout the English colonies. Similarly, Ghiselin's tankard (Philadelphia Museum of Art), made for Barnabas and Sarah Wilcox prior to Barnabas's death in 1690, was an equally typical Anglo-American version of the form.[6]

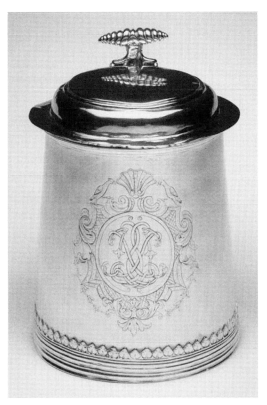

Plate 34 Tankard, silver, John Nys, Philadelphia, 1714, height 18.4 cm.

Ghiselin appears to have had little influence on the succeeding generation of Huguenot silversmiths in Philadelphia. By the beginning of the 18th century, New York had emerged as the training ground and style centre for silversmiths throughout the mid-Atlantic region. The second silversmith to work in Philadelphia, John Nys (1671–1734) – or 'Jno [John] Denys', as he was recorded in James Logan's account book – was born and presumably trained in New York City. A possible clue to his master's identity may be his 1693 marriage to a relative of the New York silversmith Henricus Boelen (1697–1755). Nys moved to Philadelphia a few years later, probably around 1695. A tankard (Philadelphia Museum of Art, Plate 34) made for James and Sarah Logan of Germantown, outside of Philadelphia, exhibited the characteristic features of late 17th century New York tankards: broad proportions, flat top, cocoon thumbpiece, and serrated, cut card decoration around base band. His braziers of *circa* 1695–99 (Philadelphia Museum of Art) were of a sophisticated continental form made by a number of New York silversmiths, although the fleur-de-lys piercings have been interpreted as reflective of French influence. Nys's braziers, engraved with the initials of Philadelphians Anthony and Mary (Coddington) Morris (the same Anthony Morris who owned Ghiselin's porringer, but a later wife), are the only surviving American examples of this form that can be securely dated to the 17th century, since Mary died in 1699.[7]

If New York was an important style centre for mid-Atlantic Huguenot silversmiths, Huguenot silversmiths were also critical to New York's primacy as both training ground and style centre, as demonstrated by the careers of two leading silversmiths of the next generation, Simeon Soumaine (1685–*c.* 1750) and Charles LeRoux (1689–1745). The child of refugee parents, Soumaine was born in London and baptized at the Threadneedle Street Huguenot Church, but his parents immigrated to New York City prior to 1689, when his father was denizized. The younger Soumaine presumably trained in New York, perhaps with fellow Huguenot Bartholomew LeRoux I. During an almost half-century long career, Soumaine operated a successful shop and trained a number of apprentices, including at least two fellow Huguenots, Elias Boudinot (1706–1770) and Elias Pelletreau (1726–1810). The silver made in Soumaine's shop was among the finest of its time. His sugar bowl (Yale University Art Gallery, Plate 35) made for Elizabeth (Harris) Cruger, who moved from Jamaica to New York in 1738 and died in 1750, stands as one of the outstanding American interpretations of this form and demonstrates a technical skill and familiarity with international styles equal to the elder LeRoux. Also like LeRoux, Soumaine's shop produced work in the traditional New York-Dutch local style, including a brandywine bowl made *circa* 1730 for Hendrick and Catharine (Remsen) Remsen of Brooklyn (Museum of the City of New York).[8]

Plate 35 Sugar bowl, silver, Simeon Soumaine, New York City, 1738–45, height 10.6 cm.

The career of Charles LeRoux, son of Bartholomew LeRoux I, further rein-
forces the importance of Huguenot silversmiths in New York. Born in the city
and presumably trained by his father, Charles LeRoux was very successful, oper-
ating what must have been a large shop that trained a number of apprentices and
presumably employed a number of specialist craftsmen. LeRoux served for
twenty-three years as the official silversmith for New York City Common
Council, producing nine gold or silver-gilt freedom boxes (including one made
in 1735 for Andrew Hamilton, now in the Historical Society of Pennsylvania
Collection at the Atwater Kent Museum of Philadelphia) and a mace in the shape
of an oar for the Royal Vice-Admiralty Court in New York (United States District
Court for the Southern District of New York; on deposit at Museum of the City
of New York).[9]

Virtually all of the surviving silver marked by Charles LeRoux is in the
classic 'Huguenot', Anglo-Continental fashion of the 1720s, when he set up shop.
This suggests that the younger LeRoux was the go-to person in New York for
classic London-Huguenot forms. Moreover, almost nothing by him has survived
in the local New York–provincial Dutch style, even made for clients of Dutch
ancestry. A covered cup of *circa* 1731 (Yale University Art Gallery) apparently
commissioned by the De Peyster-Van Cortlandt families as a christening gift for
Frederik De Peyster, was one of the most opulent American versions of this rarely
made form. Its heavy weight, harp-shape handles, and applied cut-card and
engraved decoration all ultimately derived from Anglo-French models of the
previous generation.[10] Charles LeRoux's almost exclusive focus on the cosmo-
politan style was exceptional and possibly may reflect a skewed survival of more
stylish objects over those deemed provincial by later generations.

The appeal of this cosmopolitan style as practiced by Soumaine and LeRoux
extended beyond New York to Philadelphia, where no silversmiths at that time
were producing baroque work at the same level of sophistication. An octagonal
caster (Yale University Art Gallery) by Soumaine was made for Joshua Maddox of
Philadelphia, perhaps around 1725 at the time of his marriage to Mary
(Rudderow) Gateau. At about the same time, Patrick Gordon, Proprietary
Governor of Pennsylvania, purchased a pair of Anglo-French style sauceboats
(Philadelphia Museum of Art, Plate 36) from Charles LeRoux's shop. Of a double-
lipped form was associated in England with Huguenot silversmiths, LeRoux's
sauceboats were very similar to London examples marked by Paul de Lamerie in

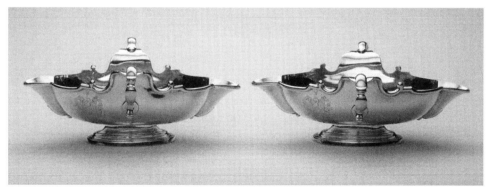

Plate 36 Pair of sauceboats,
silver, Charles LeRoux, New
York City, 1725–35, width
9.5 cm.

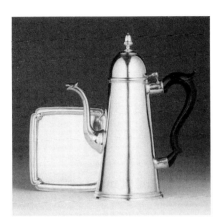

© Philadelphia Museum of Art, Gift of Mr. and Mrs. Henry Cadwalader
(stand). Private collection.

Plate 37 Coffeepot and stand, silver, Peter David, Philadelphia 1740–50, height 27.3 cm.

1720/21. Gordon may have sought out LeRoux to supply these magnificent objects, or he may have acquired his sauceboats through business connections in New York.[11]

Philadelphia silversmiths could not help but be influenced by the presence of such cosmopolitan objects in their city. A coffeepot and stand (The Metropolitan Museum of Art) made by LeRoux in 1735–40 for Ralph Assheton of Philadelphia epitomized the elegant, austere style frequently identified with Huguenot craftsmen; the square waiter was based on Chinese lacquer or porcelain prototype much like Soumaine's sugar bowl. The set is strikingly similar to a coffeepot and stand (Philadelphia Museum of Art and private collection, Plate 37) made in Philadelphia about five to ten years later by Peter David (1707–1755) for the Logan family. David may have had direct access to LeRoux's example made for Assheton, but as David himself was a Huguenot-descended silversmith who was born and trained in New York by fellow-Huguenot Peter Quintard (1699–1762), he could have learned the style before coming to Philadelphia. His straight-sided coffeepot and square waiter apparently are unique in surviving Philadelphia-made silver, whereas several New York-made examples are known.[12]

Not all silversmiths trained by New York Huguenot craftsmen followed their models, however, as demonstrated by the careers of two silversmiths who migrated elsewhere. One of Charles LeRoux's documented apprentices was Jacob Ten Eyck (1705–1793), the son of silversmith Konraet Ten Eyck (1678–1753) of Albany. In 1719 Jacob was apprenticed to LeRoux, perhaps because the opportunity it afforded him to learn the cosmopolitan style for which LeRoux clearly was renowned. However, Ten Eyck's surviving works, such as a brandywine bowl made *circa* 1730–35 for Evert and Engletie (Lansing) Wendell of Albany (Winterthur Museum), are all of traditional New York-provincial Dutch forms and styles and have no parallels in Charles LeRoux's own output.[13]

A similar scenario can be seen in the career of Elias Boudinot, who was born in New York City and apprenticed to Simeon Soumaine. Boudinot left New York for Antigua and then worked in Philadelphia from 1733 to 1752, when he moved to Princeton, New Jersey. His silver, including a tankard made for Benjamin and Deborah Franklin (The Franklin Institute) and a waiter (Art Institute of Chicago), closely followed contemporary English forms popular in Philadelphia. Boudinot, like Ten Eyck, followed models available in local ownership, and the silver made by both craftsmen suggests that local taste rather than their training was the more powerful influence in determining the style of their work.[14]

By 1750, the influence of the New York Huguenot silversmiths was waning, as the generation of craftsmen that flourished in New York in the 1720s and 1730s ended with the deaths of Charles LeRoux in 1745 and Simeon Soumaine about 1750. This change corresponded to a contemporaneous disappearance and assimilation of Huguenot churches and collective identity discerned by Jon Butler. Kristan McKinsey interpreted this diminishing prominence of Huguenot craftsmen as part of an overall trend in silversmithing in New York. Moreover, local styles in New York and elsewhere became less evident in the face of a wholesale

adoption of contemporary English Georgian manner during the third quarter of 18th century. There still were Huguenot or Huguenot-descended craftsmen working in precious metals in New York, including Charles LeRoux's son Bartholomew LeRoux II (1717–1763) and nephew Richard van Dyck (1717–1770), but they played a subsidiary role to other craftsmen.[15]

Even as their silver mimicked the English rococo style, Huguenot craftsmen still found professional opportunities in their community. Elias Pelletreau, born in eastern Long Island to a Huguenot father, was sent in 1742 to New York to be apprenticed to Simeon Soumaine. After completing his training, Pelletreau worked for only a few years as an independent craftsman in New York and returned to his native town of Southampton, a largely English-Quaker community, where he produced and sold the relatively modest objects needed by rural, agricultural community. A tankard with the Dunscomb arms (Museum of the City of New York) that Pelletreau probably made while in New York may have been engraved by fellow-Huguenot Elisha Gallaudet (c. 1730–1805), who was born in the Huguenot community of New Rochelle on Long Island Sound and worked in New York City. The design and rendering of the arms on Pelletreau's tankard, replete with the vocabulary of the rococo of Thomas Johnson, is strikingly similar to Gallaudet's 1761 bookplate for Jeremias Van Rensselaer. Another silversmith in the New York Huguenot community was Otto de Parisien (w. 1756–1797), who stood in 1757 as godfather for Elisha Gallaudet's son. He advertised himself as 'from Berlin' when he arrived in New York one year earlier, but none of the few objects that have survived bearing Parisien's mark show any trace of Continental European styles; objects such as his porringer (Minneapolis Institute of Arts) are identical to those made by other New York craftsmen.[16]

After Peter David, Philadelphia silversmiths of Huguenot descent exhibited the same pattern as their New York counterparts of maintaining some community connections but no stylistic distinctiveness. Their silver was by and large indistinguishable from that made in Philadelphia by their non-Huguenot contemporaries. Peter David founded a dynasty of Philadelphia silversmiths: both his son John David, Sr. (1736–1793) and grandson, John David, Jr. (1772–1809) worked in the trade. The silver marked by both father and son was in the local variation of the Georgian and Adam styles, and additionally John David Sr. also advertised imported 'large and small silver work'. Daniel Dupuy Sr. (1719–1807) was born into a New York Huguenot family and apprenticed to his brother-in-law, Peter David, probably coming to Philadelphia with Peter and Jeanne David in 1738. He trained his son, Daniel Dupuy Jr. (1753–1826), and a large quantity of silver in the Philadelphia neoclassical style bears a mark that could have been used by either man. The elder Dupuy is also known to have retailed silver imported from England.[17]

The most significant statement of Huguenot identity in American silver at mid-century was produced not by a silversmith, but the pewterer Joseph Leddel Sr. (c. 1690–1754), an immigrant to New York City from Hampshire, England. He married Marie Vincent in the French Church of New York in 1711, and his son Joseph Jr., also a pewterer, advertised as a specialist engraver, a skill he apparently learned from his father. In 1750, Leddel Sr. engraved three silver objects with a

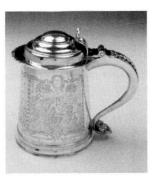

Plate 38 Tankard, silver, William Vilant, Philadelphia, *circa* 1725, engraved by Joseph Leddel, New York City, 1750, height 17.2 cm.

remarkable series of images relating to the Stuart attempt to retake the English throne in 1745 via the rebellion led by Prince Charles Edward Stuart, otherwise known as 'Bonnie Prince Charlie'. These pieces held great personal meaning for Leddel, as he owned all of them and also signed and dated his engraving. Leddel ornamented objects made by French or American Huguenot silversmiths with anti-Catholic or persecution imagery. He engraved a beaker (Museum of the City of New York) made by Hugues Lossieux (w. 1697–1722) of Saint-Malo, France in 1707/08 with a scene of the Devil leading the Pope and Prince Charles into Hell. He engraved the second object, a cann (Yale University Art Gallery) by Bartholomew LeRoux II, with scenes of the life of the Jewish patriarch Joseph, whose trials in Egypt could be interpreted representing the religious persecution faced by his namesake, Joseph Leddel.[18]

Leddel's most elaborate decorative program was the engraving on a tankard (Historic Deerfield, Plate 38) made by William Vilant (w. 1725), an obscure craftsman who apparently was born in New York and worked for a time in Philadelphia. The tankard was ornamented with large-scale mythological scenes surmounted by the heads of contemporary English political figures. On one side, for example, the portrait of Philip Dormer Stanhope, fourth Earl of Chesterfield, was engraved above the scene of Ulysses returning home to find Penelope faithfully weaving and rejecting suitors. The Latin inscription 'Penelope conjux semper Ulyssis ero [I, Penelope will always be wife to Ulysses]' identified this image as an allegory of constancy. Chesterfield, Lord Lieutenant of Ireland during the 1745 uprising, similarly embodied this virtue, as he mustered troops in support of the Hanoverian monarch and pledged a £50,000 bounty for capture of the young pretender. Such loyalty to the Protestant Hanoverians was very important to Huguenots who had lived in England, such as Leddel. His engraved statements of his political and religious affiliations, however, are without parallel in colonial American silver.[19]

Huguenot silversmiths in New York City and Philadelphia were important as leading American practitioners of the Anglo-French baroque style. The second quarter of the 18th century in New York, and particularly the work of Simeon Soumaine and Charles LeRoux, marked the zenith of an identifiable Huguenot stylistic influence. In addition to the significant achievements of these individual craftsmen, the Huguenots offer a useful case study to explore the connections and exchanges that existed between a small but specific group of artisans in two cities traditionally viewed as distinct areas of production. New York, with its quasi-aristocratic, manorial system of landowners, traditionally has been seen as favoring opulent display and grand stylistic statements. The Quaker majority in Philadelphia, on the other hand, is thought to have favored restraint, prizing quality and elegance over ostentation. As the careers of Huguenot silversmiths demonstrate, however, New York became the style center, with the Huguenots playing the active, if not central role, and Philadelphia offered fertile ground for these stylistic developments to spread. As the 18th century progressed, the small numbers and rapid assimilation of the Huguenots in the mid-Atlantic colonies diminished the role of Huguenot-descended craftsmen in both cities, although their religious identity remained important for professional connections.

FURTHER READING

David L. Barquist, *Myer Myers: Jewish Silversmith in Colonial New York*, New Haven and London, 2001.

Maurice Brix, *List of Philadelphia Silversmiths and Allied Artificers from 1682 to 1850*, Philadelphia, 1920.

Kathryn C. Buhler, *Colonial Silversmiths, Masters and Apprentices*, Boston, 1956.

Kathryn C. Buhler and Graham Hood, *American Silver: Garvan and Other Collections in the Yale University Art Gallery*, 2 vols, New Haven and London, 1970.

Jon Butler, *The Huguenots in America: A Refugee People in New World Society*, Cambridge, MA and London, 1983.

Dean F. Failey, 'Elias Pelletreau, Long Island Silversmith', MA thesis, University of Delaware, 1971.

Martha Gandy Fales, *Joseph Richardson and Family: Philadelphia Silversmiths*, Middletown Connecticut, 1974.

Christopher Hartop, *The Huguenot Legacy: English Silver 1680–1760 from the Alan and Simone Hartman Collection*, London, 1996.

Ambrose Heal, *The London Goldsmiths, 1200–1800*, Cambridge, 1935.

Morrison H. Heckscher and Leslie Greene Bowman, *American Rococo, 1750–1775: Elegance in Ornament*, exhib. cat., The Metropolitan Museum of Art, New York, 1992.

Jack L. Lindsey, *Worldly Goods: The Arts of Early Pennsylvania, 1680–1758*, exhib. cat., Philadelphia Museum of Art, 1999.

Kristan H. McKinsey, 'New York City Silversmiths and their Patrons, 1687–1750', MA thesis, University of Delaware, 1984.

Philadelphia: Three Centuries of American Art, exhib. cat, Philadelphia Museum of Art, 1976.

Alfred Coxe Prime, *The Arts and Crafts in Philadelphia, Maryland, and South Carolina, 1721–1785*, n.p., 1929.

Ian M. G. Quimby with Dianne Johnson, *American Silver at Winterthur*, Winterthur (DE) 1995.

Cheryl Robertson, 'Elias Boudinot: A Case Study in Ethnic Identity and Assimilation', MA thesis, University of Delaware 1980.

Janine E. Skerry and Jeanne Sloane, 'Images of Politics and Religion on Silver Engraved by Joseph Leddel', *Antiques* 141 (March 1992), pp. 490–499.

Page Talbott, ed., *Benjamin Franklin: In Search of a Better World*, New Haven and London 2005

'Wagner Pedigrees', research notes on Huguenot genealogy made by Henry Wagner, Huguenot Society Library, London.

Deborah Dependahl Waters, ed., *Elegant Plate: Three Centuries of Precious Metals in New York City*, 2 vols, New York, 2000.

Philip D. Zimmerman and Jennifer Faulds Goldsborough, *The Sewall C. Biggs Collection of American Art, a Catalogue: Volume I, Decorative Arts*, Dover, Delaware, 2002.

NOTES

1 Maurice Brix, *List of Philadelphia Silversmiths and Allied Artificers from 1682 to 1850*, Philadelphia, 1920, p. v.

2 Christopher Hartop, *The Huguenot Legacy: English Silver 1680–1760 from the Alan and Simone Hartman Collection*, London, 1996, pp. 10–11; Jon Butler, *The Huguenots in America: A Refugee People in New World Society*, Cambridge, MA and London 1983, pp. 46–48 (hereafter Butler).

3 Deborah Dependahl Waters, ed., *Elegant Plate: Three Centuries of Precious Metals in New York City*, 2 vols, New York, 2000, I, p. 152 (hereafter Waters). Waters identifies Bartholomew LeRoux's father as one Pierre LeRoux, a silversmith who was a member of the Goldsmith's Company in London. She credits as her source for this information Kristan H. McKinsey, 'New York City Silversmiths and their Patrons, 1687–1750', MA thesis, University of Delaware 1984, but McKinsey states unequivocally, 'Bartholomew LeRoux's life prior to coming to New York City remains a mystery at this time' (p. 22). The connection between Bartholomew and Pierre LeRoux was made by Kathryn C.

Buhler, who noted that LeRoux 'is said to have been born in London, where a Peter LeRoux is listed among seventeenth-century goldsmiths' (Kathryn C. Buhler, *Colonial Silversmiths, Masters and Apprentices*, Boston, 1956, p. 22). Although Buhler's publication lacks footnotes, the source of her information certainly was Ambrose Heal, *The London Goldsmiths, 1200–1800*, Cambridge, 1935, p. 194, who listed a 'Peter' LeRoux, goldsmith, married in Saint Martin's-in-the-Fields in 1678. In turn, Heal presumably based his information on the so-called 'Wagner Pedigrees', research notes on Huguenot genealogy made by Henry Wagner, now housed in the Huguenot Society Library in London. In his notes for the surname Roux, Wagner transcribed the following entry from the Saint Martin's parish registers: '1678 21 Aug. Vicar Generals' License Peter LeRoux of St. Martin in F. goldsmith baclr [bachelor] abt 24, m. Susanne Hamlin of Reading Spr [spinster] about 19.' Given the date of this marriage and the ages of the two people, they could not be the parents of Bartholomew LeRoux, who was made a Freeman of New York and married nine and ten years later, respectively. A thorough check of the Goldsmith's Company records reveals that Peter/Pierre LeRoux was never a member of the Company, apprenticed to Company member, or registered as a freeman in London. I am grateful to David Beasley, Librarian of the Goldsmiths' Company, and to Miss Hughes at the Huguenot Society Library, for their observations and assistance.

4 Kathryn C. Buhler and Graham Hood, *American Silver: Garvan and Other Collections in the Yale University Art Gallery*, 2 vols, New Haven and London 1970, II, pp. 18–19, cat. 565 (hereafter Buhler/Hood). For the French example see Palais Galliera Paris, 24 November 1971, lot 79.

5 Buhler/Hood (as note 3), II, pp. 16–19, cat. 564; Christie's New York, January 18–19, 2001, lot 353.

6 *Philadelphia: Three Centuries of American Art*, exhib cat, Philadelphia Museum of Art 1976, pp. 5–7, cats. 3–4 (hereafter PMA 1976).

7 PMA 1976 (as note 5), pp. 7–9, 17; cats 5, 12.

8 Buhler/Hood (as note 3), II, pp. 56–57, cat. 603; Waters (as note 2), I, pp. 188–90, cat. 64.

9 Kristan H. McKinsey, 'The LeRoux and Van Dyck Families: Life as a Silversmith in New York City before 1750' in Waters (as note 2), vol. I, pp. 34–37 (hereafter McKinsey 2000).

10 Buhler/Hood (as note 3), vol. II, pp. 62–63, cat. 612; for French prototypes, see a *circa* 1700 drawing by Nicolas de Launay, reproduced in Alain Gruber, *Silverware*, New York 1982, p. 108, pl. 124.

11 Buhler/Hood (as note 3), vol. II, pp. 57–59, cat. 604; Jack Lindsey, 'Royal Gravy: Governor Patrick Gordon's Silver Sauceboats', *Antiques*, vol. 151 January 1997, pp. 198–99. For French prototypes, see Gérard Mabille, *Orfèvrerie Française des XVIe XVIIe XVIIIe Siècles*, Paris, 1984, cat. 125; Palais Galliera Paris, 24 November 1971, lot 111.

12 Jack L. Lindsey, *Worldly Goods: The Arts of Early Pennsylvania, 1680–1758*, exhib. cat., Philadelphia Museum of Art, 1999, pp. 188–89, cats 209–10.

13 Ian M. G. Quimby with Dianne Johnson, *American Silver at Winterthur*, Winterthur (DE) 1995, p. 296, cat. 265.

14 Cheryl Robertson, 'Elias Boudinot: A Case Study in Ethnic Identity and Assimilation', MA thesis, University of Delaware 1980. The Franklin tankard is illustrated in Page Talbott, ed., *Benjamin Franklin: In Search of a Better World*, New Haven and London 2005, p. 132, fig. 4.9; the waiter in 'The Classical Presence in American Art', *Antiques*, vol. 114, September 1978, p. 500.

15 Butler (as note 1), pp. 145, 179–80; McKinsey 2000 (as note 8), pp. 33–34.

16 For Pelletreau, see Dean F. Failey, 'Elias Pelletreau, Long Island Silversmith', MA thesis, University of Delaware 1971; the tankard is illustrated in Waters (as note 2), vol. I, p. 176, cat. 55. For Gallaudet, see Waters (as note 2), vol. I, p.133; the bookplate is reproduced in Morrison H. Heckscher and Leslie Greene Bowman, *American Rococo, 1750–1775: Elegance in Ornament*, exhib. cat., The Metropolitan Museum of Art 1992, p. 43, cat. 20. For Parisien, see David L. Barquist, *Myer Myers: Jewish Silversmith in Colonial New York*, New Haven and London 2001, p. 53; the porringer is cat. 111.

17 For the Dupuys, see PMA 1976 (as note 5), p. 161; Martha Gandy Fales, *Joseph Richardson and Family: Philadelphia Silversmiths*, Middletown (CT) 1974, p. 210. For the Davids, see Philip D. Zimmerman and Jennifer Faulds Goldsborough, *The Sewall C. Biggs Collection*

of American Art, a Catalogue: Volume I, Decorative Arts, Dover (DE) 2002, p. 157; *Pennsylvania Gazette*, October 21, 1772, as cited in Alfred Coxe Prime, *The Arts and Crafts in Philadelphia, Maryland, and South Carolina, 1721–1785*, n.p., 1929, p. 57 (hereafter Prime).

18 Waters (as note 2), vol. I, pp. 151–52, cat. 37; Janine E. Skerry and Jeanne Sloane, 'Images of Politics and Religion on Silver Engraved by Joseph Leddel', *Antiques*, vol. 141 (March 1992), pp. 490–99 (hereafter Skerry/Sloane).

19 Skerry/Sloane (as note 17), pp. 495–97. Information on William Vilant is scarce. The 1707 will of David Vilant, merchant of New York, named William as his eldest son and included land holdings in east New Jersey (*New York Wills* 591 Lib 7), and in 1725 'William Vilant Gold Smith, in Philadelphia' offered for sale 250 acres in Freehold, New Jersey (*American Weekly Mercury*, August 12–19, 1725, as cited in Prime [as note 16], p. 94).

Huguenot goldsmiths in colonial Boston and Charleston

Beth Carver Wees

In his 1983 volume, *The Huguenots in America: A Refugee People in New World Society*, Jon Butler distinguishes between the Huguenot refugees who fled their native land in the 1680s and the immigrants who crossed a vast ocean to settle in the New World.[1] Rather than *re*-establishing themselves, Huguenots who travelled to the North American colonies were often young men and women seeking to establish their lives. This concept is fundamental to the story of Huguenot goldsmiths in colonial America. Few were highly skilled craftsmen seeking essentially to relocate their businesses. They were settlers in a new world; not strangers, not aliens, but newcomers.

It is uncertain just how many Huguenots settled in America between the 1680s and 1700, since the relevant shipping records have been lost. According to Butler, who analyzed the population of the North American Colonies, Huguenot migration to America totaled only 1,500 to 2,000 people — at a time when the overall population was approximately 250,000.[2] What were their chances of preserving a religious and cultural identity in the melting pot of the New World? And what were they seeking? — release from persecution; religious freedom; or opportunities for material success?

Boston's Huguenots had organized themselves as a congregation by 1685. In 1715, when the Reverend Andrew Le Mercier (1692–1763) became their pastor, the community had grown wealthy enough to build its own brick church on School Street. Among its congregants were such prosperous merchant families as the Faneuils, the Mascarenes, and the Bowdoins. The Church's glory years, however, lasted only until 1748, when, its numbers decimated by intermarriage and assimilation, it was forced to disband and to transfer its assets to the Congregational Church. No records survive from Boston's French Church, but we do know that, in an ironic twist of fate, its building later became Boston's first Catholic chapel.[3]

Neil Kamil suggests that it was the manual skills developed by Huguenot craftsmen during the 16th and 17th centuries that helped to make them self-sufficient, both during the years of persecution in France and in the Diaspora. He styles this their 'artisanal security',[4] a term appropriate to many of the Huguenots who immigrated to New England, among them a small number of individuals trained as goldsmiths and jewellers.

For most of Boston's Huguenot goldsmiths, archival documentation is all that survives; there are very few objects with which to illustrate their livelihoods. Take,

for instance, James Boyer (c. 1700–41), son of the London Huguenot distiller Peter Boyer. According to information provided by Robert Barker, James Boyer began his seven-year apprenticeship with James Papavoine, a jeweller of St. James's Westminster, in June of 1712. Nine years later he immigrated to Boston, advertising his services in the *New-England Courant* in the winter of 1722/3: 'This is to inform the Publick, That Mr. *James Boyer*, Jeweller, from London, living at Mr. Eustone's, a Dancing Master in King Street, Boston, setts all manner of Stones in Rings, &c. and performes every thing belonging to that Trade.' Characteristic of the exchange of goods and services among craftsmen and merchants, the Boston silversmith Benjamin Greene sold quantities of goods to Boyer, which are detailed in his surviving ledgers. These include casters, strainers, buckles, buttons, snuff-boxes, teaspoons and tea tongs, spectacle frames, and silver sword hilts. Conversely, Boyer supplied Greene with jewellery such as mourning rings, earrings, and buckles set with stones. When Boyer died in 1741, his combined estate was valued in Massachusetts currency at over £900, or the equivalent today of about $310,000. Yet no jewellery or silver made by him has been identified.[5]

Francis Légaré (c. 1636–1711), another Huguenot jeweller, was naturalized in England in March 1682 and appears in the Boston tax list in 1687. In addition to gold and silver stock, his estate inventory itemizes husbandry tools and tackling (suggesting seasonal farm work to help make ends meet), but no silver or jewellery by Francis Légaré survives.[6]

The objects we can associate with Boston's Huguenot goldsmiths are usually modest vessels, simple in form, such as canns, spoons, or porringers. A porringer (Plate 39) marked by René Grignon (c. 1652–1714/5) is one of only two extant objects bearing his mark. Its rounded bowl and cast handle with geometric piercings are characteristics of early New England porringers, as is the convention of engraving the owner's initials on the handle. Grignon's French-style mark, RG crowned with a heart below (Plate 40), is struck twice on the underside of the bowl.[7] The shallow porringer form itself is possibly French in origin, deriving from the popular two-handled écuelle.

Grignon immigrated to Boston from London in the mid 1680s in the entourage of the Huguenot merchant Gabriel Bernon (1644–1736). Bernon had obtained a land grant of 2,672 acres in Oxford, Massachusetts, ten miles south of Worcester, where he planned to establish a Huguenot settlement.[8] Although conflicts with Native Americans in that region threatened the town's survival, Bernon, Grignon, and Jean Papineau became partners in a wash-leather manufactory that supplied hatters and glove-makers in Boston and Newport, Rhode Island. In 1696 Grignon moved to Boston, where he became an elder in the French Church. He is later recorded in Norwich, Connecticut as master of a sailing ship and as a merchant selling silver, jewellery, textiles, farming tools, and hardware. The success of American silversmiths in the 17th and 18th centuries frequently depended upon diversification of this sort. Nevertheless, René Grignon identified himself in his will as a 'Jueller', a designation supported by his shop inventory of plate, bullion, gold, silver, stones, weights, and goldsmith's tools.[9]

The only other known object marked by Grignon is a porringer at Yale, which provides evidence of a different sort.[10] The underside of the bowl is again

Ex-collection, Mr. & Mrs. Walter M. Jeffords. © Sotheby's, Inc.

Plate 39 Porringer, silver, René Grignon, Boston, *circa* 1700, width 17.8 cm., weight 6 oz. 10 dwt.

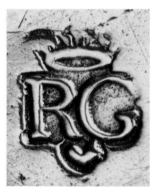

© Sotheby's, Inc.

Plate 40 Maker's mark of René Grignon on porringer, silver, Boston *circa* 1700 (see Plate 39).

struck twice with Grignon's mark. However on the lip to the left of the handle, in a location more customary at this date, is the erased mark of New England's first native-born goldsmith, Jeremiah Dummer. The presence of this additional mark brings into question whether Grignon actually made, or perhaps only retailed, either of these porringers. The handle (Plate 39) also appears on porringers marked by several other early Boston silversmiths, underscoring the complicated task of verifying makers.

Peter Feurt (1703–37), son of Bartholomew Feurt and Madelaine Peiret, was baptized in December 1703 in the French Church of New York. By the spring of 1727 he was living in Boston, where he was granted liberty by that city's select-man to open a goldsmith's shop.[11] Feurt's involvement in a scheme to establish an iron mine and foundry in Bellingham, Massachusetts soon set him on perilous financial footing from which he never recovered. Few objects survive bearing his mark. Among them is a rather sophisticated two-handled cup and cover (Plate 41) inscribed 'Ex Dono Henricus Hope Armiger', which is documented in the 1732 will of Edward Mills, Jr., of Placentia, Newfoundland: 'to Henry Hope Esqr. A Silver Cup with his Coat of Arms and mine engraved thereon.' The cup was later purchased by Charles Apthorp and descended to Sarah Apthorp Morton, whose name is engraved above the midband.[12] With its inverted bell-shaped body, leaf-capped handles, and domed cover, this cup closely follows the contemporary London model, a form much admired by Boston silversmiths and their patrons.

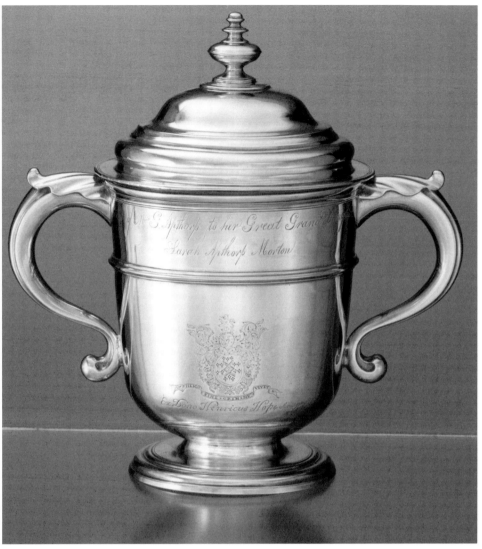

Plate 41 Two-handled Cup and Cover, silver, Peter Feurt, Boston, *circa* 1727–32, height 22.7 cm., weight 39 oz.

The prolific Boston goldsmith Jacob Hurd (1702/3–58), for instance, produced at least four two-handled covered cups. One, at the Metropolitan Museum in New York (Plate 42), is engraved with the arms and cipher of Cave, probably for William Cave of Virginia. A similar example at Yale was presented to Capt. Edward Tyng, and a third to Commander Richard Spry — both ship captains commended for having captured French privateers during King George's War.[13] It seems likely that imported London covered cups, or perhaps even trade cards and billheads, would have transmitted this design to the American Colonies. One case in point is a two-handled cup and cover marked by George Wickes (1698–1761) and engraved with the arms of the wealthy Boston merchant Thomas Hancock (1702–64) impaling those of his wife, Lydia Henchman (1714–76). How and when the cup came to Boston is undocumented, but in 1739 Hancock asked his London agent to 'look into the Herald's office and take out my armes', and it seems likely that Hancock's agent purchased the cup for him around that time. At his death in 1764 he left the cup to his wife, who subsequently bequeathed it to her nephew, John Hancock (1737–93), signer of the Declaration of Independence.[14] It has been suggested that the presence of the Wickes cup in

Plate 42 Two-handled Cup and Cover, silver, Jacob Hurd, Boston, *circa* 1735, 26.4 × 25.6 cm., weight 41 oz. 14 dwt.

Boston inspired Jacob Hurd's designs, a claim difficult to corroborate. The Feurt cup, in fact, was made several years before those marked by Hurd.[15]

Apollos Rivoire (1702–54), father of the famous patriot-silversmith Paul Revere, Jr. (1734–1818), was born to Huguenots Isaac Rivoire and Serenne Lambert and was baptized at Riocaud in southwestern France. At the age of thirteen Apollos was sent to the island of Guernsey, from whence his uncle arranged passage to New England and apprenticeship with the leading Boston goldsmith John Coney (1655/6–1722). In 1729 Rivoire married a woman of English descent, Deborah Hichborn, and anglicized his name to Paul Revere. The couple joined the New Brick Congregational Church, where all nine of their children were baptized. Although we can count Revere among the Huguenot silversmiths of Boston, his connection to that community is decidedly slight.[16] His story mirrors that of many American Huguenots who married non-Huguenots, assimilated into other Protestant sects, and trained under the tutelage of English- or native-born masters.

Revere Sr.'s surviving oeuvre, numbering some sixty objects, includes such standard domestic items as tankards, porringers, teapots, creampots, and spoons.[17]

Illustrated here is a tankard now belonging to the Metropolitan Museum (Plate 43), which epitomizes the classic 18th-century New England model with its tapered body, low domed cover with finial, and applied horizontal midband.[18]

A teapot (Plate 44) dating from about 1710 and marked by John Coney is engraved with the arms of a prominent Huguenot immigrant, Jean-Paul Mascarene, who was born in 1685 in the province of Languedoc.[19] His father fled France shortly thereafter, and the child was left in the care of relatives who smuggled him to Geneva. Mascarene was naturalized in England in 1706 and in 1711 came to America with English military troops. Although much of his military and political career took place in Nova Scotia, he lived for many years in Boston, where he married Elizabeth Perry (d. 1728) and raised a family.[20] Coney's vessel, which is quite early for a Boston-made teapot, attempts to emulate the pear-shaped model with curved spout produced by some of London's Huguenot silversmiths, albeit by a New England silversmith of English descent.

Plate 43 Tankard, silver, Paul Revere Sr., Boston *circa* 1750, 16.2 × 14 cm., weight 17 oz. 12 dwt.

Plate 44 Teapot, silver, John Coney, Boston, *circa* 1710, 19.2 × 21 cm., weight 18 oz.

The Coney teapot is hardly an anomaly; Boston's prominent Huguenots seem rarely to have patronized Huguenot goldsmiths. Another example is Peter Faneuil (1700–43), scion of a Huguenot refugee family from La Rochelle, France. Peter would become one of the wealthiest men in Boston, thanks to the astute real estate investments of his uncle, the merchant Andrew Faneuil (1672–1737). The Fanueils were part of the extensive merchant network that historians have termed 'the Protestant International', emphasizing the strength of their Protestant over their national ties.[21] It was Peter who donated to the City its central market-place, Faneuil Hall, which opened in 1742. In addition to his public benefactions, he lived the good life, importing through his London agents Madeira, cookery books, and even a 'handsome chariot'.[22] Like many wealthy Bostonians he became an Anglican, and the minister who preached at his funeral in 1743

neglected even to mention Peter Faneuil's Huguenot heritage.[23] And like other prosperous Bostonians, the Faneuils ordered much of their plate from London, including a 1751 coffeepot that descended in the family of his brother and heir Benjamin.[24]

The physician Pierre Baudouin (1640–1706), also from La Rochelle, fled to Ireland in the 1680s and then to Portland, Maine before settling in Boston by May 1690. His son, James Bowdoin (1676–1747), became a successful merchant, and his grandson, James Bowdoin II (1726–90) would eventually become governor of Massachusetts. When an inventory of James Bowdoin II's plate was taken in September 1774, it totaled over 861 ounces of silver and included dinner and tea wares, salvers, candlesticks, tankards, punch bowls, and bread baskets, mostly of foreign manufacture.[25]

⟵

In contrast to Boston, whose prosperity was largely merchant-based, Charleston, South Carolina developed as a planter society, its wealthy inhabitants erecting fine houses, finely furnished, and its agricultural success heavily dependent upon the African slaves who by 1720 made up two-thirds of the South Carolina population.[26] In response to French-language promotional literature promising religious toleration as well as social and economic opportunities, Huguenots began immigrating to South Carolina by 1679 and continued to settle there well into the 1690s.[27] It was in Charleston that the first French church in North America was founded, in the City's so-called Orange or French Quarter, and it retains today the oldest surviving Huguenot congregation in the United States. Its first minister was Elie Prioleau (1659–99) from Pons in Poitou, whose son Samuel would become a jeweller in his adopted city of Charleston.

Samuel Prioleau (1690–1752) is identified in archival documents as a 'jeweller' and a 'Goldsmith', but by 1732 he had become Colonel of the Troop of Horse Guards and is subsequently styled 'Colonel Prioleau'.[28] The mark on a steel-bladed knife has been attributed to him, but symptomatic perhaps of the dearth of surviving Huguenot silver, even that attribution has recently been called into question.[29]

Of the fifty-eight Huguenots who applied for naturalization under the 1697 South Carolina statute, only two identified themselves as goldsmiths, although the list included such other Huguenot artisans as a clockmaker, a watchmaker, two gunsmiths, two joiners, and three blacksmiths. Many of these craftsmen eventually took up farming in the land-rich society of South Carolina. As Butler points out, these immigrants were often quite young and not yet deeply committed to their trades. Instead, they followed the lead of discerning English colonists by purchasing large tracts of land for farming.[30]

Huguenot goldsmiths commanded most of colonial Charleston's silver and jewellery trade, and archival records survive for a number of them. Very few of their objects, however, are known today. The French-born Solomon Légaré

(*c.* 1674–1760) was naturalized in England before immigrating with his family to Boston, where he apprenticed as a silversmith, probably in his father's shop. Estranged from his father after marrying against the older man's wishes, he moved to South Carolina around 1696. Surviving records document his involvement in an unsuccessful silver mining venture, as well as his standing as a prosperous Charlestonian. At his death Solomon Légaré's inventory listed 68 oz. 16 dwts. old silver and gold, but no surviving objects.[31]

John Paul Grimke (1713–91), possibly a Huguenot,[32] trained in London and was working in Charleston by 1740. A record of his apprenticeship to one John Brown, 'citizen & jeweller', survives, with an apprenticeship premium of £22, the tax on which was paid in 1731.[33] An extensive advertisement, published in 1759 in the *South Carolina Gazette,* names the wide variety of articles Grimke imported from London to be sold for 'READY MONEY ONLY'.[34] The following year he advertised a 'journeyman who is an extraordinary fine chaser, those who are inclined to have their old plate beautified, may have it chased in the newest taste at a small expense'.[35] John Paul Grimke died in 1791 and was buried in St. Michael's Episcopal Churchyard.[36] No silver or jewellery bearing his mark is known.

A remarkable survival is the account book of Nicolas De Longuemare, Jr. (d. 1711/12), chronicling the years 1703 to 1710 and now in the collection of The Charleston Museum (Plate 45). De Longuemare's tidy accounts — in French for his Huguenot patrons and in phonetically-spelled English for all others — reveal a range of goods and services provided by one of Charleston's earliest goldsmiths, who lived in the French Quarter of the city, on the banks of the Cooper River. In addition to the predictable transactions for brass and silver seals, spoons, buckles, buttons, spectacles, watches, and jewellery, De Longuemare sold rum, olive oil, and hoes. He also dealt in silks, and for several months each year lived on his farm, where his accounts turn to the sale and purchase of raw silk, beef, cotton, and wheat.[37]

Plate 45 Account Book, Nicolas De Longuemare, Charleston 1703–1710.

Although no silver marked by De Longuemare has come to light, four pieces of church plate can be attributed to Miles Brewton (1675–1745), a non-Huguenot who had commercial dealings with De Longuemare and whose work reflects a familiarity with the plainer Huguenot style. All three standing cups bearing the MB conjoined mark associated with Brewton have similar raised bowls and cast baluster stems. One of these, still owned by the Episcopal Diocese of South Carolina, is engraved around the rim: *Belonging to St. Thomas Parish in South Carolina Anno Dom: 1711.*[38]

Moreau (1710–61) and Jonathan (d. 1811) Sarrazin, father and son, advertised as silversmiths and jewellers. A lengthy advertisement of 1764 announced, *'Just imported in the* Little-Carpenter, *Capt.* William Muir, *from* LONDON, *and to be sold by* JONATHAN SARRAZIN *At the Tea-Kettle and Lamp, the corner of Broad and Church-Streets.'*[39] Jonathan's imported stock featured fashionable domestic plate such as silver and flint glass casters in silver frames; chased or plain coffeepots; sauce boats; teapots; knives and forks in shagreen cases; and all manner of jewellery. Of his own work, he advertised that 'He continues to make and mend all kinds of jewellery, and motto rings as usual.'[40]

Jonathan's father Moreau was working as a goldsmith and engraver by 1734. Among his few extant objects is a large serving spoon called a 'rice spoon' by South Carolinians. This spoon is engraved with the emblem and motto of the South Carolina Society (Plate 46), a social and philanthropic organization established by local Huguenots in 1737 as a means of preserving their identity. Sarrazin himself was an early member.[41]

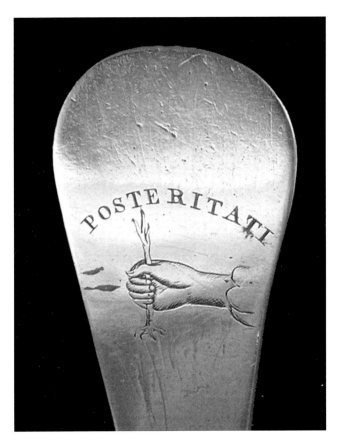

Plate 46 Serving Spoon (detail), silver, Moreau Sarrazin, Charleston 1734–1761, overall length 40 cm.

© The Charleston Museum, Charleston, South Carolina.

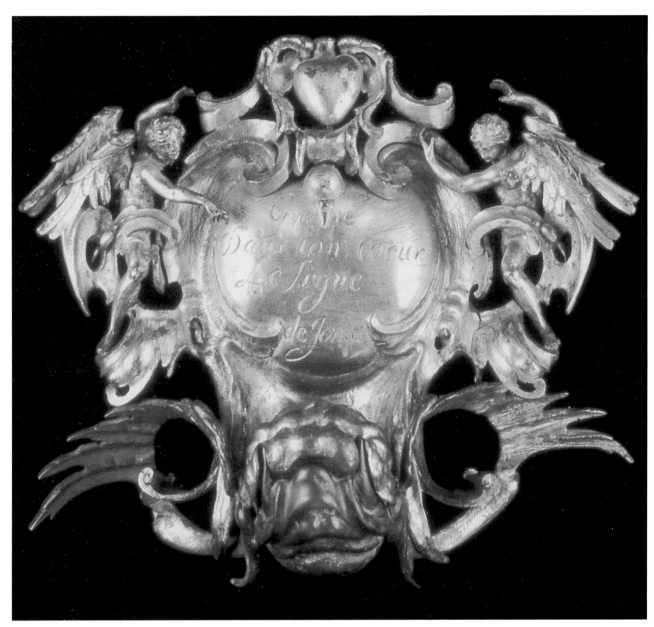

Plate I Holy water stoup, partly
gilt brass, attributed to Denis
Boutemie, Paris *circa* 1620,
height 22 × 25 cm.

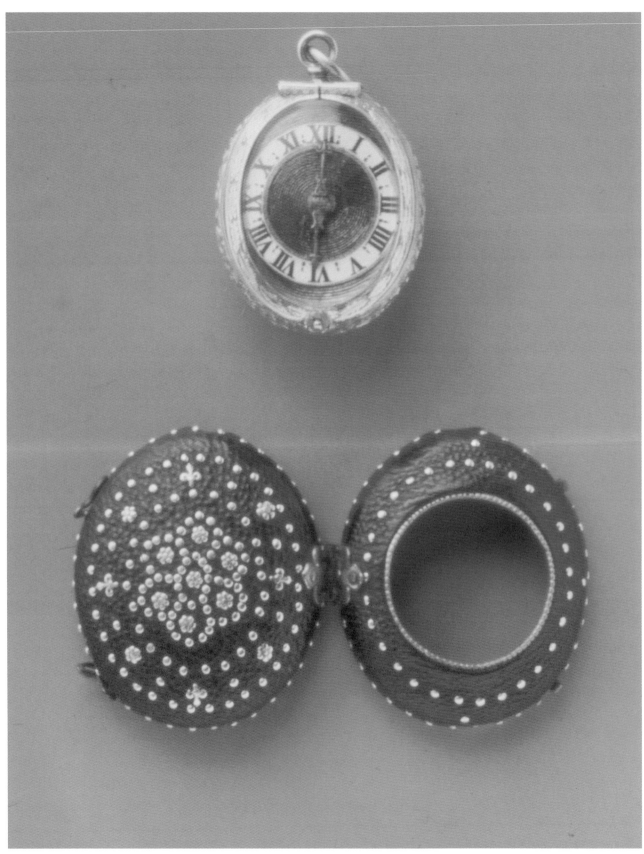

Paris, Musée du Louvre, department des Objets d'art, inv. OA 8305. © Réunion des Musées Nationaux.

Plate II Gold watchcase and its leather case, Abraham and probably Isaac Gribelin, Blois *circa* 1610, width 3.2 × 2.6 cm.

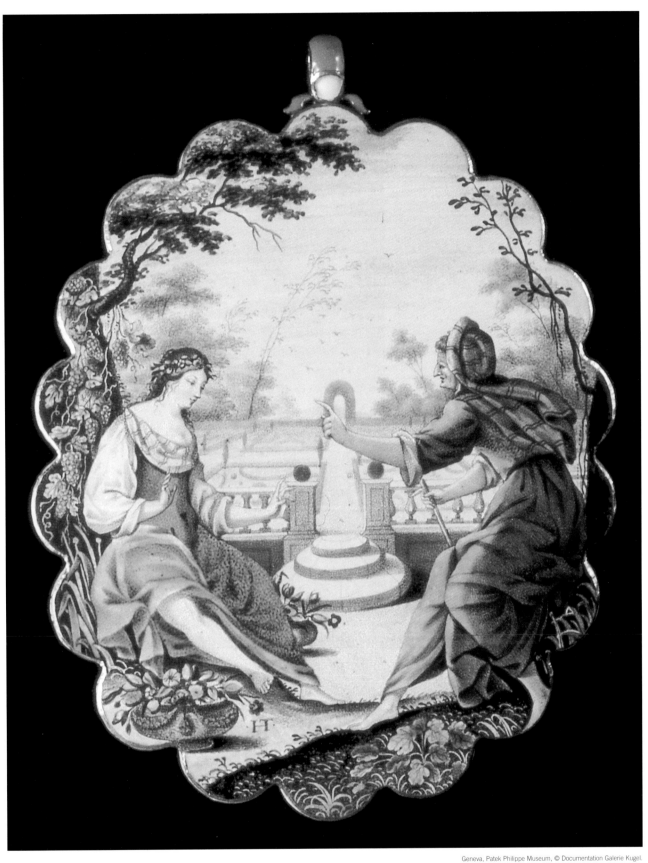

Plate III Hand-mirror with
painted enamels, Henry Toutin
(monogram HT), Paris *circa*
1645–1650, height 10.6 cm.

Plate IV '*Aiguière à l'Amour*'
(detail of the inside lid), enam-
elled gold, Pierre Delabarre,
Paris *circa* 1625–1635, height
26.1 cm.

Plate V Jewelled scent-bottle
with opals and white enamel on
gold, from the Cheapside
Hoard, Paris (?), early 17th
century, height 6.5 cm.

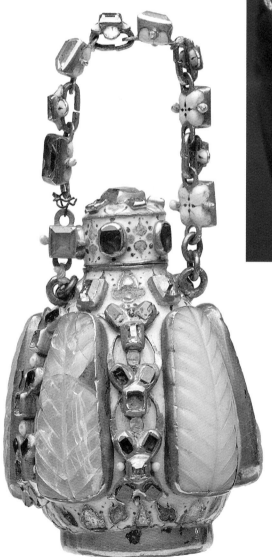

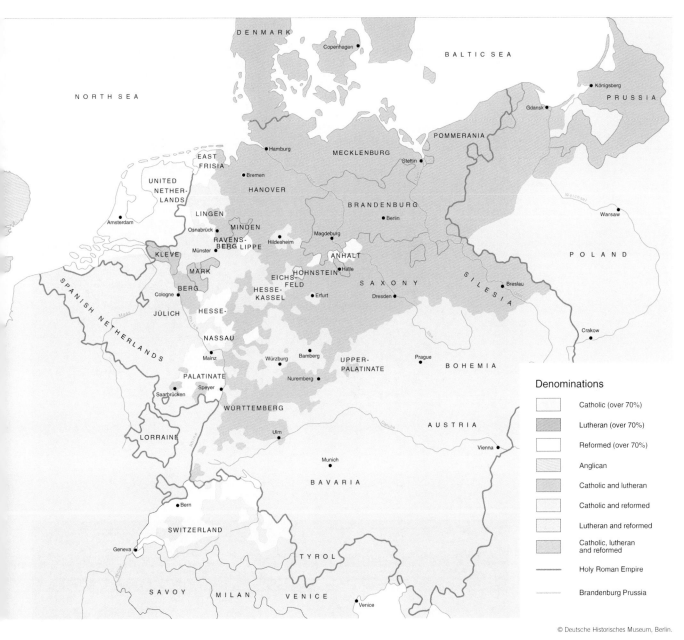

Denominations

Catholic (over 70%)

Lutheran (over 70%)

Reformed (over 70%)

Anglican

Catholic and lutheran

Catholic and reformed

Lutheran and reformed

Catholic, lutheran and reformed

Holy Roman Empire

Brandenburg Prussia

Plate VI Map showing religious denominations in Europe in the late 17th century.

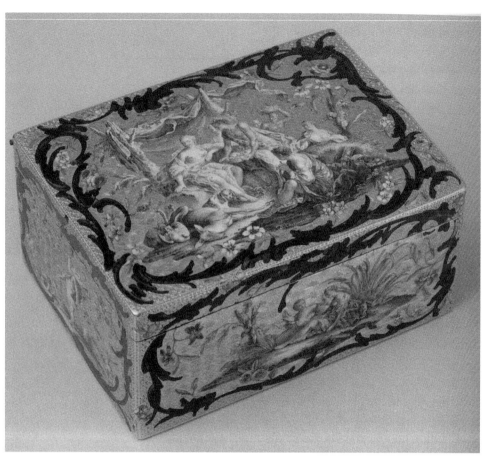

Plate VII Snuff box, Daniel Baudesson, goldsmith; Daniel Chodowiecki, enamel-painter, Berlin *circa* 1755, 4.1 × 8.4 × 6.2 cm.

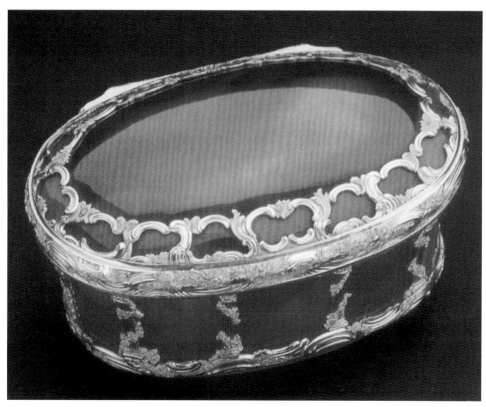

Plate VIII Snuff box, agate and gold, Daniel Baudesson, Berlin *circa* 1765, 5 × 9 × 6.2 cm.

Plate IX Snuff box, gold, diamonds, brilliants, enamel, Jean Guillaume George Krüger, Berlin, *circa* 1755.

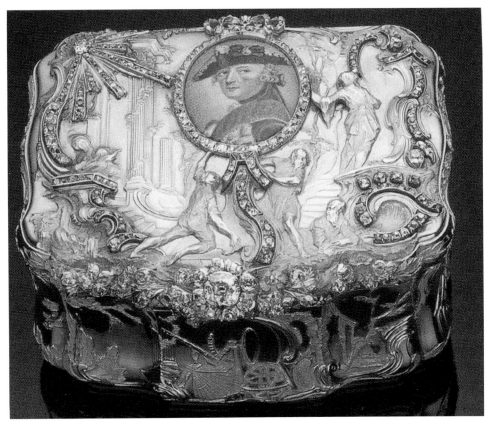

Plate X The Reclam Family, oil on canvas, Johann Friedrich August Tischbein, after 1776.

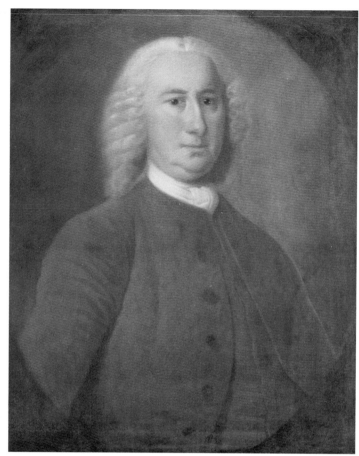

Plate XI Gabriel Manigault, 1757, oil on canvas, Charleston, Jeremiah Theus (American, 1716–1774), 1737, 76.2 × 62.2 cm.

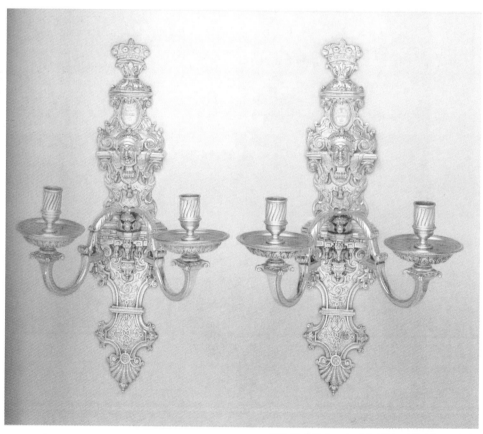

Plate XII Sconces, pair, silver-gilt, Paul de Lamerie, London, *circa* 1714, 55.7 cm.

One individual previously associated with Charleston's Huguenot gold-smiths, Alexander Petrie (1707–68), was in fact not of Huguenot descent. Research conducted by Historic Charleston curator Brandy Culp has revealed that he was the son of David Petrie and Agnes Spence of Elgin, Scotland, where he may have trained before settling in Charleston in the early 1740s. Petrie attended the First Scots Presbyterian Church in Charleston, and many of his male descendants were Presbyterian ministers. His surviving oeuvre indicates a highly skilled craftsman and one conversant with contemporary London styles. Petrie certainly had dealings with some of Charleston's Huguenot silversmiths, such as Jonathan Sarrazin, who purchased his stock in hand in 1765. At the estate sale held after Petrie's death in 1768, Sarrazin also purchased his 'negro silversmith' Abraham for the hefty sum of £810 South Carolina currency, or the equivalent today of $112,000.[42]

By the 1760s, cohesion in Charleston's Huguenot community had been deterio-rating for half a century. Although some held fast to their French heritage, Anglican conformity was widespread. Huguenots increasingly adopted English ways, emulating their agricultural lifestyle, including slave holding, and becoming members of the social and political elite.[43] The Charleston merchant and planter Gabriel Manigault (1704–81; Plate XI), for instance, whose father emigrated from La Rochelle in the 1680s, is a distinguished example of a familiar narrative. Manigault became one of the wealthiest men in the North American colonies, appointed public treasurer in 1735 and later a member of the South Carolina Assembly. In time he owned over 47,000 acres, and, with 490 slaves, he was one of the largest slave owners in South Carolina. Born of Huguenot parents, he married Ann Ashby in 1730 in an Anglican ceremony, and the couple baptized their son Peter at Saint Philip's, Charleston's leading Anglican Church, where Gabriel became a church elder. Yet he remained loyal to Huguenot causes, contributing thousands of pounds to assist poor French immigrants; thousands more to the Huguenot-supported South Carolina Society; and, when the French Church erected a new building in 1744, donating a handsome communion service, which unfortunately disappeared during the Civil War. At his death in 1781, Gabriel Manigault was buried in the family vault at the French Huguenot Church.[44]

Huguenot goldsmiths in colonial Boston and Charleston migrated to two very different, albeit both very English cities, where assimilation and adaptation offered the clearest opportunities for personal and financial success. They supplied the needs of their patrons with imported and locally-made goods, and they diversified

their occupations to help make ends meet. What few objects survive to illustrate their craft reflect less their origins as Huguenots than the natural transmission of Old World styles and techniques that characterizes American silver made throughout the colonial period.

FURTHER READING

Ellenor M. Alcorn, *English Silver in the Museum of Fine Arts, Boston, Vol. 1: Silver Before 1697*, Boston, 1993.

Kathryn C. Buhler and Graham Hood, *American Silver, Garvan and Other Collections in the Yale University Art Gallery*, New Haven, 1970.

Jonathan M. Beagle, 'Remembering Peter Faneuil: Yankees, Huguenots, and Ethnicity in Boston, 1743–1900', *New England Quarterly* 75 (September 2002), pp. 389–90.

E. Milby Burton, *South Carolina Silversmiths, 1690–1860*, 1968, reprinted Savannah, Georgia, 1998.

Jon Butler, *The Huguenots in America, A Refugee People in New World Society*, Cambridge, MA, 1983.

Ada R. Chase, 'René Grignon, Silversmith', *Antiques* 34, no. 1 (July 1938), pp. 26–27.

Neil Kamil, *Fortress of the Soul: Violence, Metaphysics, and Material Life in the Huguenots' New World, 1517–1751*, Baltimore, 2005.

Patricia Kane, *Colonial Massachusetts Silversmiths and Jewellers*, Yale University Art Gallery, 1998.

Gordon E. Kershaw, *James Bowdoin II, Patriot and Man of the Enlightenment*, Lanham, Maryland, 1991.

G. Andrew Moriarty, *The New England Huguenots*, reprinted from *Proceedings of the Huguenot Society of London* 13, no. 6 (1929).

Samuel Gaillard Stoney, 'Nicholas De Longuemare: Huguenot Goldsmith and Silk Dealer in Colonial South Carolina', *Transactions of the Huguenot Society of South Carolina*, no. 55 (1950), pp. 38–65.

David B. Warren, Katherine S. Howe, and Michael K. Brown, *Marks of Achievement: Four Centuries of American Presentation Silver*, Houston and New York, 1987.

Laurence Wylie, 'French Sails into Boston', *The French Review* 49, no. 6 (May 1976), p. 889.

NOTES

Several individuals have made important contributions to this essay. Brandy S. Culp, Curator of Historic Charleston Foundation, was especially generous in sharing her research on Charleston silversmiths. Grahame Long, Curator of History, and Rebecca McClure, Assistant Archivist at the Charleston Museum, as well as Charlotte Crabtree at The Silver Vault of Charleston provided information, images, and guidance. I am grateful to Robert Barker for graciously sharing research materials and to Tessa Murdoch for helpful references and encouragement. This chapter is indebted as well to the published work of several scholars, among them Patricia Kane and her colleagues who assembled the monumental volume, *Colonial Massachusetts Silversmiths and Jewellers*, published by the Yale University Art Gallery in 1998, and Professors Jon Butler at Yale and Neil Kamil at the University of Texas, whose exemplary books on the Huguenot experience in America have helped to shape my thinking.

1 Jon Butler, *The Huguenots in America, A Refugee People in New World Society*, Cambridge, MA, 1983, p. 41 (hereafter Butler).

2 See Butler (as note 1), pp. 47–49.

3 G. Andrew Moriarty, *The New England Huguenots*, reprinted from *Proceedings of the Huguenot Society of London*, vol. 13, no. 6 (1929), and Butler (as note 1), pp. 83, 90. See also

Laurence Wylie, 'French Sails into Boston', *The French Review*, vol. 49, no. 6 (May 1976), p. 889.

4 Neil Kamil, *Fortress of the Soul: Violence, Metaphysics, and Material Life in the Huguenots' New World, 1517–1751,* Baltimore, 2005, pp. 1–2 (hereafter Kamil). See also Glenn Adamson, in 'Book Reviews', *Studies in the Decorative Arts*, vol. 14, no. 1 (Fall–Winter 2006–7), p. 127.

5 Patricia E. Kane, ed., *Colonial Massachusetts Silversmiths and Jewellers,* New Haven, 1998, pp. 198–201 (hereafter Kane). Currency conversion is based on numbers provided in John J. McCusker, *How Much Is That In Real Money? A Historical Commodity Price Index for Use as a Deflator of Money Values in the Economy of the United States,* Worcester, MA: American Antiquarian Society, 2001, p. 34 (hereafter McCusker).

6 Kane (as note 5), pp. 651–52.

7 See Sotheby's New York, 29 October 2004, lot 698. For a similar porringer of London manufacture, see Ellenor M. Alcorn, *English Silver in the Museum of Fine Arts, Boston, Vol 1: Silver Before 1697,* Boston, 1993, cat. no. 83.

8 Gabriel Bernon's papers are at the Rhode Island Historical Society, MSS 294.

9 Kane (as note 5), pp. 518–21. See also Ada R. Chase, 'René Grignon, Silversmith', *Antiques*, vol. 34, no. 1, pp. 26–27.

10 Kathryn C. Buhler and Graham Hood., *American Silver, Garvan and Other Collections in the Yale University Art Gallery*, New Haven 1970, vol. 1, cat. no. 20 (hereafter Buhler and Hood).

11 Kane (as note 5), p. 478.

12 Kane (as note 5), pp. 478–79; Buhler and Hood (as note 9), cat. no. 136.

13 See Kane (as note 5), pp. 581, 595. For the Tyng cup, see Buhler and Hood (as note 9), cat. no. 157; for the Spry cup, see David B. Warren, Katherine S. Howe, and Michael K. Brown, *Marks of Achievement: Four Centuries of American Presentation Silver*, Houston and New York, 1987, cat. no. 57.

14 The history of this cup, rife with family lore, is carefully detailed by Ellenor Alcorn in *English Silver in the Museum of Fine Arts Boston, Vol 2: Silver From 1697,* Boston 2000, pp. 101–2 (hereafter Alcorn 2000), where she notes that the Hancock arms replace earlier engraving, now erased.

15 Kane (as note 5), p. 479 records Feurt's death in August 1737 and dates the cup *circa* 1727.

16 Butler (as note 1), p. 86.

17 Kane (as note 5), pp. 848–52.

18 Acc no 33.120.506, Bequest of Alphonso T. Clearwater.

19 Metropolitan Museum acc. no. 33.120.526.

20 See Barry Moody, 'Mascarene, Jean-Paul (1685–1760)', *Oxford Dictionary of National Biography*, Oxford University Press, 2004 [http://www.oxforddnb.com/view/article/18258].

21 Jonathan M. Beagle, 'Remembering Peter Faneuil: Yankees, Huguenots, and Ethnicity in Boston, 1743–1900', *New England Quarterly* 75 (September 2002), pp. 389–90.

22 *American National Biography*, New York, 1999, vol. 7, p. 699.

23 Butler (as note 1), pp. 84, 86.

24 See Alcorn 2000 (as note 13), cat. no. 103 for this coffeepot, which is marked by William Shaw and William Priest.

25 See Gordon E. Kershaw, *James Bowdoin II, Patriot and Man of the Enlightenment,* Lanham, Maryland, 1991, p. 88.

26 Butler (as note 1), p. 91.

27 Butler (as note 1), pp. 53, 92.

28 E. Milby Burton, *South Carolina Silversmiths, 1690–1860*, 1968, reprinted Savannah, Georgia, 1998, pp. 152–53 (hereafter Burton).

29 Information provided by Charlotte Crabtree of the Silver Vault of Charleston.

30 Butler (as note 1), pp. 95–96.

31 Kane (as note 5), p. 653.

32 Although Grimke's connection to the Huguenot community is undocumented, he became a member in 1753 of the South Carolina Society, founded by local Huguenots to help preserve their heritage; see Burton (as note 27), p. 74.

33 UK National Archives, IR 1/13 folio 13. I am indebted to Robert Barker for this cita-
tion and to Brandy Culp for permitting me to include it in this essay.

34 *South Carolina Gazette*, 10–17 November 1759, quoted in Burton (as note 27), p. 75.

35 *South Carolina Gazette*, 8–15 November 1760; quoted in Burton (as note 27), p. 76.

36 Burton (as note 27), p. 78.

37 Samuel Gaillard Stoney, 'Nicholas De Longuemare: Huguenot Goldsmith and Silk Dealer
in Colonial South Carolina', *Transactions of the Huguenot Society of South Carolina*, no. 55
(1950), pp. 38–65. I am most grateful to Brandy Culp for supplying me with a copy of
the account book transcription and other documents relating to Nicholas De
Longuemare. See also Butler (as note 1), p. 100.

38 Frank Horton, 'Miles Brewton, Goldsmith', *Journal of Early Southern Decorative Arts*, vol.
7, no. 2 (November 1981), pp. 1–13.

39 Illustrated in Burton (as note 27), p. 164.

40 Advertisement reproduced in Martha Gandy Fales, *Early American Silver for the Cautious
Collector,* New York, 1970, endpapers.

41 On Moreau Sarrazin, see Burton (as note 27), pp. 166–69.

42 Brandy Culp provided much of this biographical information. See also Burton (as note
27), pp. 146–49 and 164–65. Currency conversion is based on the numbers provided in
McCusker (as note 5).

43 Butler (as note 1), pp. 106–14.

44 *American National Biography*, vol. 14, pp. 409–10, and Butler (as note 1), pp. 125–26,
137–39. I am grateful to Charlotte Crabtree for information on the communion plate.

CHAPTER **6**

The Huguenot goldsmiths of Cork

John R. Bowen

Much is properly made of the effect and influence of Huguenot refugees and immigrants on the history of the city and county of Cork, in the southern part of Ireland. Never very numerous in absolute terms, these Huguenots arrived when the government was seeking actively to encourage Protestant settlement in Ireland as a means of pacifying the country, and ensuring its loyalty, during and after the turbulent 17th century. They were welcome arrivals from the government's perspective, if not always from that of incumbent trades-people, who did not necessarily appreciate increased competition. Within two generations these Huguenot immigrants had not only established themselves in a new country, but had also reached a significant level of pre-eminence in the commercial and civic life of Cork, and their influence was widely felt. Some had established large industries and businesses, and amassed considerable fortunes.

Cork was in fact the third largest Huguenot colony in Ireland, after those of Dublin and Portarlington but owing to the destruction of the relevant Irish records, little in the way of documentary evidence of the details of the lives of these Huguenot settlers in Cork survives, making the telling of their story very difficult.

At first glance it may appear remarkable that the Huguenot emigrations included Ireland as a destination, one of the most peripheral places in Europe, and for people who were fleeing religious persecution at the hands of a Roman Catholic state, one of its most predominantly Catholic parts.[1] Notwithstanding that, the Huguenot immigrants, and this essay will focus on the small number of goldsmiths amongst them, contributed a meaningful chapter to the overall story of their own 'diaspora' in the City and County of Cork. What follows illuminates the story of these Huguenot goldsmiths of Cork.

Huguenot goldsmiths in Cork

The Huguenot settlers had a major impact on the city of Cork. In reality their numbers were never huge but their legacy is indelible.[2] The goldsmiths amongst them brought their own attitude to design and their own techniques. They never dominated the local trade, but rather, they exercised influence on it.[3] They arrived in two main waves; the first after 1662 and the second after 1692, just as mercantile activity based on the provisions' export trade was beginning to generate real wealth for the urban economy of the city and hinterland. It was also the beginning of a period of relatively settled and peaceful political conditions in

the country at large. This combination of circumstances saw significant growth in the size of Cork throughout the 18th century.

Against this background of an expanding city and economy, and through some three or four generations, Huguenot goldsmiths became completely assimilated. It was not just access to the practice of their trade that the new immigrants sought and obtained, but also to participation in the very council of the city. Between 1690 and 1800 no fewer than five mayors of Cork were Huguenots, beginning with Peter Reneu in 1694. This was a greater level of participation by Huguenots in the political life of Cork than was the case in Dublin which Dickson suggests may have been 'due to a greater willingness of the Cork Huguenot elite to meld themselves into the Anglican social milieu'.[4]

Huguenot goldsmiths figure prominently in the Cork guild. This was, to give it its full title, *The Master and Wardens and Company of the Society of Goldsmiths of the City of Cork*. It was constituted in 1656 and its original charter is preserved in the Cork Public Museum. Two of its founding trustees were Edward and Robert Goble, braziers. In this context it is worth noting that as well as goldsmiths, the society also represented 'Braziers, pewterers, founders, Plummers, whiteplate-workers, Glaziers, Sadlers, upholsterers and the like.'[5]

The Gobles present scholars with a problem, exacerbated by the relative absence of records. Robert Goble was originally thought of as one person, old enough to have been appointed a trustee of the Society in 1656, and who had a working career that finished in either 1719 or 1737. It is obvious that this is practically impossible. It is now accepted that Robert Goble, the goldsmith, was not the Robert Goble, brazier, appointed trustee in 1656. Furthermore, it is certain that Robert Goble, goldsmith, was actually two Robert Gobles, likely father and son. It is also probable that the son served his apprenticeship to his father.

The family's Huguenot credentials are far from certain, and evidence for these rests with the authority of Mr. Robert Day, an eminent Cork historian and antiquarian, who died in 1914.[6] Day's assertion that M. Goble was a Huguenot who fled France after the Revocation of the Treaty of Nantes in 1685, appears on the face of it unlikely. However, one of Day's direct paternal ancestors was the Huguenot, Susanna Rouviere of Youghal, who was baptized in 1728. She married Thomas Day of Ballyvergin, Co. Cork, in 1745.[7] Given Day's Huguenot ancestry it may be unwise to dismiss his opinions out of hand.

Research by Conor O'Brien[8] has established that the name Goble had existed in Cork for some time before the subject period. However, Huguenot immigrants to Cork adopted anglicized versions of their surnames in order to blend in with the local population.[9] The descendants of the Huguenot pastor, Rev. Jean Picque, adopted the surname Pick; those of Carrée, became Quarry; and du Clos became Dukelow. Is it possible that these goldsmith Gobles had in fact taken their French-sounding surname and modified it into something with a greater local character? A further interesting twist to this is a note by Lee, wherein she states (of the Gobles): 'The writer has been informed that the last representative of this family in the City took his mother's name of Barry.'[10]

Robert Goble I, goldsmith, is first mentioned as a 'jeweller'. The term is still used in the trade in Cork today to denote a more capable craftsman than a gold-

smith. This first reference is in the context of his acting in a banking capacity to the Churchwardens of Christ Church in the year 1676, where according to the Vestry Book,[11] a sum of money bequeathed to the parish with the interest thereon to be applied to feeding the poor should be 'lett out to Mr. Robert Goble, the Jeweller'. Thus Robert Goble may have enhanced his 'indigenisation' by conforming to the Anglican church (the French church would not be established until 1694), and later opting for interment in the French burial ground. Robert Goble fashioned some extremely accomplished work and, in particular, ecclesiastical silver for the expanding Anglican church. He also was the maker of the celebrated mace of the trade guilds of Cork of 1696, now in the collection of London's Victoria & Albert Museum,[12] as well as items of civic silver such as freedom boxes and the Silver Oar of Cork now in the collection of the Cork Public Museum.

Robert Goble II is the likely subject of the entry in the Council Book for 10 September 1694 wherein it was 'ordered that Mr Robert Goble be sworn free'.[13] He is likely therefore to have obtained his freedom by virtue of being the son of a freeman and apparently in the same trade as his father. He too was an accomplished goldsmith as demonstrated by his freedom box presented to the Earl of Kildare in 1716[14] (Plate 47).

Given the uncertainty surrounding the Gobles' Huguenot pedigree, the first Huguenot goldsmith of whom there is any specific knowledge is Samuel Pantaine. He was warden of the Cork Company in 1678, master the following year and again in 1686. It is not known from whence in France he came, or by what route, but clearly he was an early arrival. Few examples of his work survive. The beautiful trefid-handled basting spoon (Plate 48) is a rare example. Also illustrated is Pantaine's mark which consists of the letters SP in an incuse punch.

Plate 47 Freedom box, silver, Robert Goble, Cork *circa* 1716, diameter 8.1 cm.

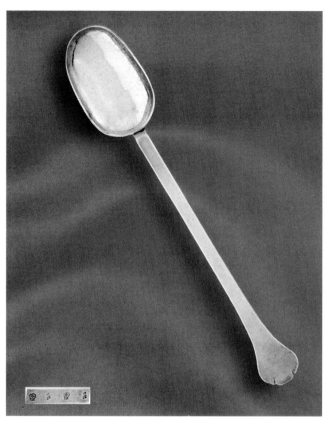

Plate 48 Trefid handled basting spoon, silver, Samuel Pantaine, Cork *circa* 1690, length 34.5 cm.

© Private Collection.

It is notoriously difficult to trace detailed genealogies in Ireland where a turbulent history has seen the survival of few records. The registers of the Huguenot church in Cork apparently perished in a flood in Cork in 1796.[15] The civil records of the city of Cork were destroyed in a fire at the Cork courthouse in 1891, and the Irish Public Records Office in the Custom House, Dublin, was burned in 1921 during the War of Independence.

Fortunately, some Cork records survive in the form of transcriptions of the originals which were made by Victorian scholars and antiquarians such as Caulfield and Day. These are an invaluable resource for present-day historians. A prime example is the *Council Book of the Corporation of the City of Cork*, edited by Caulfield and published in 1876. It is unfortunate that this does not cover the period 1643 to 1690 which would be of most interest in the quest for knowledge of the Huguenots of Cork. It is hoped additional records may turn up, but the unfortunate truth is that we will almost certainly never know the full story of the Huguenot colony of Cork. The best sources for the history of the Huguenot colony in Cork are the 1936 work by Grace Lawless Lee, *The Huguenot Settlements in Ireland,* and Alicia St. Leger's 1991 work *Silver Sails and Silk-Huguenots in Cork 1685–1850.* A number of references to Huguenot goldsmiths in Cork are made in Joan Evans' paper, 'Huguenot Goldsmiths in England and Ireland'.[16]

Huguenot refugees were welcomed by the government because of their religious beliefs, and the presumption of their loyalty on that account. The incumbent trades-people however were less enamoured of the new arrivals. This was primarily on the grounds of increased competition in what was a small and local

market. One of the arriving Huguenot goldsmiths Anthony Semirot was recorded in the 'Freeman's Register' in 1693 as being a 'French refugee' and 'was admitted and sworn a member of ye society of Goldsmyths of Corke by Wm. Hovell Esq., mayor of sd. Cittie, for ye sum of 20s. according to ye Act. Ye master of sd. Society first refusing ye same'. Notwithstanding this rather inauspicious start to his career in Cork, Semirot rose through the ranks of the society becoming warden in 1710 and master in 1712. He died in 1743. Semirot's surviving work is extremely scarce. The beautiful coffee pot (Plate 49) is one of the most impressive examples of his work which is extant. It is also perhaps the earliest Cork coffee pot which survives.

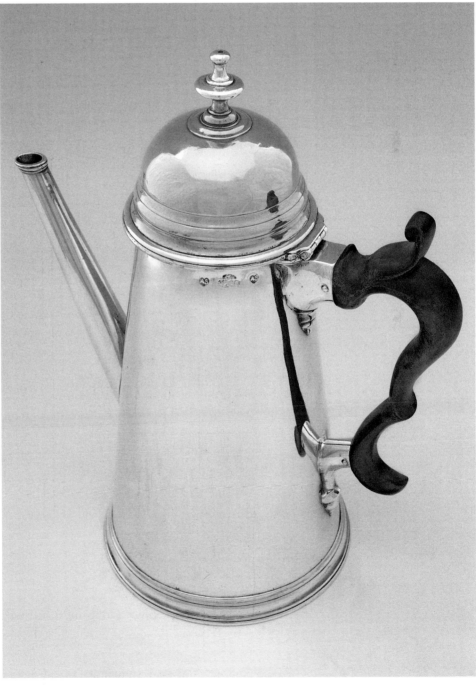

Plate 49 Coffee pot, silver, Anthony Semirot, Cork *circa* 1710, height 26.5 cm.

The concerns about competition from the newly-arrived settlers were aired in the council of the Corporation of Cork in the same year, 1693, as 'foreigners . . . taking away the livelyhood of His Majesty's faithful and loving subjects'.[17] Clearly this was a matter of keen interest at the time but it must be remembered that the council was comprised largely of Freemen of the various guilds and Societies, complete with vested interests!

Another arrival, in 1699, was Adam Billon. The *Council Book of the Corporation of the City of Cork* records the following under the date 12 July 1699: 'Put to the vote, whether the undernamed persons recommended by the Bishop of Corke (being French Refugees), shall be admitted free gratis or not: And. Dupond, Jo. DelaCroix, Matt. Ardowin, Jun., Peter Guillot, Peter Guillot Jun., Adam Billon, Jo. Billon. Ordered, that in consideration that the above persons are all such as have fled their country on account of the Protestant religion, be admitted free of this Corporation gratis, only paying the Town Clerk's fees.'[18] Adam Billon was an accomplished goldsmith judging by the evidence of his surviving pieces. Two tankards discussed below attest to his capability.

Another Huguenot goldsmith of Cork arrived through a different route. He was James (or Jacques) Foucault who was first noted in Cork in 1714. Foucault was apparently the son of a Dublin surgeon Peter (Pierre?) Foucault. He was apprenticed to the Dublin goldsmiths' trade in 1700, choosing later to relocate to Cork, for reasons which are not clear. One possible explanation might be that his wife was either a Cork woman, or had strong Cork connections. In any case Foucault practised his craft in Cork where he was one of the principal suppliers of freedom boxes to the Corporation. He was also a diligent member of the same Corporation as the records of the Council confirm. He died sometime about 1729, as the *Council Book* records that his widow was paid for a number of freedom boxes supplied.[19] I am not aware of the existence of any examples with his maker's mark, or of any surviving pieces wrought by him.

Many of the Huguenot immigrants to Cork became involved as merchants in the trade of staples. In the case of some of these merchants, their sons became apprenticed to goldsmiths. Thus we see a number of Huguenot names appearing as goldsmiths in the second or third generations. This attests to the fact that the craft of the goldsmith was held in high esteem by contemporary Cork society, and as such was an appropriate calling for a prosperous merchant's son. William Teulon is a good example of this. His father may have been John Teulon, one of two distillers of the same name. Teulon was noted as a goldsmith in 1784 and the family connection with the trade was maintained in subsequent times. S. & E.C.A. Teulon were listed as a firm of goldsmiths in directories in the 19th century. Lunham[20] notes that two brothers of Nismes, in the south of France, Pierre and Antoine Tholon or Teulon fled from Nismes to Greenwich. Pierre Teulon remained in Greenwich whilst Antoine moved to Cork, where he probably arrived in 1708. From him descended the Teulons of Cork, who included Captain Charles Teulon of the 28th Regiment who fought at Waterloo. At the time of writing (1918) Lunham noted that some descendants of Antoine Teulon were still resident in the Cork area.

The first documented evidence for William Teulon, goldsmith, is his marriage to Honora Heyland in 1791. He was last noted as 'living' in 1844. The

work of William Teulon is primarily executed in styles typical of Cork silver of the time. The lines of the pair of bright-cut Celtic point spoons by him are typical of Cork-made items of the turn of the 19th century and are very similar to the pair by Carden Terry (Plate 50). William Teulon was a mainstream goldsmith of the early 19th century whose work showed no real evidence of his Huguenot ancestry. Teulon's maker's mark consists of an incuse WT with a tiny star.

John Toleken may have been a late vocation to the trade. He was noted as a 'foreign merchant' upon his naturalization in 1768. By 1795 he was a practising goldsmith and he retired in 1836 when his business passed to his son, James. It seems more likely that the John Toleken, goldsmith, who registered in Dublin in 1798 was the son of John Toleken of Cork. Toleken was obviously well regarded by his peers and was a signatory to the petition in 1807 for the establishment of an assay office in Cork. He was a competent goldsmith and the teapot illustrated (Plate 51), dating to about 1815, is quite unusual in its design and unlike the contemporary work of Cork goldsmiths. For the most part Toleken's work is typical of contemporary early 19th century work, as in the case of William Teulon, without showing any evidence of his Huguenot ancestry. Whether the teapot illustrated may be said to be Huguenot-influenced in any way, is open to doubt.

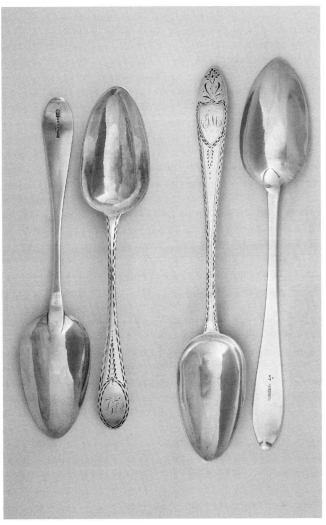

Plate 50 A pair of bright-cut Celtic-point serving spoons, silver, William Teulon, Cork *circa* 1790 (right) and a similar pair by Carden Terry, Cork *circa* 1790 (left) length 26, 22.5 cm.

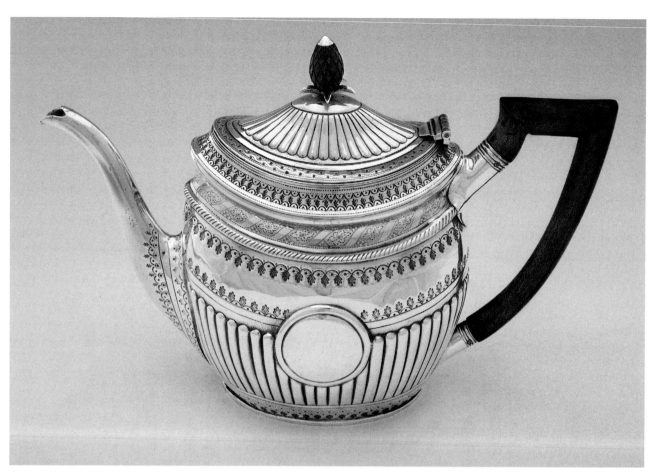

Plate 51 Teapot, silver, John Toleken, Cork *circa* 1815, height 20.5 cm.

Huguenot goldsmiths in Cork County

As well as the city of Cork, the town of Youghal in the county of Cork had local goldsmiths. Youghal was a significant location for the settlement of Huguenot veterans of the Williamite wars. Edward Gillett, goldsmith, was apparently of Huguenot stock and was first noted in 1705 when he obtained his freedom. He served on the council from 1712 and was mayor in 1721. He was still living in 1740. His son, John, pursued the craft and was mentioned in 1749. The town of Kinsale was less significant as a Huguenot community and no Huguenot goldsmiths are recorded there. There were other Huguenot settlements in the county, notably the colony of silk-workers at Innishannon, but similarly, no record exists of goldsmiths amongst their number.

Other Huguenot goldsmiths of Ireland

Whilst this essay deals with the Huguenot goldsmiths of Cork city and county, it seems appropriate to point out that the main concentration of Huguenot immigrants to Ireland was found in the capital, Dublin. These numbered many goldsmiths[21], including Isaac d'Olier, Jean Letablere, and a later arrival from England, James le Bas, whose descendant Ronald is the current Assay Master at the Company of Goldsmiths of Dublin. (See Appendix 7).

The legacy of Cork's Huguenot goldsmiths

The Huguenot goldsmiths arriving in Cork brought their own styles and techniques with them. In this context Bennett specifically identifies the harp-handle, the baluster shape and the specific skill of working with heavier gauge metal.[22] Another obvious skill was their facility at repoussé chasing. Notwithstanding these skills and techniques, on arrival in Cork, the immigrant Huguenot goldsmiths entered a market that was essentially local in character as well as being small in absolute terms.

As the provisions export trade from the port of Cork developed strongly in the early 1700s Huguenot mercantile and commercial success grew, capitalizing on the available opportunity. As their requirements for the trappings of wealth, including wrought plate, became manifest it may reasonably be inferred that a certain proportion of this demand from their co-religionists was met by the Huguenot goldsmiths of Cork.

Comparison of Huguenot-made items with other contemporary items by native goldsmiths illustrates the influence they brought and applied. Consider the tankard by Hercules Beere of Youghal, which dates to about 1670 (Plate 52). This is entirely plain, competently executed and with minimal decoration. It has a

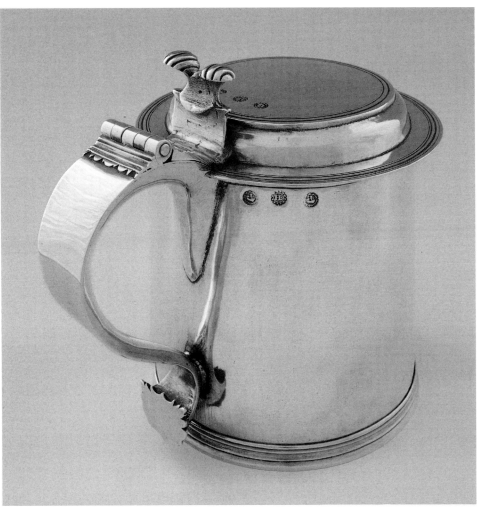

Plate 52 Tankard, silver, Hercules Beere, Youghal *circa* 1670, height 17.5 cm.

Plate 53 Tankard, silver, Adam Billon, Cork, *circa* 1710, height 20.5 cm.

Plate 54 Tankard, silver, Adam Billon, Cork *circa* 1710, height 21 cm.

moulded-edged flat top to its lid and its S-shaped handle is affixed directly to the body of the tankard. Now contrast this with the two examples by Adam Billon (Plates 53 & 54) which date to about 1710. These have wonderful chased and domed lids. They also have more elaborate handles, both in construction with the C and S shape, and in decoration with the beading and applied work carried down the front of the handle. Structurally they are reinforced by a band around their bodies and the handles are affixed to the body in each case using cut-card reinforcement, a refinement in technique associated with Huguenot goldsmiths.

The Kinsale example by Joseph & William Wall, which probably dates to about 1712 (Plate 55), shows how the Huguenot influence began to be felt amongst non-Huguenot makers. There is no evidence of Huguenot goldsmiths practising in Kinsale and yet evidence of their influence is seen in the beautiful foliate cut-card detail where the handle is affixed to the body of the tankard. Further stylistic evidence is in the beautifully decorated front to the handle very reminiscent of the work of Billon.

Looking next at the two tankards from the early 1720s, the first by William Clarke and the second by Thomas Lilly (Plate 56) we see the pattern of subtle Huguenot influence in the domed lids, in the use of cut-card reinforcement as well as in the decorated handles.

Having noted the fundamentally local character of the Cork market for the output of the goldsmiths, it is evident that the Huguenot arrivals as well as bringing their own styles and techniques had to adapt to local market demands from beyond their own co-religionists. The writer has noted two kitchen peppers both *circa* 1725, one by Adam Billon, a Huguenot, and the other by Caleb Rotheram. Apart from the slight difference in size, and in the detail of the piercing of the lids,

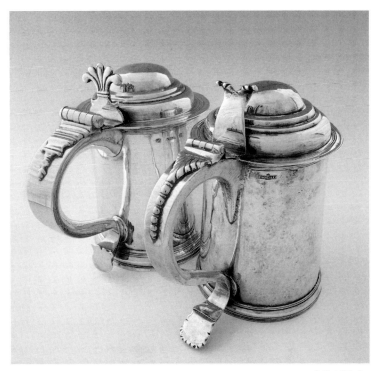

Plate 55 Tankard, silver, Joseph & William Wall, Kinsale *circa* 1710, height 16.6 cm.

Plate 56 Tankards, silver, William Clarke, Cork *circa* 1720, height 20.8 cm., and Thomas Lilly, Cork *circa* 1720, height 20 cm.

Plate 57 Pair of Hanoverian pattern serving spoons, silver, William Clarke, Cork *circa* 1720 (top), length 20 cm. and Anthony Semirot, Cork *circa* 1722 (bottom), length 19.7 cm.

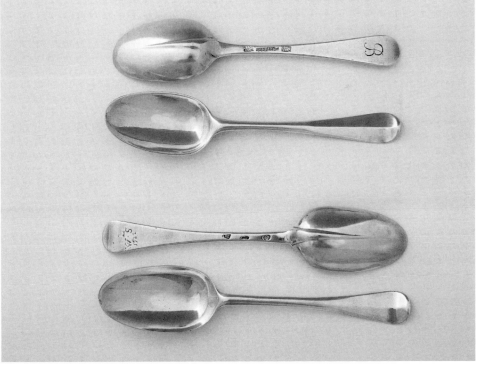

they are practically indistinguishable. The same is true of two pairs of Hanoverian pattern spoons dating from the 1720s by Anthony Semirot and by William Clarke (Plate 57).

The baluster shape and the skills in high-relief chasing introduced to Cork silver by the Huguenot goldsmith settlers is nowhere better manifest than in the

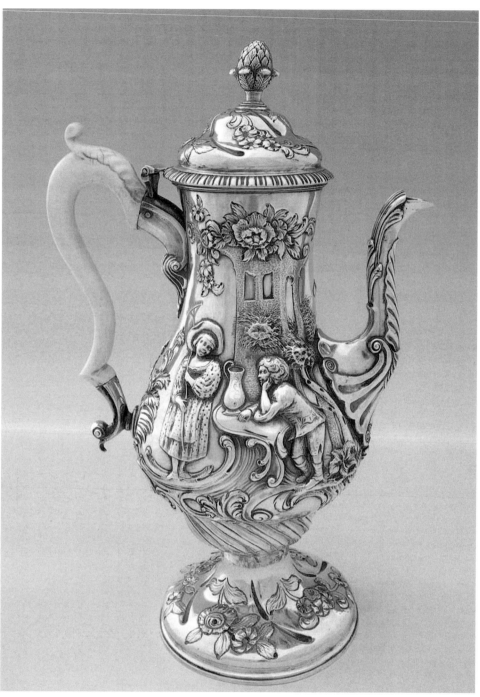

Plate 58 Coffee pot, silver, John
Nicholson, Cork *circa* 1775,
height 33 cm.

© Private Collection.

beautiful chased coffee pot by John Nicholson of Cork (Plate 58). This dates to
about 1775 and clearly shows significant influences of the goldsmith's Huguenot
predecessors.

Epilogue

What became of these Huguenot goldsmiths of Cork, and their descendants?
What is their legacy and how might we assess it? There was a general decline in
the prosperity of Cork with the ending of the Napoleonic Wars in 1815 which
eliminated the significant government contracts for provisions to feed large armies

in the field and fleets at sea. The resultant decline in the fortunes of the merchant classes coincided with the opening of the Irish market to British trade after the Act of Union of 1800. The artisan-based trade of the Cork and Irish goldsmiths was not really able to compete with industrial-scale production in Britain. British imports were available to purchase through the retail trade in Cork at prices significantly lower than those applying to locally produced items. The result was the rapid disappearance from Cork of the craft of the goldsmith. Indeed, by 1840 there were no practising silversmiths or goldsmiths in Cork.

The Huguenot goldsmiths of Cork city and county are now just a dim and distant memory. Their influence on the society in which they came to live has always been recognized and held in high esteem. The surviving examples of their work stand in eloquent testimony to the level of their skills. Their influence on Cork silver and gold of the Georgian period is quite significant. It is frustrating that so little documentary evidence survives regarding their lives and their assimilation into local society. However, it is hoped that this essay may prompt further research into the fascinating subject of Cork's Huguenot goldsmiths.

FURTHER READING

Douglas Bennett, *Collecting Irish Silver, 1637–1900*, London, 1984.

Douglas Bennett, *Irish Georgian Silver*, London, 1972.

John R. Bowen and Conor O'Brien, *Cork silver and gold: four centuries of craftsmanship*, Cork, 2005.

C. E. J. Caldicott, H. Gough, J.-P. Pittion, eds. *The Huguenots in Ireland: anatomy of an emigration*, Dún Laoghaire, 1987.

Richard Caulfield, ed., *Council Book of the Corporation of the City of Cork*, Guildford, 1876.

Cornelius Cremen, 'The silver oar', *Journal of the Cork Historical & Archaeogical Society*, XXIV (1918), pp. 6–8.

David Dickson, 'Huguenots in the Urban Economy of eighteenth century Dublin and Cork' in C. E. J. Caldicott, H. Gough and J.-P. Pittion, eds, *The Huguenots and Ireland, anatomy of an emigration*, Dún Laoghaire, 1987, pp. 31–32.

Joan Evans, 'Huguenot goldsmiths in England and Ireland' , *Proceedings of the Huguenot Society*, XIV, no. 4 (1933), repr. London 1933.

Richard Hayes, *Old Irish links with France: some echoes of exiled Ireland*, Dublin, 1940.

Raymond Hylton, *Ireland's Huguenots and their Refuge, 1662–1745: an unlikely haven*, Brighton & Portland, 2005

C. J. Jackson, *An illustrated history of English plate, ecclesiastical and secular*, 2 vols, London, 1911.

Charles J. Jackson, *English goldsmiths and their marks*, 2 vols, 2nd edn (1921).

Grace Lawless Lee, *The Huguenot settlements in Ireland*, London, 1936.

T. A. Lunham, 'Some notices of early French refugees in Cork', *Journal of the Cork Historical & Archaeological Society*, XXIV (1918), pp. 11–12.

Conor O'Brien, 'Some misidentified Munster goldsmiths', *Silver Society Journal*, 13 (2001), pp. 31–39.

Ian Pickford, ed. *Jackson's silver and gold marks of England, Scotland and Ireland*, 3rd rev. edn, Woodbridge, 1989.

Alicia St. Leger, *Silver, Sails and Silk – Huguenots in Cork, 1685–1850*, Cork 1991.

F. H. Tuckey, *The county and city of Cork remembrancer*, Cork, 1837.

C. A. Webster, *The church plate of the diocese of Cork, Cloyne and Ross*, Cork, 1909.

R. Wyse Jackson, *Irish Silver*, Cork, 1972.

M. S. D. Westropp, 'The Cork goldsmiths, silversmiths, jewellers, watchmakers and apprentices', *Journal of the Cork Historical & Archaeological Society*, vol. XXXI, 1926, pp. 8–13.

M. S. D. Westropp, 'The goldsmiths of Cork', *Journal of the Cork Historical & Archaeological Society*, vol. XII, 1906, pp. 37–43.

NOTES

1 This is one of the fundamental theses of Raymond Hylton's *Ireland's Huguenots and their Refuge, 1662–1745: an unlikely haven*, Brighton & Portland, 2005 (hereafter Hylton 2005).

2 Hylton 2005 (as note 1), p. 166, estimates their number at 300–400 settlers in total.

3 David Dickson 'Huguenots in the Urban Economy of eighteenth century Dublin and Cork' in C. E. J. Caldicott, H. Gough and J.-P. Pittion, eds, *The Huguenots and Ireland*, Dún Laoghaire, 1987, p. 323, makes this point specifically in relation to the Huguenot goldsmiths of Dublin, but undoubtedly the same would have applied in Cork.

4 Hylton 2005 (as note 1) quoting Dickson (as note 3), p. 165.

5 Register of Freemen of Cork 16 May 1656 to 2 December 1741.

6 Cornelius Cremen 'The silver oar', *Jour. Cork Hist. & Arch. Soc.*, vol. XXIV, 1918, quotes Robert Day as the authority for the assertion that Goble is a Huguenot name, and that Robert Goble is interred in the Huguenot burial place in Cork.

7 Grace Lawless Lee, *The Huguenot settlements in Ireland*, London, 1936, p. 78.

8 In a conversation with the writer.

9 Lee 1936 (as note 7), p. 26.

10 Lee 1936 (as note 7), p. 49.

11 Lee 1936 (as note 7), pp. 48–9.

12 Charles J. Jackson *English goldsmiths and their marks*, 2nd edn, 1921, pp. 682–5.

13 Richard Caulfield, ed., *Council Book of the Corporation of the City of Cork*, Guildford, 1876, p. 236.

14 Bowen and O'Brien 2005, p. 165.

15 Hylton 2005 (as note 1), p. 166.

16 *Proceedings of the Huguenot Society*, vol. XIV, no. 4 1933; repr. London, 1933.

17 Lee 1936 (as note 7), p. 31.

18 Caulfield, 1876 (as note 13), p. 274.

19 Caulfield 1876 (as note 13), p. 485: '*9 July 1729 That £8 6s. be paid the Widow Foucault for seven silver boxes given with freedoms,* . . .'.

20 T. A. Lunham 'Some notices of early French refugees in Cork', *Jour. Cork Hist. & Arch. Soc.*, vol. XXIV, 1918, pp. 11–12.

20 Dickson 1987 (as note 3) notes some 78 Huguenot goldsmiths in Dublin in the period 1720–80.

22 Douglas Bennett, *Collecting Irish Silver, 1637–1900*, London, 1984, p. 24.

International influences on Paul de Lamerie

Tessa Murdoch

Paul de Lamerie's European origins

Paul de Lamerie's European origins are well known. This famous goldsmith was the son of Paul Souchay de la Marie, a French protestant officer in the army of Dutch William of Orange. De Lamerie's mother, Constance le Roux, was also a French protestant. Born in s'Hertogenbosch (Bois le Duc), Holland on 9 April 1688 and baptized at the Walloon church there on the 14th April, his godparents Jaques Bourse and Marguerite Vignon were established members of the Huguenot communities in The Hague and Amsterdam respectively.

The goldsmith's mother's family came originally from Rouen. Her ancestor Jean Le Roux emigrated to Amsterdam in 1619 but a relative of the same name was still living in Rouen sixty-six years later at the time of the 1685 Revocation of the Edict of Nantes, which forced French protestants to abjure their faith if they remained in France. Both Paul de Lamerie's godparents were related to his mother's family. Marguerite Vignon may have been connected with the goldsmith Jean du Vignon who contributed in 1711 to the silver Communion set made for use in the English Church at The Hague, now shown in the Sacred Silver Galleries at the Victoria and Albert Museum.[1]

Paul de Lamerie's father was one of many French military officers who fled to Holland, where they enrolled in the regiments of the Dutch army, and were maintained by the revenues of William of Orange. Those who accompanied William to England in 1688, formed four regiments for service in Ireland. The de Lamerie family followed William to England but the goldsmith's father did not elect for service in Ireland. Recorded in the Poor Rate records for 1691 in Berwick Street, Soho, he later received an army pension. The goldsmith's uncle, Jean Souchay de Lamerie, who witnessed his baptism, also came to England and received a pension from William III in 1698. He had settled in Dublin by 1699 and received a further pension there in 1715. He is recorded as a member of the French church in Dublin in 1702–3.[2]

Paul de Lamerie's apprenticeship and training

The young Paul de Lameric grew up in the heart of the Huguenot community in London's Soho but with family contacts in Holland and Ireland. By 1703 he was ready for apprenticeship to Pierre Platel, goldsmith, a mature and respected member of that community. The indenture describes the goldsmith's father as a

gentleman. Like de Lamerie's parents, Pierre Platel came to England in the train of William of Orange with his elder brother Claude and took out denization in May 1697. The Platel family came via Lille but Pierre was born in France in 1664, near Bar le Duc, Lorraine.[3] As he trained in France as a goldsmith, Platel became free of the Worshipful Company of Goldsmiths in London by redemption in 1699 when he entered his mark as a large worker. Incorporating the first two initials of his family name crowned with a mullet and with a fleur-de-lys below, the mark demonstrates his French origins. In 1699 Platel's premises were on the North side of Pall Mall where from 1700 he lived with his wife Elizabeth. Paul de Lamerie joined them at that address in August 1703 by which time the Platels already had two children.

Platel's location adjacent to the court of St. James and in close proximity to other luxury tradesmen, including the leading court upholsterer, the French Catholic, Francis La Pierre, helped to ensure that he attracted patronage of the highest order. In 1700 Platel supplied a silver-gilt toilet service for King William's Dutch favourite Hans Bentinck, 1st Earl of Portland to mark his second marriage that year to Jane Temple. In 1701 Platel supplied a gold helmet-shaped ewer and basin for the 1st Duke of Devonshire; the fine engraving on the basin is attributed to Blaise Gentot, who also engraved a silver table top for the same patron. The silver pilgrim bottle made for General Charles Churchill, brother of John Churchill, 1st Duke of Marlborough, in about 1710 was probably produced by Platel while de Lamerie was still serving with him (Plate 59). In addition to supplying the Royal Jewel House, Platel's clients included John Hervey, 1st Earl of Bristol for whose daughter Platel supplied a Royal Christening gift for the Jewel House in 1708. In 1709 Lord Bristol still refers to Platel in his accounts as the 'French' silversmith.[4]

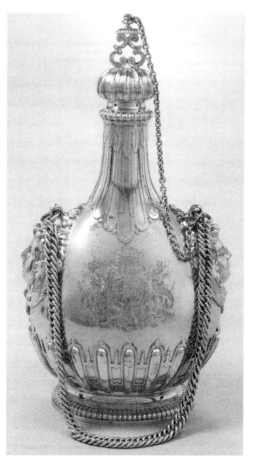

Plate 59 Pilgrim Bottle, silver, Pierre Platel, London *circa* 1710, height 41 cm.

M.854&2-1927. © Victoria and Albert Museum.

Paul de Lamerie stayed with Platel until 1713 when he was made free of the Goldsmiths' Company on the 4th February and entered his first mark on the following day. He worked initially from Windmill Street, near the Haymarket. His appointment as Goldsmith to the King in 1716 continued his master's official association with the Jewel House. De Lamerie's finest early works include a pair of silver-gilt sconces now in the Gilbert Collection, London (Plate XII), which were

made in about 1713 to 1715 possibly for royal use.[5] They demonstrate awareness of the sophisticated repertoire of ornament published as prints by French designers Jean Berain in Paris and Berain's former pupil Daniel Marot in The Hague and Amsterdam and have been described as the most important work supplied by de Lamerie early in his career as an independent goldsmith. The wine fountain that de Lamerie supplied in 1719, in the collection of the Harpur Crewe family at Calke Abbey, Derbyshire also demonstrates de Lamerie's familiarity with engraved ornament by Daniel Marot, published in 1703 and 1712 in Holland (Plate 12).[6]

During the 1720s de Lamerie consolidated his English roots by forming a business partnership with Ellis Gamble, a specialist silver engraver, who worked at the sign of the Golden Angel in Cranbourn Street, off Leicester Fields and is best remembered today for the young apprentice he took on in 1714 – William Hogarth (1697–1764). The engraving of Ellis Gamble's trade card is attributed to Hogarth. De Lamerie's marked silver often bears engraved decoration of high quality. De Lamerie and Gamble took out a joint policy with the Sun Insurance Company for £1000 'for their Goods and Merchandise in their now Dwelling house' in Cranbourn Street in 1723. This was probably to cover de Lamerie's stock whilst it was being engraved on Gamble 's premises for by 1726 Lamerie had a separate policy for £500 worth of household goods and stock in trade on his own premises in Windmill Street. By 1728 their relationship may have terminated as they both took out separate policies at their individual addresses. In that year the Exchequer Seal Salver supplied by de Lamerie for the Prime Minister Sir Robert Walpole was elaborately engraved with a central vignette by Hogarth (Plate 60).

Plate 60 Engraving of the Exchequer Seal of George I by William Hogarth, for Robert Walpole's salver, Paul de Lamerie, London 1727/8, width of salver 48 × 48.5 cm.

Paul de Lamerie's personal bookplate in a similar style was previously attributed to Hogarth (Frontispiece); it incorporates representations of Autumn and Winter probably based on sculptures of the Four Seasons by Legros, made between 1707 and 1711 for the Bavarian Elector Max Emmanuel and possibly shown in the gardens of his French residence at St. Cloud from 1714.[7]

The design of Ellis Gamble's trade card, the engraving on the Walpole Salver and de Lamerie's book plate are significant as they incorporate the human figure. The young Paul de Lamerie would have been aware during his apprenticeship of the opportunity to draw from the living model presented by the private academy which met in the evenings at Sir Godfrey Kneller's home in Great Queen Street, Covent Garden – a fashionable German portrait painter. By 1720 the Huguenot painter Louis Chèron had founded another academy in St. Martin's Lane with the artist John Vanderbank which provided the novel opportunity to draw from the female as well as the male model. It is probable that the 'Alex Gamble' who the engraver George Vertue records as attending Chèron's academy can be identified with Hogarth's master and de Lamerie's partner Ellis Gamble.[8] George Vertue, who is a fount of information on artists and craftsmen in London at this period, was himself apprenticed to a specialist engraver of silver who had the top reputation of any in town. As Chèron had trained at the French Academy of Painting and Sculpture in both Paris and Rome, those who attended the evening life classes which he directed were able to benefit from the continental tradition of art education. Such skills encouraged the use of figurative ornament both in engraving on silver and in relief and three dimensional form. The use of figurative ornament was already associated with continental silver. It is found in the decorative ornament on the handles of helmet-shaped ewers by French makers both in France and in London, and in engraved ornament on silver by the Huguenot Simon Gribelin and the Londoner Joseph Sympson who also attended Chèron's academy. But the early art academies in London encouraged a greater awareness of the importance of the study of the human figure in developing artistic talent and raising the profile of artistic production and helped to raise the quality of ornament on decorative as well as fine art – at life classes seal engravers, sculptors and surgeons, rubbed shoulders with painters.[9]

Sources of European ornament

The designs produced for engraving on silver also drew on a wealth of engraved ornament then available locally from the print shops in Great Newport Street off St. Martin's Lane and from the book shops in the Strand. Many of these were run by fellow Huguenots. One shop in Newport Street run by the Regnier family (Plate 61) in 1750 was already established in Long Acre by 1712 when Von Uffenbach, a German visitor to London, recorded visiting the house of one of the most elegant and best seal engravers in England by that name. By 1730, James Regnier, at the same address, sold 'all sorts of PRINTS, Italian, French, Dutch and others and all sorts of Ornaments, Statues, Vazes, Fountains, Gardens, Buildings, Landscapes, Prospects, Sea Pieces, Beasts, Birds, and COLOURED PRINTS for Japan Work'.[10] Another, belonging to William De La Cour, Drawing Master, in

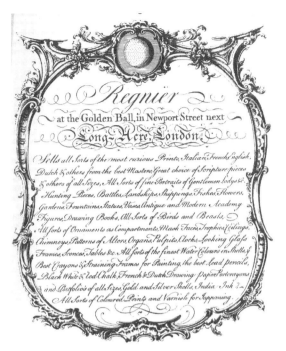

© Department of Prints and Drawings, British Museum.

Plate 61 Trade card of Regnier, *circa* 1750.

Plate 62 Trade card of William de la Cour, *circa* 1740.

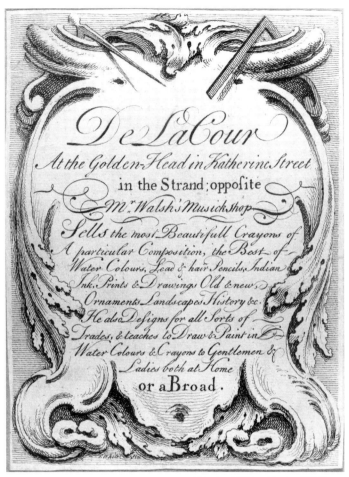

© Department of Prints and Drawings, British Museum.

the Strand opposite Mr Walsh's Music Shop (Plate 62), as well as selling artists' materials, also sold 'Prints & Drawings Old and New', and 'Ornaments'. His trade card noted that 'He also Designs for all Sorts of Trades'. William de la Cour is thus a possible candidate as designer of the group of silver attributed to the Maynard Master. During the 1740s he published eight books of rococo ornaments some of which he engraved himself – others were engraved by Jacob Bonneau and François Vivares. Engraved ornament circulated widely and was acquired by sculptors and other craftsmen working in the applied arts. The Flemish sculptor Michael Rysbrack subscribed in 1736 to the London-based Italian Gaetano Brunetti's 'Sixty Different Sorts of Ornaments'[11] which was delivered in 1737, but there is evidence that an earlier edition was published in London in 1731. Paul Crespin drew on Brunetti's ornaments for the wine cooler for the Duke of Marlborough, 1733–4, as did the remarkable ewer and basin supplied by George Wickes in 1735–6 for presentation by the Common Council of the Corporation of Bristol to the City's Recorder John Scrope, and also a covered jug marked in Dublin in 1737 now in the Ashmolean Museum, Oxford.[12] As the established Huguenot cartographer Jean Rocque was one of the engravers of Brunetti's suite, the publication would have been sold through contacts in the book and print trade in Dublin.[13]

The role of the designer

A leading designer to goldsmiths working in the rococo style was Gravelot – his full name Hubert-François Bourguignon (1699–1773) – who travelled to London in 1732 or 1733 having trained in Paris in François Boucher's studio. He was invited by the French engraver Claude Du Bosc, already established in London, who was publishing an English translation of Bernard Picart's *Ceremonies et coutumes religieuses de tous les peuples et de tous les temps*, 1733–1739. Gravelot's skill as a draughtsman was soon recognized by the goldsmiths who commissioned him to produce designs for them. The engraver George Vertue commented in 1741, 'he practises etching . . . in which he has done many curious plates from his own desseins masterly and free and de bon gout'. His sheet of etched studies including the design for an etui in the V&A[14] demonstrates that he was certainly designing for smaller scale goldsmiths' work. Another design for a border, in the Cooper Hewitt Museum, New York (Plate 63) dated 1739, although intended for a print, demonstrates Gravelot's ability to combine sophisticated figurative drawing symbolizing complex allegorical narratives with sinewy strapwork giving the design a depth which indicates Gravelot's ability to design for realization in three dimensions. On the right Britannia conquers Envy, Superstition and Spain and on the left Hypocrisy, Ignorance and Popery fall before the true Protestant Religion. The design was intended for the General Chart which formed the frontispiece to the engraved representation of the 17th century tapestry hangings then in the House of Lords which illustrated the English defeat of the Spanish Armada in

Plate 63 Hubert François Gravelot, (French 1699–1773). Design for an Ornamental Border, used for the Surround to the General Chart engraved in John Pine's Tapestry Hangings in the House of Lords, 1739. Brush and brown and grey ink, and wash on off-white laid paper, 37.5 × 60.9 cm.

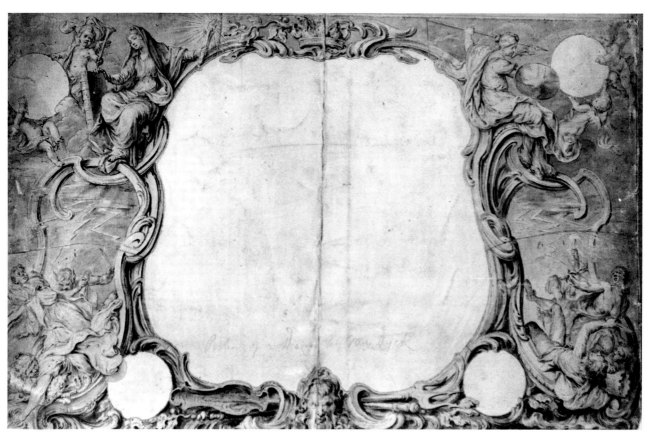

1588, published by John Pine in 1739. The band-like strapwork is similar to that around Hogarth's paintings on the staircase to the hall of St Bartholomew's Hospital. Such strapwork is characteristic of the unmarked ewer and basin, currently on loan to the V&A (Plate 64), which bears the arms of Sir Stephen Fox. These pieces are thought to have been made in 1740–1 just before Stephen Fox was created Lord Ilchester. He had married in 1735/6 Elizabeth Strangways, who was only thirteen at the time. So they may have been commissioned as a belated wedding present. The pieces have been attributed to de Lamerie's workshop by comparison with the Maynard dish, the most spectacular piece in the Cahn collection, which is marked by Paul de Lamerie, dated 1736–7 (publicly exhibited with the Cahn Collection for the first time) in the knowledge that de Lamerie had supplied church plate for Fox's wife's family from 1736.[15] The elaborate allegorical figurative decoration on the dish frames a seascape with border features symbolizing the Four Elements, of which Fire is most dramatically rendered by the alighting eagle who represents Jupiter – his thunderbolts piercing the clouds. Such watery imagery, the ewer is encircled by bullrushes and encrusted with shells, was appropriate for silver traditionally associated with washing of hands and which was probably intended for use as part of Lady Fox's toilet service.

Gravelot taught drawing at the St. Martin's Lane Academy in the 1730s alongside William Hogarth and the French sculptor Louis François Roubiliac. He also set up his own drawing school in Covent Garden where his pupils included the young Thomas Gainsborough and the second generation Huguenot engraver

Plate 64 The Ilchester Ewer and Basin, silver-gilt, *circa* 1740, unmarked, height of ewer 24.2 cm., width of basin 42.5 cm.

Charles Grignion. The frontispiece to 'Views of Adjacent Villages in the County of Middlesex' engraved after Gravelot's design by his pupil Charles Grignion demonstrates how well his designs were rendered by others.[16] Gravelot's role as a designer of silver needs re-assessing.

De Lamerie and Paul Crespin: A Huguenot business association

In 1727/8, de Lamerie traded with the distinguished Huguenot goldsmith Paul Crespin, whose portrait (on the cover), showing him with an earlier silver vase after the designs of Enea Vico, demonstrates that he was probably dealing in and copying earlier silver as well as making to commission. The evidence for this partnership lies in the remarkable pair of wine coolers (Plate 65) which bear Paul de Lamerie's mark overstruck by that of Paul Crespin and are dated 1727. These were made for Philip Stanhope, 4th Earl of Chesterfield, for use at his embassy in The Hague, but are based on an earlier model supplied by Paul de Lamerie for Thomas Howard, 8th Duke of Norfolk; the pair are still at Arundel Castle. At the same time Crespin copied a pair of candlesticks by Lille goldsmith Elie Pacot which had originally been made for John Churchill, 1st Duke of Marlborough, but found their way to the Jewel House and were also issued to Lord Chesterfield in 1727 for use in his embassy at The Hague.[17]

Crespin had established a reputation in the early 1720s for meticulous craftsmanship as exemplified in his cruet set at Colonial Williamsburg and for working on a large scale. In 1724 Paul Crespin was associated with 'a curious Silver Vessel for bathing, which weigh'd about 6030 ounces' which was assayed at Goldsmiths' Hall in July. It was then transported to Kensington Palace where it was viewed by King George I 'who was well pleased with so curious a Piece of Workmanship,

Plate 65 Chesterfield Wine Cooler, Paul de Lamerie overstruck by Paul Crespin, London 1727–1728, 26.5 cm.

M.1-1990. © Victoria and Albert Museum, London.

which can scarcely be match'd in all Europe'. This bath is described in some detail by a contemporary as supported on three dolphins, their tails curling up around the outside surface, while inside three mermaids' bodies followed the curve of the tub. The two sides were decorated with appropriate scenes of Diana bathing and Perseus and Andromeda. It was intended for the King of Portugal and the commission was probably obtained for Paul Crespin through his younger brother who was royal goldsmith at Lisbon. Tragically the silver bath was destroyed in the Lisbon earthquake in 1755.[18] Little is known about Paul Crespin's training as a silversmith — he was apprenticed to the little known Huguenot Jean Pons — but he evidently took to heart the challenge to raise the status of goldsmiths' work to that of sculpture, demonstrating his ability to model elaborate mythological figurative subject matter in relief in precious metal. The publicity campaign which accompanied this achievement is characteristic of the artistic climate in London in the 1720s and 1730s where artists and craftsmen took on the role of marketing and publicity with as much tenacity as major museums today.

High Style Silver

The famous episode of the Jernegan wine cistern, so comprehensively told by Peter Cameron in 1998, should be summarized here.[19] The first sketch for a wine cistern was provided by the London born artist and engraver George Vertue at the behest of the Catholic retailer-goldsmith Henry Jernegan. The piece was to be made by German immigrant goldsmith Charles Kandler for Jernegan's English client Littleton Pointz Meynell. Meynell wanted 'the largest and finest Silver Cistern that ever was or could be made'. Jernegan responded by commissioning 'several curious Draftsmen and consulted with them and others in Order to procure Drafts of proper Subjects to adorn so magnificent a piece of Plate'. He then applied to 'one of the best statuaries (the Flemish sculptor John Michael Rysbrack) to make a model in clay and wax. The note in Vertue's hand, which accompanies his design given to the London Society of Antiquaries in 1740, states that Rysbrack was responsible for modelling the male and female figured handles as well as the reliefs. For production Jernegan ordered 4000 ounces of silver (2000 less than Crespin's silver bath). The making entailed 'very great Expence in procuring proper Moulds for casting the many and various figures with which the said Cistern was to be ordered'. Furthermore, Jernegan was obliged to send it to 'the Copper Mill the Silversmiths Hamers not having weight sufficient to make any Impression on it'. Jernegan claimed to have used 1,200 ounces of silver in the process and that the production took four years to complete, employing twenty workmen on a weekly basis. When Meynell refused to take delivery and pay for the cistern, Jernegan attempted to market the cistern to foreign royalty and in 1735 commissioned an engraving from G. Scotin after Gravelot at a cost of five hundred pounds. In the lettering for the engraving Jernegan took the credit for the 'invention' of the cistern (Plate 66). In 1736 Jernegan lobbied Parliament for recompense on the grounds that his cistern 'manifested that the Sculptors and Artificers of Great Britain are not inferior to those of other Nations'. The cistern was eventually disposed of by lottery and the silver medal issued to the winners

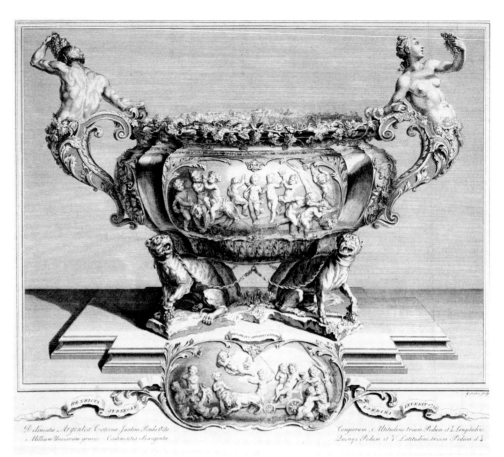

Plate 66 The Jernegan Cistern, engraving by G. Scotin after Gravelot, 1735, 46.8 × 54 cm.

dated 1736 was based on a design by Gravelot (the original is in the Yale Center for British Art) and struck at the Royal Mint. It shows the Queen – Caroline of Ansbach, known for her interest in the arts but who was to die the following year – watering a grove of palm trees and bears the legend 'Growing Arts Restored' and 'Caroline Protecting'.[20]

Kandler apparently supplied Meynell with other silver including the tea kettle and stand, *circa* 1730 (Plate 67), on display in the British Galleries at the V&A and the pair of tureens in the Cahn Collection. The latter, made about 1730, incorporate as ornamental handles the horse head, the crest of the Meynell family. A comparison of a study of a horse's head by John Michael Rysbrack in the National Gallery of Victoria, Melbourne, Australia (Plate 68), suggests that Rysbrack may have provided the models for tureen handles. Rysbrack's Melbourne drawing dates from the early 1730s when he was modelling an equestrian statue of William III for the City of Bristol which was put up by public subscription in 1736.[21] The Jernegan wine cistern demonstrated that designers, sculptors and goldsmiths were working closely together on important commissions in London. The tabernacle designed by James Gibbs for the chapel of the 8th Duke of Norfolk at Arundel Castle was made in ormolu by Charles Kandler in London in 1730. It is plausible that Rysbrack again provided the model for the figure of the Crucified Christ. Kandler can probably be identified as the older brother of Johann Joachim Kandler, the leading modeller at the Meissen porcelain factory, where, as a recent conference in Dresden has demonstrated, the links

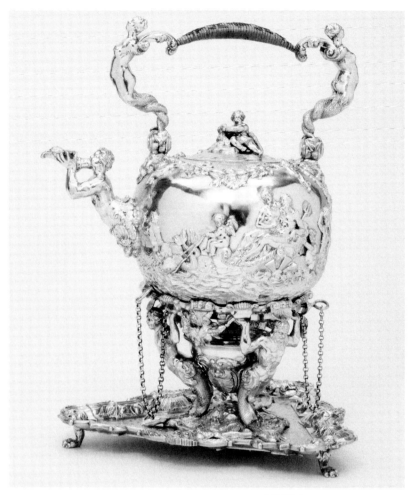

Plate 67 Tea Kettle and Stand, London, Charles Kandler, *circa* 1730, height 33.6 cm.

M.49-1939. © Victoria and Albert Museum, London.

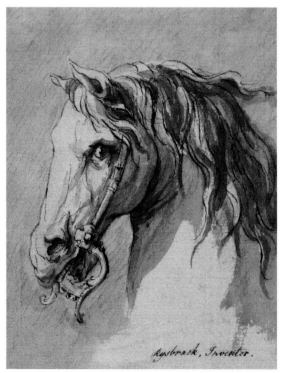

Plate 68 Study for the horse's head of the bronze equestrian statue of William III, 1735, chalk, pen, ink and wash. John Michael Rysbrack, Belgian born 1694, arrived England 1720, died 1770, 16.7 × 12.1 cm (sheet).

Inv. © National Gallery of Victoria, Melbourne; Felton Bequest, 1977

between sculpture and porcelain were strong. Meissen porcelain forms provided inspiration for silver and Paul de Lamerie's escallop shell bread basket of 1747–8 in the Ashmolean recalls a Meissen escallop-shaped dish which was decorated by Höroldt in 1728. Meissen porcelain was certainly reaching London by the 1730s.

Rysbrack evidently continued to model for silversmiths. In August 1743 a London newspaper described a musical clock, 'The Temple of the Four Grand Monarchies of the World', one of several such elaborate productions. Another cutting from the same year advertises 'The Temple and Oracle of Apollo', constructed of silver-gilt and rock crystal, and embellished with 'a great Number of solid Silver Figures both within and without, most of which are gilt'. The Temple of the Four Grand Monarchies boasted a clock movement by Charles Clay and was finished by George Pyke; the sides were decorated with painted 'Avenues' by the Venetian artist Jacopo Amigoni with subjects relating to each monarchy and with at the entrance to each avenue reliefs cast in silver representing the 'Genii of the Arts and Sciences' from models supplied by Rysbrack representing 'Painting, Sculpture, Geometry, Musick, Architecture, Arithmetick and Astronomy' (Plate 69). 'These are reposing on a Piece of Architecture in Basso Relievo, made of Brass, in true Perspective: by the Obelisks of which stand eight Deities in Silver, in their respective Attitudes, as having some Allusion to the Subjects of each Piece of Painting. These represent some remarkable Passage in the Lives of the before-mention'd famous Founders of these memorable Monarchies'; the music played included pieces by Handel, Corelli and Geminiani. The illustrated detail shows the foreground of the avenue illustrating Augustus Caesar giving Peace to Rome flanked by silver deities modelled by Rysbrack in relief representing Apollo and Diana, with the genii seated in front. The plinth supported bronzes by the French sculptor Roubiliac of the four great monarchies of antiquity as mentioned in the

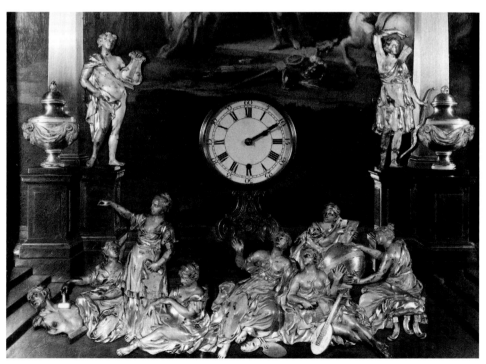

Plate 69 Silver relief after models by John Michael Rysbrack on the Temple of the Four Grand Monarchies, music clock by Charles Clay at Kensington Palace, *circa* 1743.

book of Daniel: Chaldaea, Persia, Macedonia and Rome and the clock was surmounted by 'a Group of Figures in Bronze representing Hercules taking the celestial Globe off the Shoulders of Atlas'. The cost exceeded £4,500. Once again Gravelot was given the task of producing a drawing from which an engraved representation of the clock on its original plinth was made by his pupil Charles Grignion as a means of finding a buyer. The clock was eventually acquired by Augusta, Princess of Wales.[22] Gravelot had attempted to nurture her patronage of the arts when he designed a medallion representing Frederick & Augusta Prince & Princess of Wales which is also in the Yale Center for British Art.[23]

Paul de Lamerie and Nicholas Sprimont

Paul de Lamerie's links with Paul Crespin in the 1720s have been noted. Crespin in turn is closely associated with the goldsmith Nicholas Sprimont (1715–1771) with whom he combined to produce the celebrated marine service for Frederick, Prince of Wales. The Neptune centrepiece bears marks of Paul Crespin and as recently demonstrated by Chris Garibaldi and Kathryn Jones, Turin maker's marks of 1720–42.[24] Sprimont was responsible for the accompanying crab salts and crayfish salts of 1742–3 and a set of four sauce boats marked in 1743–5. Less well documented is the connection between Paul de Lamerie and Nicholas Sprimont. Sprimont was born in Liège, and was probably apprenticed there to his goldsmith uncle; he may also have trained in Paris in the workshop of Thomas Germain. He is first recorded in London in 1742 when he took on a Huguenot apprentice and married Anne Protin at the Knightsbridge Chapel. In 1743 he entered his mark at Goldsmiths' Hall and the following year demonstrated his close friendship with the leading sculptor Roubiliac by standing godfather to his daughter Sophie. Sprimont's 1740 Toledo and 1746 V&A Ashburnham centrepieces demonstrate the sculptural quality of the silver bearing his mark; was the silver produced under his mark influenced by his friendship with Roubiliac? By 1747 Sprimont had founded the Chelsea Porcelain manufactory where examples of Meissen porcelain were deliberately copied. A pair of candlesticks marked by Sprimont in 1746/7 in the Boston Museum of Fine Arts are identical to a pair marked by de Lamerie in 1747/8 in the Cahn collection. Did this model originate with Sprimont? Sprimont was a talented designer – as evidenced by his design for a salt cellar and spoons and for a tureen for the 1st Earl of Leicester (Plate 70), both in the V&A. Later, as manager of the Chelsea porcelain factory he provided training in designing for thirty boys from parish and charity schools.[25] There is no evidence that Lord Leicester's tureen was actually produced by Sprimont either in silver or in porcelain, but was the design perhaps realized by Paul de Lamerie, who had supplied Leicester with silver at the outset of his career in 1718–19. The tureen if realized to Sprimont's design was made after 1744 when Thomas Coke was ennobled as it incorporates an Earl's coronet. By 1760 the Holkham silver included the requisite set of three tureens for service à la Française, one larger 'terreen' weighing 169 ounces and the other two 95 and 98 ounces respectively.[26] Unfortunately most of this silver was melted down and refashioned in the early 19th century and documentary evidence has not yet been

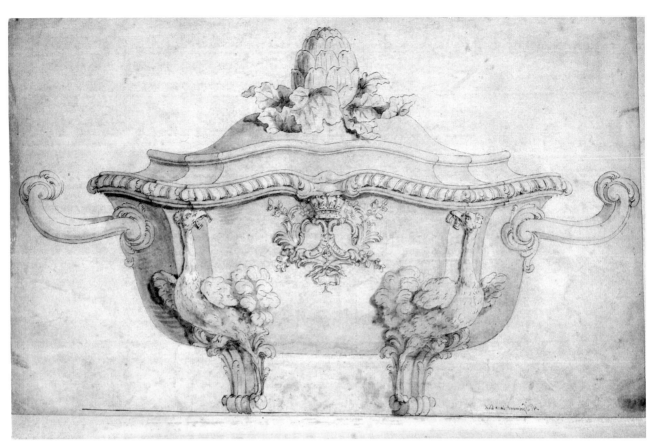

Plate 70 Design for a tureen for the Earl of Leicester, Nicholas Sprimont, *circa* 1744.

found to indicate whether Sprimont or de Lamerie were paid for supplying Lord Leicester with silver in or after 1744.

Both Frederick Prince of Wales and Thomas Coke, 1st Earl of Leicester employed the designer and architect William Kent as interior designer. De Lamerie, Crespin and Sprimont are usually presented as working in the rococo style rather than the Palladian baroque associated with William Kent, but a comparison of the elaborate candlesticks in Paul Cahn's collection of 1742/3 with the giltwood torcheres supplied in 1733 by carver John Boson to Kent's designs for Lady Burlington's Little Parlour at Chiswick and now at Chatsworth, demonstrates the extent to which different art forms drew on the same vocabulary of ornament.

The Ilchester ewer and basin (Plate 64) epitomizes the enigmatic nature of the rococo silver supplied by de Lamerie and his contemporaries. London's West End, centred on the Court at St. James and the luxury craftsmen who supplied leading patrons, was a mecca of foreign artists and designers. They congregated in St. Martin's Lane at Slaughter's Coffee House, described by George Vertue as a 'rendezvous of persons of all languages & nations Gentry artists and others', and in the evenings at the Academy where apprentices and their masters would take advantage of the opportunity to draw side by side from the living model.[27] They browsed in the print shops of Great Newport Street and they formed partnerships with or supplied native craftsmen. The Cahn collection includes spirited London-made rococo silver by other Huguenot goldsmiths including Peter Archambo and Abraham Portal who both served apprenticeships with de Lamerie; native gold-

smiths Phillips Garden, Edward Wakelin and Lawrence Johnson; the Dutch gold-smith Ernest Sieber, and German goldsmith James Shruder.

Links between goldsmiths working in London and Amsterdam and The Hague need further research. Ernest Sieber, who is represented in the Cahn collection by a coffee pot of 1748/9, had worked in Russia and was later recorded as working in The Hague. There is no direct connection between de Lamerie and Sieber, but did de Lamerie maintain contact with family friends in Holland? There must be connections between second generation Huguenot goldsmiths in Amsterdam and The Hague and in London. A gold snuff box by Jean Saint, *circa* 1750, which passed through Sotheby's Amsterdam in December 2006,[28] demon-strates that this second generation Huguenot goldsmith was working in the latest French style inspired by the engravings of Meissonier. Was Jean Saint related to the London based carver and gilder Gedeon Saint (1729–1799)? Philippe Metayer, who signed the 1754 gold cup and cover, now in the Rijksmuseum, was almost certainly connected to Lewis Mettayer, the maker of the splendid ewer and basin bearing the coat of arms of Brigadier Pocock which was presented to St. Martin in the Fields in 1732 and is now in the Cahn Collection. The design for this important commission – gold cup and cover – was circulated through an engraving by J'van Schley published in Amsterdam in 1753.[29]

To summarize, stylistic analysis of rococo silver marked by de Lamerie demonstrates that its sources are closer to German than French prototypes. When de Lamerie died in 1751, his will was witnessed by James Shruder, whose pres-ence in London is first documented in 1733 when, described as a chaser, he took one Julian Crispin as apprentice. De Lamerie's will also mentions his journeymen Frederick Knopfell and Samuel Collins who finished the plate in hand at the time of his death. Knopfell entered his own mark as a goldsmith in 1752, but has also been identified as Frederick Klupfel, jeweller, who had close connections with Dresden.[30] In 1763 Shruder is described as a 'Modeller and Papier Mâché Manufacturer' which suggests that during his thirty-year career in London he may have modelled much of the rococo silver that was retailed by the leading London West End goldsmiths.[31]

William de La Cour and Hubert Gravelot are just two suggestions of possi-ble designers of rococo silver marked by the second generation Huguenot and native goldsmiths. The role of the designer, bolstered by training offered in the European tradition at London's new art academies and drawing schools, was of growing importance. The challenge of identifying the Maynard Master remains because of the wealth of possibilities from assistants in the leading sculptors' workshops. Candidates include the Danish draughtsman Mr Siste and the modeller Charles Stanley, both of whom worked for Roubiliac. Other possibili-ties are the itinerant yet highly talented Italian modellers in stucco – members of the Artari family and Giovanni Bagutti – who travelled wherever their talent was required; or the mysterious Bartholemew Cramillion, recorded as working in Dublin's Rotunda Hospital Chapel, in the mid-1750s whose relative worked in the luxury metal trades in London.[32] It is probable that many of these craftsmen shared a common hinterland in terms of training and experience which has led to the temptation to identify de Lamerie's principle rococo modeller with crafts-

men working in stucco drawing on a common vocabulary in a similar stylistic idiom.

The international network enjoyed by de Lamerie and his contemporaries extended to the new world. Phillips Garden's brother Francis, who is credited with the design of his elegant trade card, is recorded in Boston, Massachusetts, as an engraver of silver from the mid 1740s.[33] In addition to the captive market for Huguenot silver at the Russian court, George Frederick Handel's leading castrato Senesino, retired to his native Siena, entertained in style in his newly acquired town palace using a silver dinner service acquired in London from Paul de Lamerie.[34]

The London *General Evening Post* noted de Lamerie's death in 1751 as the passing of a 'Tender Father, a kind Master and an upright Dealer'. The new research undertaken by Ellenor Alcorn demonstrates that it was as a dealer and retailer that de Lamerie excelled, even if the exact identity of all the craftsmen he employed still remains largely a mystery. It was by drawing on an international network of designs and models, and supervising the wide-ranging continental and native talent available in London at the time, that de Lamerie attained a successful career and a lasting reputation.

FURTHER READING

Ellenor Alcorn, *Beyond the Maker's Mark: Paul de Lamerie Silver in the Cahn Collection*, Cambridge, 2006.

R. Baarsen, ed., *Rococo in Nederland*, Rijksmuseum, Amsterdam, 2001–2.

Geoffrey Beard, *Decorative Plasterwork in Great Britain*, London, 1975.

Ilaria Bignamini, 'George Vertue, Art Historian and Art Institutions in London, 1689–1768', *The Walpole Society*, LIV (1988), pp. 2–148.

Peter Cameron, 'Henry Jernegan, the Kandlers and the client who changed his mind', *Silver Studies: The Journal of the Silver Society*, 8 (1996), pp. 487–501.

Kay Christmas, *Pierre Platel: Huguenot Goldsmith 1664–1719 and the Platel Family*, typescript in the Huguenot Library, London, deposited 1985.

Edward Croft Murray, 'The Ingenious Mr. Clay', *Country Life*, 104 (1948), pp. 1378–80.

A. Delaforce, 'Paul Crespin's silver-gilt bath for the king of Portugal', *Burlington Magazine* (1997), pp. 38–40.

Katharine Eustace, *Michael Rysbrack Sculptor 1694–1770*, City of Bristol Museum and Art Gallery, 1982, no. 26, pp. 97–98.

Mark Girouard, 'Coffee at Slaughters: The Two Worlds of St. Martin's Lane: English Art and the Rococo', *Country Life* (1966), pp. 58–61, 188–190, 224–227.

John Hayward, *Huguenot Silver in England, 1688–1727* (1959), Appendix: Entries relating to purchases of silver, extracted from the diaries of John Hervey, first Earl of Bristol

Susan Hare, *Paul de Lamerie: At the Sign of the Golden Ball*, Goldsmiths' Hall, exhibition catalogue, London, 1990.

Ralph Hyde in Sheila O'Connell, ed., *London in 1753*, 'Portraying London mid-century – John Rocque and the Brothers Buck', British Museum, exhibition catalogue, London, 2003.

Kathryn Jones and Christopher Garibladi, 'Crespin or Sprimont? A question revisited', *Silver Studies: The Journal of the Silver Society*, 21 (2006), pp. 25–42.

Tessa Murdoch, 'The Huguenots and the English Rococo' in Charles Hind, ed., *The Rococo in England: A Symposium*, London, 1986, p. 73.

Tessa Murdoch, 'Nicholas Sprimont' in the *New Dictionary of National Biography*, Oxford, 2004.

Tessa Murdoch, ed., *Noble Households, Eighteenth-Century Inventories of Great English Houses: A Tribute to John Cornforth*, Cambridge, 2006, p. 237.

Michael Snodin, ed., *Rococo: Art and Design in Hogarth's England*, Victoria and Albert Museum, exhibition catalogue, London, 1984.

George Vertue, Note Books, vols I–VI, *The Walpole Society*, vols XVIII, XX, XXII, XXIV, XXVI, XXX, 1929–1950.

NOTES

1 Museum numbers M.4–2–1995; M.5–2–1995; M.9–2–1995; M.10–2–1995.

2 *Huguenot Society Quarto Series* VII, Registers of the Reformed Churches of St. Patrick and St. Mary, Dublin.

3 See Kay Christmas, 'Pierre Platel Huguenot Goldsmith 1664–1719 and the Platel Family', typescript in the Huguenot Library, London, deposited 1985.

4 John Hayward, *Huguenot Silver in England, 1688–1727* (1959) Appendix: Entries relating to purchases of silver, extracted from the diaries of John Hervey, first Earl of Bristol, 1688–1727, pp. 83.

5 Tim Schroder confirms that the sconces were engraved with the crest of the Foley family in the early 19th century. The coronets are later additions and the spiral fluting on the sockets is in keeping with a date of about 1800 and may have been supplied by Rundells, if the sconces were sold from the Royal Collections at that time.

6 Susan Hare, *Paul de Lamerie: At the Sign of the Golden Ball*, Goldsmiths' Hall exhibition catalogue, 1990, no. 37, p. 76.

7 Hare, as note 6, p. 12.; François Souchal, *French Sculptors of the 17th and 18th Centuries, The Reign of Louis XIV*, II, pp. 271–272.

8 Vertue, George, Note Books, III, *The Walpole Society*, vol. XXII, p. 12; VI, vol. XXX, p. 170.

9 For the St. Martin's Lane Academy see Ilaria Bignamini, 'George Vertue, Art Historian and Art Institutions in London, 1689–1768', *The Walpole Society*, vol. LIV, 1988, pp. 2–148.

10 *The Daily Courant*, 22nd April, 1730 no. 8903, transcribed by R. W. Symonds, Wintherthur Library, Delaware.

11 Ellenor Alcorn, *Beyond the Maker's Mark: Paul de Lamerie Silver in the Cahn Collection* (2006), p. 28, fig. 20

12 Michael Snodin, ed., *Rococo: Art and Design in Hogarth's England*, 1984, D1, C4.

13 Ralph Hyde in Sheila O'Connell, ed., *London in 1753*, 'Portraying London mid-century – John Rocque and the Brothers Buck', British Museum, exhibition catalogue (2003), p. 33.

14 Snodin (see note 11), H4.

15 Tim Schroder points out that the techniques used on the Ilchester dish are quite different from the Maynard and similarly elaborate dishes in the Gilbert Collection and the London Goldsmiths' Company which incorporate lots of applied ornament, whereas the Ilchester dish is entirely embossed.

16 See T. Murdoch, 'The Huguenots and the English Rococo' in Charles Hind, ed., *The Rococo in England: A Symposium*, 1986, p. 73.

17 Christie's, London, 14 June 2005, lot 261.

18 A. Delaforce, 'Paul Crespin's silver-gilt bath for the king of Portugal', *Burlington Magazine* (1997), pp. 38–40

19 Peter Cameron, Henry Jernegan, the Kandlers and the client who changed his mind, *Silver Studies: The Journal of the Silver Society*, 8, 1996, pp. 487–501.

20 Yale Center for British Art, New Haven, B 1975.4.444.

21 Katharine Eustace, *Michael Rysbrack Sculptor 1694–1770*, City of Bristol Museum and Art Gallery, 1982, no. 26, pp. 97–98

22 Edward Croft Murray, The Ingenious Mr. Clay, *Country Life*, 104, 1948, pp. 1378–80.

23 Yale Center for British Art, B1975.4.440

24 Kathryn Jones and Christopher Garibladi, 'Crespin or Sprimont? A question revisited', *Silver Studies: The Journal of the Silver Society*, 21, 2006, pp. 25–42.

25 T. Murdoch, 'Nicholas Sprimont' in the *New Dictionary of National Biography*, Oxford, 2004.

26 T. Murdoch, ed. *Noble Households, Eighteenth-Century Inventories of Great English Houses: A Tribute to John Cornforth*, 2006, p. 237

27 Mark Girouard, 'Coffee at Slaughters: The Two Worlds of St. Martin's Lane: English Art and the Rococo', *Country Life*, 1966, pp. 58–61, 188–190, 224–227.

28 Sotheby's, 11 December 2006, lot 69.

29 Renier Baarsen, ed., *Rococo in Nederland*, Rijksmuseum exhibition catalogue, Amsterdam, 2001–2, nos 28, 29.

30 Arthur Grimwade, *London Goldsmiths, 1697–1837, Their Marks and Lives*, third edition, 1990, p. 756. I am most grateful to Robert Barker for calling my attention to new material found by Grimwade included in his third edition as addenda.

31 Mortimer, *The Universal Director*, 1763.

32 Geoffrey Beard, *Decorative Plasterwork in Great Britain*, 1975; for recent discoveries see Joe McDonnell, *Irish Eighteenth-century Stuccowork and its European Sources*, Dublin, 1991; ibid., The Art of the Sculptore-Stuccadore Bartholemew Cramillion in Dublin and Brussels 1755–72, *Apollo*, September 2002, pp. 41–49; The Cramillion Lectern, *Irish Arts Review*, Winter 2007, pp. 122–125. Peter Cramillion, a gold watch case maker in the parish of St James's Clerkenwell, London, was apprenticed in 1754.

33 I am most grateful to Sheila O'Connell for this information.

34 *Handel and the Castrati, The Story Behind the 18th Century Superstar Singers*, Handel House Museum, 2006, p. 6.

Biographical Details of the Huguenot Goldsmiths Recorded

1. Huguenot goldsmiths in the 17th century in Paris, the Centre and West of France
 Michèle Bimbenet-Privat

2. Huguenot goldsmiths and those that worked in the French style in The Hague, 1680–1730
 Jet Pijzel-Dommisse

3. Huguenot goldsmiths in Berlin and Cassel
 Tessa Murdoch

4. Huguenot goldsmiths in New York and Philadelphia
 Caroline Rainey

5. Huguenot goldsmiths in Boston and Charleston
 Beth Carver Wees

6. Names of known, believed or possible Huguenot goldsmiths of Cork
 John Bowen

7. Names of known, believed or possible Huguenot goldsmiths of Dublin
 Tessa Murdoch and Thomas Sinsteden

8. Goldsmiths, designers, engravers, modellers and sculptors in Paul de Lamerie's circle
 Tessa Murdoch

Huguenot goldsmiths in the 17th century in Paris, the Centre and West of France

Michèle Bimbenet-Privat

From: Michèle Bimbenet-Privat, *Les orfèvres et l'orfèvrerie de Paris au XVIIe siècle*, Paris, 2002; Claude-Gérard Cassan, *Les orfèvres de basse Normandie*, Art et Curiosité, janvier–mars 1980; Thibaut Fourrier, *La minorité protestante de Blois de l'entourage de la cour au Refuge*, thèse de doctorat de l'Université de Tours, 1994; Monique Jacob, *Les orfèvres d'Anjou et du bas Maine*, Paris, 1998; Elie Pailloux, *Orfèvres et poinçons XVIIe–XVIIIe–XIXe s., Poitou, Angoumois, Aunis, Saintonge*, La Rochelle, 1962.

I Towns and countries [*]

Angers

Amyrault Jean/Angers
Beauvais Antoine/Saumur
Besnard Robin/Angers
Billault Jean/Saumur
Boesnier Isaac/Angers
Boesnier Michel/Angers
Boucher Isaac/Angers
Boucher Jean/Angers
Boucher Pierre/Angers
Bouchet René/Saumur
Bourdais François I/Angers
Bourdais François II/Angers
Chappuis Odet/Angers
Chesneau Gabriel/Angers
Chrestien Etienne/Angers
Collas Etienne/Angers
Colpin Michel/Angers
Coutant Isaac/Angers
Crispin Israël I/Angers
Crispin Israël II/Angers
Daller Mathieu I/Angers
Daller Mathieu II/Angers
Dance David/Angers

Delabarre Jean/Angers
Delabarre Josias/Angers
Delacourt Michel/Angers
Desbordes Jacques/Saumur
Dubied Isaac/Angers
Eveillard Pierre/Angers
Faligan André/Saumur
Faligan Pierre I/Saumur
Foucher Maurice/Angers
Gaultier David/Saumur
Georges Philippe/Saumur then
 Saintes
Girard Abraham/Saumur
Girard Jacques/Saumur
Girault Jacques/Angers
Guillaume Samuel/Saumur
Hémard André/Angers
Jouffard Philibert/Saumur
Labbé Louis/Angers
Labbé Pierre/Angers
Lambert Jean/Angers
Lasnier Abraham/Angers
Lemercier Jean/Laval

[*] The name of every goldsmith is followed by the town in which he was living.

Angers – *continued*

Maisonneuve Henri/Angers
Mazurier Horace/Angers
Michon Pierre/Saumur
Noël Jacques/Saumur
Pasler Martin/Angers
Pelletier André/Angers then Saumur
Pelletier Jacques I/Saumur
Pelletier Jacques II/Saumur
Poisson Isaac/Angers
Poisson Jacques/Angers

Poitevin Isaac/Saumur
Robin François/Saumur
Seheult Jacques/Angers
Seheult Jean l'Aîné/Angers
Seheult Jean le jeune/Angers
Seheult Pierre/Angers
Seheult Tertullien/Angers
Thibault Daniel (La
 Guichardière)/Angers
Wimers Jean de/Angers Paris

Blois

Bellanger Samuel/Blois
Bordier Jacques/Blois
Chartier Antoine/Blois
Chartier Pierre/Blois
Delagarde Isaac/Blois
Deseptans Jean II/Blois
Deseptans Michel I/Blois
Deseptans Michel II/Blois
Dubois Jean II/Blois then Paris
Dufour Charles II/Blois
Dutens Jean/Blois
Foubert Daniel/Blois
Foubert Israël/Blois then Tours
Foubert Théodore/Blois

Fréart Abraham/Blois
Gousset Pierre/Blois
Gribelin Abraham/Blois
Gribelin Isaac/Blois
Lemaire Daniel/Blois
Lubin Etienne/Blois
Lubin Henri/Blois
Perdriau Jacob/Blois
Perdriau Marc/Blois
Posay Michel de/Blois
Tessier Jacques/Blois
Toutin Jean/Blois then Paris
Vauthier Daniel/Blois
Yver Henri/Blois

Bordeaux

Barthe Isaac/Nérac
Cathala Elie/Nérac
Tresser Daniel/Nérac
Bérangier [Bellanger ?]
 Moyse/Bordeaux
Brinbeuf J/Bordeaux
Freron Pierre/Bordeaux
Guiraut Jacob/Bordeaux
Guiraut Jacques/Bordeaux
Guiraut Jean/Bordeaux
Guiraut Pierre/Bordeaux

Labat Jacques/Bordeaux
Marion Jean/Bordeaux
Ramondon Jean/Bordeaux
Rions Jean/Bordeaux
Rivière Apollon/Bordeaux
Thévenin Claude/Bordeaux
Thévenin Pierre/Bordeaux
Tostée David/Bordeaux
Tostée Gabriel/Bordeaux
Tostée Jean/Bordeaux
Viala David/Bordeaux

Caen

Angot Isaac/Caen
Bence Pierre/Caen
Davoys Philippe/Caen

Desmares Michel/Baycux
Dufour Jean/Caen
Dufresne Jacques/Saint-Lô

Caen – *continued*

Dufresne Pierre/Saint-Lô
Fumée Antoine/Caen
Giot Pierre/Saint-Lô
Harel Jean/Caen
Jue Isaac/Caen
Lalouel Jean/Saint-Lô
Lemercier Pierre/Caen
Malherbe Jacques/Saint-Lô
Poulain Jean/Caen

Poulain Pierre/Caen
Poullain Abraham/Caen
Saint David/Saint-Lô
Saint Gédéon/Coutances
Saint Jacques/Saint-Lô
Saint Jean/Saint-Lô
Saint Pierre/Saint-Lô
Varin Nicolas/Caen
Varin Noël/Caen

Paris

Aubert Samuel/Paris
Bain Pierre/Paris
Balduc Jean II/Paris
Balduc Pierre/Paris
Baudry Samuel/Paris
Bellanger [Bérangier ?] Moyse/Paris
Belle Josias/Paris
Belliart Jacques/Paris
Bergeron Isaac/Paris
Berny Samuel/Paris
Bingant Salomon/Paris
Bion/Artus Paris
Blanques Jacob/Paris
Bosc Sylvestre/Paris
Boulle Paul/Paris
Boursin Daniel/Paris
Boursin Edme/Paris
Boursin Jean I/Paris
Boursin Jean II/Paris
Boursin Louis/Paris
Brandon Jean/Paris
Caillart Jacques I/Paris
Caillart Jacques II/Paris
Cattier Ange/Paris
Chambon Abraham/Paris
Chetteaux Jacques/Paris
Clayes Jean/Paris
Collet Paul/Paris)
Coutin Isaac/Paris
Creuzé Pierre/Paris
Debourg Jacques/Paris
Debourg Michel/Paris
Delabarre François/Paris
Delabarre Isaac/Paris

Delabarre Jean/Paris
Delabarre Joseph/Paris
Delabarre Josias I/Paris
Delabarre Josias II/Paris
Delabarre Pierre/Paris
Delaunay Paul/Paris
Delavigne Claude/Paris
Doucet Etienne/Paris
Du Guernier Louis/Paris
Dubois Pierre/Paris
Ducloux Etienne/Paris
Duhamel Louis/Paris
Erondelle Charles/Paris
Erondelle Jean/Paris
Erondelle Richard/Paris
Fouquet Claude/Paris
Fouquet Jean/Paris
Gaillart Jean/Paris
Gence Denis/Paris
Girard François/Paris
Girard Jean/Paris
Gobille Jean/Paris
Godard Daniel/Paris
Godard Ulfrand/Paris
Godeau Louis/Paris
Gribelin Charles/Paris
Gribelin Nicolas/Paris
Harache Pierre/Paris
Hersant Henri/Paris
Hersant Jean/Paris
Ladoireau Pierre/Paris
Le Barbier Jacques/Paris
Légaré Claude/Paris
Légaré Gédéon/Paris
Légaré Jacob/Paris

Paris – *continued*

Légaré Laurent/Paris
Légaré Louis/Paris
Lejuge Thomas/Paris
Lepage Luc/Paris
Lepage Siméon I/Paris
Lepage Siméon II/Paris
Leriche Paul/Paris
Leroux Nicolas/Paris
Leroy François II/Paris
Leroy Jean/Paris
Lesueur Etienne/Paris
Loiseau Pierre/Paris
Loiseau Samuel/Paris
Loiseau Thomas/Paris
Londé Philippe/Paris
Lorin/Jean 2 Paris
Lorin Jean 1/Paris
Marchand Isaac/Paris
Marchand Pierre 1/Paris
Marchand Pierre 2/Paris
Masse Théophile Paris
Maurice Daniel/Paris
Moiller/Paris
Mosin Daniel/Paris
Mosin Pierre/Paris
Mothe Abel/Paris
Mothe Claude/Paris
Patin Jacques/Paris
Picart Pierre I/Paris
Pijart François/Paris
Pingard Jean/Paris
Pittan Jacob/Paris

Pittan Jean/Paris
Pittan Nicolas/Paris
Planck Jacob/Paris
Raillard Joseph/Paris
Rate Abraham/Paris
Regnier André/Paris
Regnier Pierre 1/Paris
Regnier Pierre 2/Paris
Regnier Pierre Daniel/Paris
Riberolles Pierre 2/Paris
Rivart Samuel/Paris
Roussel Claude/Paris
Royer Abraham/Paris
Royer Daniel/Paris
Schoorman Antoine/Paris
Seheult Abraham/Paris
Seheult Jacques/Paris
Seheult Jacques/Paris
Seheult Pierre Paris
Seheult Tertullien/Paris
Stornac Sébastien/Paris
Sweerman Henri/Paris
Toutin Henry/Paris
Toutin Jean I/Paris
Toutin Jean II/Paris
Vallée Edme/Paris
Van Asperen (Benoît)/Paris
Van de Lan Abraham/Paris
Van Vianen Martin/Paris
Vautier Daniel/Paris
Verbeck Thomas/Paris
Vert Moyse/Paris

Poitou Saintonge

Balluet Isaac/Les Sables d'Olonne
Berland Isaac/Saint-Jean d'Angely
Berland Jean/Châtellerault
Bernard Gabriel/La Rochelle
Besnard Abraham/La Rochelle
Billé Isaac/Saint-Jean d'Angely
Bouguereau Macé/La Rochelle
Bourdeaux Abraham de/Poitiers
Caillon Daniel/La Rochelle
Chabot Georges/La Rochelle

Coupé Daniel/Niort
Creuzé Luc/Châtellerault
Delavau Isaac/La Rochelle
Denis Gédéon/La Rochelle
Desbordes Abraham/La Rochelle
Doscher Jean/La Rochelle
Dousset Isaac/Melle
Dubosq Isaac/Fontenay le Comte
Fanoeuil Isaac/La Rochelle
Fournier David/Saintes

Poitou Saintonge – *continued*

Fradin Jérémie/Châtellerault

Galliot Samuel/Angoulême

Garnier David/Parthenay

Gatineau/Saint-Jean d'Angely

Gatineau Isaac/Saintes

Gaultier Abraham/Niort

Giraud Moyse/Fontenay le Comte

Goullet Daniel/Saint-Maixent

Guillaume Josué/La Rochelle

Guillaume Samuel/Melle

Huault Jean/Châtellerault

Le Mazière David/La Rochelle

Légaré Jacob/La Rochelle

Lemercier Elie/Angoulême

Marmain Daniel/Civray

Massias Olivier/Angoulême

Mervache Daniel/Poitiers

Mervache François/Poitiers

Mervache Paul/Poitiers

Poiret Abraham/Poitiers

Prestau Isaac/Cognac

Prou Ezéchiel/Saint-Martin de Ré

Robin Gédéon/Saint-Maixent

Sené Daniel/Saintes

Sironneau Elisée/Cognac

Verger Abraham/Lusignan

Viet Elisée/Niort

Violette Jean/Saint-Maixent

Violette Moyse/Niort

Voyer Samuel/Cognac

Rouen

Agasse Jeuffin/Rouen

Briant Isaac/Rouen

Cottard Abraham/Rouen

Delahaye Jean/Rouen

Dépréaulx Jacob/Rouen

Desnos Jean/Rouen

Dubuisson Pierre/Rouen

Dubuisson Thomas/Rouen

Dubusc Abraham/Rouen

Dubusc Jacques/Rouen

Dugard Abraham/Rouen

Dumont Abraham/Rouen

Ferman Guillaume/Rouen

Gaillard Etienne/Rouen

Gaillard Simon/Rouen

Goulle Etienne/Rouen

Goulle ou Goullay Jean/Rouen

Guerente Isaac/Rouen

Hamelin Jean/Rouen

Harache Etienne/Rouen

Harache Jérémie/Rouen

Harache Nicolas/Rouen

Harache Pierre/Rouen

Hébert Moyse/Dieppe

Heurtault Etienne/Rouen

Langlois Abraham/Rouen

Langlois Isaac/Rouen

Langlois Jacob/Rouen

Langlois Jacques/Rouen

Lasnier Abraham/Rouen

Lasnier Jacques/Rouen

Le Cauchois Jacques/Rouen

Le Doyen Abraham/Rouen

Le Doyen Denis/Rouen

Le Maignen Abraham/Rouen

Le Maignen Jean/Rouen

Le Plastrier Denis/Rouen

Le Plastrier Denis le jeune/Rouen

Le Plastrier Jean l'aîné/Rouen

Le Plastrier Jean le jeune/Rouen

Le Plastrier Simon le jeune/Rouen

Le Plastrier Simon le père/Rouen

Le Sire André/Rouen

Leblond David/Rouen

Lecambrai Jacques/Rouen

Leclerc Abraham/Rouen

Lecourt Benjamin/Rouen

Lecourt Charles/Rouen

Lecourt David/Rouen

Lecourt Jean II/Rouen

Lecourt Jean III/Rouen

Lecourt Pierre I/Rouen

Lecourt Pierre II/Rouen

Ledoyen Denis II/Rouen

Rouen – *continued*

Ledoyen Jean/Rouen
Lemesgre Abraham/Rouen
Lemetayer Jacques/Rouen
Lemire Isaac/Rouen
Lepage Etienne/Rouen
Lepage Siméon/Rouen
Lepaige Antoine/Rouen
Lepape Simon/Rouen
Lorin Jean/Rouen then Paris
Mahieu Etienne/Rouen
Malmaison Etienne/Rouen
Malmaison Jean/Rouen
Malmaison Salomon/Rouen
Mameaux Daniel/Rouen
Mameaux Isaac/Rouen
Mameaux Jacob/Rouen
Mameaux Vincent/Rouen
Margas Guillaume/Rouen
Margas Jean/Rouen
Margas Samuel I/Rouen
Margas Samuel II/Rouen
Martel Abraham I/Rouen
Martel Abraham II/Rouen
Martel Adrien/Rouen
Martel Isaac/Rouen
Martel Jérémie/Rouen

Martel Nicolas/Rouen
Massien Nicolas/Rouen
Mignot Abraham/Rouen
Morisse Luc/Rouen
Noël Payne/Rouen
Pantin Abraham I/Rouen
Pantin Abraham II/Rouen
Pantin Abraham III/Rouen
Pantin Guillaume I/Rouen
Pantin Guillaume II/Rouen
Pantin Isaïe/Rouen
Pantin Nicolas/Rouen
Pantin Simon/Rouen
Payne Henry/Rouen
Ponty/Rouen
Quellot David/Rouen
Rocusson Philippe/Rouen
Roumieu Nicolas/Rouen
Roux Pierre/Rouen
Seheult Guillaume/Rouen
Tardif Isaac/Rouen
Verbeck Thomas, (Marie Lefebvre, widow)/Rouen
Viart Jean/Rouen
Vimont David de/Rouen

II Goldsmiths' names (general list)

Agasse Jeuffin/Rouen
Amyrault Jean/Angers
Angot Isaac/Caen
Aubert Samuel/Paris
Bain Pierre/Paris
Balduc Jean II/Paris
Balduc Pierre/Paris
Balluet Isaac/Les Sables d'Olonne
Barthe Isaac/Nérac
Baudry Samuel/Paris
Beauvais Antoine/Saumur
Bellanger [Bérangier ?] Moyse/Bordeaux and Paris

Bellanger Samuel/Blois
Belle Josias/Paris
Belliart Jacques/Paris
Bence Pierre/Caen
Bérangier Moyse/Bordeaux, see Bellanger
Bergeron Isaac/Paris
Berland Isaac/Saint-Jean d'Angely
Berland Jean/Châtellerault
Bernard Gabriel/La Rochelle
Berny Samuel/Paris
Besnard Abraham/La Rochelle
Besnard Robin/Angers

General list – *continued*

Billault Jean/Saumur	Coutant Isaac/Angers
Billé Isaac/Saint-Jean d'Angely	Coutin Isaac/Paris
Bingant Salomon/Paris	Creuzé Luc/Châtellerault
Bion/Artus Paris	Creuzé Pierre/Paris
Blanques Jacob/Paris	Crispin Israël I/Angers
Boesnier Isaac/Angers	Crispin Israël II/Angers
Boesnier Michel/Angers	Daller Mathieu I/Angers
Bordier Jacques/Blois	Daller Mathieu II/Angers
Bosc Sylvestre/Paris	Dance David/Angers
Boucher Isaac/Angers	Davoys Philippe/Caen
Boucher Jean/Angers	Debourg Jacques/Paris
Boucher Pierre/Angers	Debourg Michel/Paris
Bouchet René/Saumur	Delabarre François/Paris
Bouguereau Macé/La Rochelle	Delabarre Isaac/Paris
Boulle Paul/Paris	Delabarre Jean/Angers then Paris
Bourdais François I/Angers	Delabarre Joseph/Paris
Bourdais François II/Angers	Delabarre Josias I/Angers then Paris
Bourdeaux Abraham de/Poitiers	Delabarre Josias II/Paris
Boursin Daniel/Paris	Delabarre Pierre/Paris
Boursin Edme/Paris	Delacourt Michel/Angers
Boursin Jean I/Paris	Delagarde Isaac/Blois
Boursin Jean II/Paris	Delahaye Jean/Rouen
Boursin Louis/Paris	Delaunay Paul/Paris
Brandon Jean/Paris	Delavau Isaac/La Rochelle
Briant Isaac/Rouen	Delavigne Claude/Paris
Brinbeuf J/Bordeaux	Denis Gédéon/La Rochelle
Caillart Jacques I/Paris	Depréaulx Jacob/Rouen
Caillart Jacques II/Paris	Desbordes Abraham/La Rochelle
Caillon Daniel/La Rochelle	Desbordes Jacques/Saumur
Cathala Elie/Nérac	Deseptans Jean II/Blois
Cattier Ange/Paris	Deseptans Michel I/Blois
Chabot Georges/La Rochelle	Deseptans Michel II/Blois
Chambon Abraham/Paris	Desmares Michel/Bayeux
Chappuis Odet/Angers	Desnos Jean/Rouen
Chartier Antoine/Blois	Doscher Jean/La Rochelle
Chartier Pierre/Blois	Doucet Etienne/Paris
Chesneau Gabriel/Angers	Dousset Isaac/Melle
Chetteaux Jacques/Paris	Du Guernier Louis/Paris
Chrestien Etienne/Angers	Dubied Isaac/Angers
Clayes Jean/Paris	Dubois Jean II/Blois then Paris
Collas Etienne/Angers	Dubois Pierre/Paris
Collet Paul/Paris)	Dubosq Isaac/Fontenay le Comte
Colpin Michel/Angers	Dubuisson Pierre/Rouen
Cottard Abraham/Rouen	Dubuisson Thomas/Rouen
Coupé Daniel/Niort	Dubusc Abraham/Rouen

General list – *continued*

Dubusc Jacques/Rouen
Ducloux Etienne/Paris
Dufour Charles II/Blois
Dufour Jean/Caen
Dufresne Jacques/Saint-Lô
Dufresne Pierre/Saint-Lô
Dugard Abraham/Rouen
Duhamel Louis/Paris
Dumont Abraham/Rouen
Dutens Jean/Blois
Erondelle Charles/Paris
Erondelle Jean/Paris
Erondelle Richard/Paris
Eveillard Pierre/Angers
Faligan André/Saumur
Faligan Pierre I/Saumur
Fanoeuil Isaac/La Rochelle
Ferman Guillaume/Rouen
Foubert Daniel/Blois
Foubert Israël/Blois then Tours
Foubert Théodore/Blois
Foucher Maurice/Angers
Fouquet Claude/Paris
Fouquet Jean/Paris
Fournier David/Saintes
Fradin Jérémie/Châtellerault
Fréart Abraham/Blois
Freron Pierre/Bordeaux
Fumée Antoine/Caen
Gaillard Etienne/Rouen
Gaillard Simon/Rouen
Gaillart Jean/Paris
Galliot Samuel/Angoulême
Garnier David/Parthenay
Gatineau/Saint-Jean d'Angély
Gatineau Isaac/Saintes
Gaultier Abraham/Niort
Gaultier David/Saumur
Gence Denis/Paris
Georges Philippe/Saumur then
 Saintes
Giot Pierre/Saint-Lô
Girard Abraham/Saumur
Girard François/Paris
Girard Jacques/Saumur

Girard Jean/Paris
Giraud Moyse/Fontenay le Comte
Girault Jacques/Angers
Gobille Jean/Paris
Godard Daniel/Paris
Godard Ulfrand/Paris
Godeau Louis/Paris
Goulle Etienne/Rouen
Goulle ou Goullay Jean/Rouen
Goullet Daniel/Saint-Maixent
Gousset Pierre/Blois
Gribelin Abraham/Blois
Gribelin Charles/Paris
Gribelin Isaac/Blois
Gribelin Nicolas/Paris
Guerente Isaac/Rouen
Guillaume Josué/La Rochelle
Guillaume Samuel/Melle and Saumur
Guiraut Jacob/Bordeaux
Guiraut Jacques/Bordeaux
Guiraut Jean/Bordeaux
Guiraut Pierre/Bordeaux
Hamelin Jean/Rouen
Harache Etienne/Rouen
Harache Jérémie/Rouen
Harache Nicolas/Rouen
Harache Pierre/Rouen then Paris
Harel Jean/Caen
Hébert Moyse/Dieppe
Hémard André/Angers
Hersant Henri/Paris
Hersant Jean/Paris
Heurtault Etienne/Rouen
Huault Jean/Châtellerault
Jouffard Philibert/Saumur
Jue Isaac/Caen
Labat Jacques/Bordeaux
Labbé Louis/Angers
Labbé Pierre/Angers
Ladoireau Pierre/Paris
Lalouel Jean/Saint-Lô
Lambert Jean/Angers
Langlois Abraham/Rouen
Langlois Isaac/Rouen
Langlois Jacob/Rouen

General list – *continued*

Langlois Jacques/Rouen
Lasnier Abraham/Angers and Rouen
Lasnier Jacques/Rouen
Le Barbier Jacques/Paris
Le Cauchois Jacques/Rouen
Le Doyen Abraham/Rouen
Le Doyen Denis/Rouen
Le Maignen Abraham/Rouen
Le Maignen Jean/Rouen
Le Mazière David/La Rochelle
Le Plastrier Denis/Rouen
Le Plastrier Denis le jeune/Rouen
Le Plastrier Jean l'aîné/Rouen
Le Plastrier Jean le jeune/Rouen
Le Plastrier Simon le jeune/Rouen
Le Plastrier Simon le père/Rouen
Le Sire André/Rouen
Leblond David/Rouen
Lecambrai Jacques/Rouen
Leclerc Abraham/Rouen
Lecourt Benjamin/Rouen
Lecourt Charles/Rouen
Lecourt David/Rouen
Lecourt Jean II/Rouen
Lecourt Jean III/Rouen
Lecourt Pierre/Rouen
Lecourt Pierre II/Rouen
Ledoyen Denis II/Rouen
Ledoyen Jean/Rouen
Légaré Claude/Paris
Légaré Gédéon/Paris
Légaré Jacob/La Rochelle and Paris
Légaré Laurent/Paris
Légaré Louis/Paris
Lejuge Thomas/Paris
Lemaire Daniel/Blois
Lemercier Elie/Angoulême
Lemercier Jean/Laval
Lemercier Pierre/Caen
Lemesgre Abraham/Rouen
Lemetayer Jacques/Rouen
Lemire Isaac/Rouen
Lepage Etienne/Rouen
Lepage Luc/Paris
Lepage Siméon/Rouen

Lepage Siméon I/Paris
Lepage Siméon II/Paris
Lepaige Antoine/Rouen
Lepape Simon/Rouen
Leriche Paul/Paris
Leroux Nicolas/Paris
Leroy François II/Paris
Leroy Jean/Paris
Lesueur Etienne/Paris
Loiseau Pierre/Paris
Loiseau Samuel/Paris
Loiseau Thomas/Paris
Londé Philippe/Paris
Lorin Jean 1/Paris
Lorin/Jean 2 Paris
Lorin Jean/Rouen
Lubin Etienne/Blois
Lubin Henri/Blois
Mahieu Etienne/Rouen
Maisonneuve Henri/Angers
Malherbe Jacques/Saint-Lô
Malmaison Etienne/Rouen
Malmaison Jean/Rouen
Malmaison Salomon/Rouen
Mameaux Daniel/Rouen
Mameaux Isaac/Rouen
Mameaux Jacob/Rouen
Mameaux Vincent/Rouen
Marchand Isaac/Paris
Marchand Pierre 1/Paris
Marchand Pierre 2/Paris
Margas Guillaume/Rouen
Margas Jean/Rouen
Margas Samuel I/Rouen
Margas Samuel II/Rouen
Marion Jean/Bordeaux
Marmain Daniel/Civray
Martel Abraham I/Rouen
Martel Abraham II/Rouen
Martel Adrien/Rouen
Martel Isaac/Rouen
Martel Jérémie/Rouen
Martel Nicolas/Rouen
Masse Théophile Paris
Massias Olivier/Angoulême

General list – *continued*

Massien Nicolas/Rouen

Maurice Daniel/Paris

Mazurier Horace/Angers

Mervache Daniel/Poitiers

Mervache François/Poitiers

Mervache Paul/Poitiers

Michon Pierre/Saumur

Mignot Abraham/Rouen

Moiller/Paris

Morisse Luc/Rouen

Mosin Daniel/Paris

Mosin Pierre/Paris

Mothe Abel/Paris

Mothe Claude/Paris

Noël Jacques/Saumur

Noël Payne/Rouen

Pantin Abraham/Rouen

Pantin Abraham I/Rouen

Pantin Abraham II/Rouen

Pantin Abraham III/Rouen

Pantin Guillaume/Rouen

Pantin Isaïe/Rouen

Pantin Nicolas/Rouen

Pantin Simon/Rouen

Pasler Martin/Angers

Patin Jacques/Paris

Payne Henry/Rouen

Pelletier André/Angers then Saumur

Pelletier Jacques I/Saumur

Pelletier Jacques II/Saumur

Perdriau Jacob/Blois

Perdriau Marc/Blois

Picart Pierre I/Paris

Pijart François/Paris

Pingard Jean/Paris

Pittan Jacob/Paris

Pittan Jean/Paris

Pittan Nicolas/Paris

Planck Jacob/Paris

Poiret Abraham/Poitiers

Poisson Isaac/Angers

Poisson Jacques/Angers

Poitevin Isaac/Saumur

Ponty/Rouen

Posay Michel de/Blois

Poulain Jean/Caen

Poulain Pierre/Caen

Poullain Abraham/Caen

Prestau Isaac/Cognac

Prou Ezéchiel/Saint-Martin de Ré

Quellot David/Rouen

Raillard Joseph/Paris

Ramondon Jean/Bordeaux

Rate Abraham/Paris

Regnier André/Paris

Regnier Pierre 1/Paris

Regnier Pierre 2/Paris

Regnier Pierre Daniel/Paris

Riberolles Pierre 2/Paris

Rions Jean/Bordeaux

Rivart Samuel/Paris

Rivière Apollon/Bordeaux

Robin François/Saumur

Robin Gédéon/Saint-Maixent

Rocusson Philippe/Rouen

Roumieu Nicolas/Rouen

Roussel Claude/Paris

Roux Pierre/Rouen

Royer Abraham/Paris

Royer Daniel/Paris

Saint David/Saint-Lô

Saint Gédéon/Coutances

Saint Jacques/Saint-Lô

Saint Jean/Saint-Lô

Saint Pierre/Saint-Lô

Schoorman Antoine/Paris

Seheult Abraham/Paris

Seheult Guillaume/Rouen

Seheult Jacques/Angers then Paris

Seheult Jean l'Aîné/Angers

Seheult Jean le jeune/Angers

Seheult Pierre/Angers then Paris

Seheult Tertullien/Angers then Paris

Sené Daniel/Saintes

Sironneau Elisée/Cognac

Stornac Sébastien/Paris

Sweerman Henri/Paris

Tardif Isaac/Rouen

Tessier Jacques/Blois

Thévenin Claude/Bordeaux

General list – *continued*

Thévenin Pierre/Bordeaux
Thibault Daniel (La
 Guichardière)/Angers
Tostée David/Bordeaux
Tostée Gabriel/Bordeaux
Tostée Jean/Bordeaux
Toutin Henri/Paris
Toutin Jean I/Blois then Paris
Toutin Jean II/Paris
Tresser Daniel/Nérac
Vallée Edme/Paris
Van Asperen (Benoît)/Paris
Van de Lan Abraham/Paris
Van Vianen Martin/Paris
Varin Nicolas/Caen
Varin Noël/Caen

Vauthier Daniel/Blois then Paris
Verbeck Thomas/Paris
Verbeck Thomas, (Marie Lefebvre,
 widow)/Rouen
Verger Abraham/Lusignan
Vert Moyse/Paris
Viala David/Bordeaux
Viart Jean/Rouen
Viet Elisée/Niort
Vimont David de/Rouen
Violette Jean/Saint-Maixent
Violette Moyse/Niort
Voyer Samuel/Cognac
Wimers Jean de/Angers
Yver Henri

Huguenot goldsmiths and those that worked in the French style in The Hague, 1680–1730

Jet Pijzel-Domisse

Jacques Chevalier the Elder married in 1699 at the Walloon Church, The Hague. He was then a widower and his second wife Jacoba Stolkin a 'young daughter of the Paltz' (the Palatinate). He probably already had one son from his first marriage, Jacques Chevalier the Younger, a goldsmith, who was sworn in on 2 March 1711 and died 15 January 1729. The maker's marks attributed to both Chevalier the Elder and Younger, a horse in an oval, look similar. Surviving objects attributed to Jacques Chevalier the Elder include a Bakers' Guild cup, 1689; a silver chamber pot, 1687; and a tea caddy, 1695.

REFERENCES: E. Voet, H.E. van Gelder, *Merken van Haagsche goud- en zilversmeden. Haagsche goud- en zilversmeden uit de XVIe, XVIIe en XVIIIe eeuw*, Den Haag 1941 (hereafter Voet, Van Gelder), p. 44, no. 47, 76; Jet Pijzel-Dommisse, *Haags goud en zilver. Edelsmeedkunst uit de hofstad*, Den Haag/ Zwolle 2005 (hereafter Pijzel-Dommisse), p. 79, fig. 64; p. 157, fig. 139; p. 301, fig. 219 (last two both probably wrongly attributed to The Younger); Documents System (hereafter Docsys) Gemeentemuseum The Hague

Louis Digues a 'young man from Blois' married Anna Catharina Castiljon in The Hague in 1693. Although he is described as a goldsmith in a legal document of 1697 there are no further documentary references and no silver bearing his mark is known.

REFERENCE: Voet, Van Gelder, p. 46.

Jesaias (or Esajas) van Engauw was born in The Hague, 9 June 1675, the son of Hendrik van Engauw, goldsmith/and jeweller and elder of the Lutheran Church, and Clara Preissensin ('from Pruysen'), also from a goldsmith's family. He married 1 April 1696 Theodora van der Beeck from Delft, and though he was sworn in on 25 June 1701, he declared in an official document that he had already started to work at the time of his marriage. Surviving silver includes candlesticks, boxes, casters, cups, a Catholic tabernacle (Plate 13), ewers and basins, a wine cooler and coffee urns; applied coats of arms indicate that many of his clients were aristocratic or royal (like the Prince of Orange). Though not of Huguenot origin, some of his work is fully decorated in the French style derived from prints by Daniel Marot (Plate 12), or in more modest taste with decorative mouldings and (often pointed) gadroons. In 1728 and 1736 he served as Dean of the Goldsmiths' Company. He died 20 June 1737.

REFERENCES: Voet, Van Gelder, pp. 51, 52, no. 83; Pijzel-Dommisse, p. 27, fig. 17, p. 78, fig. 68, p. 92, fig. 84, cat. 25, 32, 85; Docsys Gemeentemuseum The Hague.

Hermanus van Gulick was born in the Netherlands, probably in The Hague, and was married in there on 22 March 1676 to Cathryna Wachtmeesters from Amersfoort. He was sworn in on 22 June 1682, but was working already before that date (probably since his marriage), as a cruet set and stand for a Catholic Church and a shield for the St. Noach- or Wine Merchants Guild were marked and dated in 1680. His work shows French influence in the use of ornamental borders, acanthus leaves, gadrooning and fluting; he also used the designs of Daniel Marot (Plates 12). His work was ordered by Dutch and foreign aristocrats, by guilds, polder boards and churches; the objects include a fountain for a Russian prince, sconces, candlesticks, cups, shields, and objects for the Catholic mass. They are preserved in the Hague Historical Museum, the Gemeentemuseum, The Hague and The Hermitage, St. Petersburg. Van Gulick served as Dean of the Goldsmiths' Company in 1696. He died 2 October 1723.

REFERENCES: Voet, Van Gelder, p. 59, no. 39; Pijzel-Dommisse, p. 31, fig. 20, pp. 83, 87, figs 73, 74, 77, p. 97, fig. 89, cat. 19i; Docsys Gemeentemuseum The Hague.

Mattheus Loockemans was born in The Hague on 8 December 1649 as the son of Nicolaas Loockemans and Sara Mijtens. Nicolaas and his father Dirck (=Theodoor) Loockemans were among the most important goldsmiths in The Hague, supplying the stadholders and the States General with precious objects in silver, gold and enamel, acting also as jewellers. Apprenticed in his father's workshop, Mattheus was probably completing his training abroad when his father died in June 1673: his sisters continued the workshop with the help of the foreman Barent van Milanen until 1675. In that year Mattheus returned to The Hague, married on 10 November Anna van Steenwijck and probably took over the workshop. In 1678 he bought what was probably his father's house on the Venestraat. Among the surviving objects in the past wrongly attributed to him, marked with the anchor in a shield, are an English inspired garniture of jars and a perfume burner dated 1678/1679, made for Hans Willem Bentinck in the Portland collection at Welbeck; and two candlesticks dated 1679, almost exact copies of the Parisian candlesticks of the toilet set made for Princess Mary Stuart, now at Chatsworth (Plate 10). Mattheus Loockemans died 19 December 1719.

REFERENCES: Voet, Van Gelder, p. 82; Pijzel-Dommisse, pp. 33, 77, 158, figs 21, 65, 141, cat. 218, 273 (wrongly attributed to Mattheus with fake marks); Docsys Gemeentemuseum The Hague.

Adam Loofs was born in the Netherlands, probably in Amsterdam around 1645. It is not yet known when he went to Paris, his name is mentioned for the first time in the Archives of the Dutch Embassy chapel, where he is listed as an elder in 1670, 1672 and 1674, together with the King's Cabinetmaker Pierre Gole. Around 1672 Loofs married Anne Frère (in 1674 their first child was born): she may have been the daughter of his probable master Jean Frère, a goldsmith from Metz working at the market of Saint-Germain des Prés in Paris. Not officially a *maitre orfèvre*, Loofs must have been a working goldsmith in Paris as he had a apprentice called Estienne des Rousseaux around 1675. In September 1679 Loofs delivered to the court of stadholder William III in The Hague two silver tables,

accompanied by mirrors and guéridons, made in Paris by an unknown silversmith in association with Loofs. In May 1680 he was appointed Ordinary Gold- and Silversmith and Keeper of the Plate at the court in The Hague. In June 1680 he registered as a new resident, two years later, 16 May 1682, he was sworn in to the Goldsmiths' Company and entered his mark. Loofs maker's mark (AL conjoined below crowned horn, two dots) is very similar to the marks of Parisian goldsmiths and no doubt inspired by these. Loofs supplied the stadholder's court with many fashionable objects in the French style, ranging from mounts of enamelled gold on ebony furniture, and the most splendid chandeliers, andirons, pilgrim bottles, 'buires' (Plate 22) and vases (Plate 18), to more humble dishes, salts, teapots and spoons. He also delivered jewelry and diamonds, and in general was responsible for the maintenance of the plate. Besides his work for the court he also supplied other families associated with the court with silver and jewelry (Plates 18, 22). After the death of his patron William III Loofs continued to be Keeper of the Plate. He served as Dean of the Goldsmith Company in 1687, 1696, 1698 and 1700.

Adam Loofs and Anne Frère had five children, Pierre (1674–1726) and Marie Anne, both born in Paris; and Marie, Suzanne and Anne born in 1680, 1684 and 1688, all three baptized in the Walloon Church in The Hague. Pierre was trained as a goldsmith, designer and engraver and worked from 1717 onwards as 'Hofbaumeister' in Cassel: in 1706 he married Catharine, daughter of Jean-Henri de Moor, another Dutch born goldsmith from Paris, who after 1683 worked for king Christian V of Denmark.

Adam Loofs died in late April / May 1710, the death certificate has not been found.

REFERENCES: Voet, Van Gelder, p. 82 (not always correct), nr 40; S. W. A. Drossaers, Th.H. Lunsingh Scheurleer, *Inventarissen van de inboedels in de verblijven van de Oranjes en daarmede gelijk te stellen stukken 1567–1795,* Den Haag 1974-1976, vol. I, pp. 411-25; J. R. ter Molen, 'Adam Loofs, zilversmid van de koning-stadhouder en enkele nieuwe aspecten van zijn leven en werk', in: *Antiek* 22 (1987/8), pp. 518–26; Pijzel-Dommisse, p. 23, fig. 10, p. 26, fig. 13, p. 34, fig. 31, pp. 57–58, p. 116, figs 111–12, pp. 157, 197, figs 151, 165, 218, pp. 368-69, figs 228–29, cat. 33; Docsys Gemeentemuseum The Hague.

Richard Musseau married Anna Paeck 5 September 1694 in the Walloon Church in The Hague. Both came 'from France' and had not been married before. Probably due to problems within the guild he was officially sworn in on 4 November 1702, but probably worked as a goldsmith in The Hague soon after his marriage. Two objects are attributed to him, a kettle on stand made in 1707 (Plate 9) and a tazza, copy of three older specimens of 1621, made in 1710 for a Lutheran Church. He died shortly afterwards: his widow married again in 1711.

REFERENCES: Voet, Van Gelder, p. 91, no. 78; Pijzel-Dommisse, cat. 171; Docsys Gemeentemuseum The Hague.

Jean Rostang married as a 'young man from France' 1 March 1711 Anna Paeck, widow of Richard Musseau, and was sworn in on the ninth of the same month. His maker's mark (I.R below crowned rose, two dots) indicates his French background. His documented silver includes a sconce with two branches dated 1713,

a christening basin with cover for the Walloon Church in Delft dated 1719, a shield for a Civic Guard 1720, a Torah shield for the Jewish congregation in The Hague 1734 and a footed salver, dated 1735. He died 17 November 1735

References: Voet, Van Gelder, p. 103, no. 79; Pijzel-Dommisse, cat. 221; Docsys Gemeentemuseum The Hague.

Jean Sonjé (or Sanjé) married as a 'young man from Picardie' 7 July 1686 to Helene Linsay, a 'young woman' from Doesburg, a small town in the east of the Netherlands. The only silver attributed to him, based on the maker's mark of a sun, is a cruet set and stand, made in 1712/1713 for a Catholic Church in The Hague (Plate 8). A Jean 'Sonnier' died 10 May 1726.

References: Voet, Van Gelder, p. 104, no. 104; Pijzel-Dommisse, p. 99, fig. 89; Docsys Gemeentemuseum The Hague.

Albert de Thomese (or Thomasse) was married as a 'young man from Cleeff' (Germany) 26 February 1708 (for the Church 11 March), to Cornelia van Trooyen. In the same year, 19 December 1708, he was sworn in. The couple had five sons and a daughter: the eldest son Jan was a silversmith and above all 'kashouder' (retailer and goldsmith-banker), his third son Adrianus was a jeweller. Albert produced silver for the Government, the Stadholder and the most important families in The Hague. In 1749 he delivered two chandeliers with 8 branches for nearly 4000 guilders to Stadholder William IV, married to Princess Anna of Hannover. His work includes toilet services (Gemeentemuseum The Hague), teapots and kettles, tureens, an epergne, casters, candlesticks, candelabra, sconces and chandeliers. These are mostly in a sober style characteristic of The Hague in the early eighteenth century and described in the Netherlands as the Louis XIV-style: octagonal or round forms with mouldings and sometimes gadrooning. A set of six large candlesticks of 1727 are more elaborate, with finely cast and chased French ornament. In the 1740s his work incorporates asymmetrical rococo curves. Albert was very successful: a wealthy citizen of The Hague; he owned some large houses. His son Jan was a member of the 'Vroedschap' (the most important city council) and acted as the most significant agent between customers and silversmiths in the middle of the century in The Hague. In 1735 Albert served as Dean of the Goldsmith' Company. He died 12 February 1753.

References: Voet, Van Gelder, pp. 115, 116, no. 80; A. Krekel-Aalberse, 'Achtkante theepot met de Haarlemsche *N* van 1795', in: *De Stavelij Jaarboek* 2005, pp. 69–72; Pijzel-Dommisse 2005, p. 91, fig. 82, p. 204, fig. 160, pp. 372, 373, cat. 20, 26, 222; Docsys Gemeentemuseum The Hague.

Jacques Tuillier was married to Jeanne Sauvage, as recorded in a document of 1706 about their house on the Veerkade in The Hague. Both their French names suggest a French background, but there is no information to prove this. He was sworn in on 2 July 1701, at the end of a 10-year period in which no new admissions to the guild were recorded, but he was probably active before this date. Surviving objects include candlesticks, salvers, inkstands, sauce boats, a large

cooler, a toilet set mirror, a kettle on stand and ecuelles. His work, typical of silver made in The Hague, is of strong form, the decoration restricted to mouldings and gadrooning. He served as Dean of the Goldsmith's Company in 1725, 1726 and 1731 and died after 1741 (the date of his last recorded work).

REFERENCES: Voet, Van Gelder, p. 117, no. 56; Pijzel-Dommisse, cat. 34, 149, 220, 237; Docsys Gemeentemuseum The Hague.

Biographies of Huguenot goldsmiths in Berlin and Cassel

Tessa Murdoch

Daniel Baudesson (1716–1785) goldsmith

Born in Berlin, his father was a refugee from Metz. From 1741, he worked in Berlin with the Huguenot Samuel Colliveaux. After this, he spent some time in Paris. On his return to Berlin, he specialized in producing gold boxes, he made eighteen for Frederick the Great between 1747 and 1765. Baudesson worked closely with the Huguenot painter Daniel Chodowiecki (1726–1801). Baudesson has been described as one of the most imaginative designers of snuff boxes in Germany; his work certainly rivalled that of the best Paris goldsmiths. In 1766 he is referred to as '*Hofjuwelier*' (court goldsmith).

Isaac Beaucair (1723–1793) goldsmith

Apprenticed to his father Pierre Beaucair, he took on a Huguenot apprentice Jacques Louis Clément (1748–1837). Isaac Beaucair continued to conduct his business in French until 1782.

Pierre Baudouin (Master 1716–1721) goldsmith

Baudouin, who also came from Metz, was apprenticed to Louis Rollin in Cassel in 1699.

Pierre Beaucair (1696–1775) goldsmith

Born in Metz and trained there. Settled first in Hanau and is documented in Cassel from 1720 where he worked for Louis Rollin. He became master goldsmith in 1721. He made a ewer for the French Church in Cassel which is dated 1733. He lived in Cassel until his death in 1775.

Louis Buyrette (fl. *circa* 1740) jeweller and goldsmith

His widow sold ten boxes to the Royal Household between 1743 and 1749. These included 'Tabatière de Jaspe blanc garnie d'or et avec rosettes façon de Cornemuse' for 130 thalers in November 1743 and the following month one 'de jaspe garnie de brilliants et rubis', another in stone cut as a tiger with diamond teeth, and a third formed as a tortoise.

Philipp Colliveaux (fl. *circa* 1750–1760) jeweller and goldsmith

He worked in Berlin and sold Frederick the Great three snuffboxes in 1753 and 1754.

Samuel Colliveaux (fl. *circa* 1740–1750) jeweller and goldsmith
Daniel Baudesson worked with Colliveaux in Berlin in the 1740s.

Pierre Fromery (1659–1738) jeweller
Born in Sedan, he is thought to have left France for Prussia in 1668. He died in Berlin. He worked for Carl August of Brandenburg, Bishop of Magdeburg. With his son, Alexander Fromery, established a tradition of enamelling in Berlin and persuaded the leading enameller Christian Friedrich Herold to work for them in addition to his work for the Meissen Porcelain manufactory.

Alexander Fromery (fl. 1730–1740) jeweller
Son of Pierre Fromery, Alexander took over his father's business on his death in 1738. He signed a plaque illustrating the flight of Stanislas Leczinski from Danzig to Bar in 1734 'Alex Fromery à Berlin'.

Pierre Jassoy (1662–1714) jeweller
Born in Metz, recorded in Cassel by the 1680s. Moved to Hamburg in 1690 and subsequently recorded in Berlin, where he died.

André Jordan (fl. 1743–1775), jeweller and goldsmith
Brother of Jean Louis Jordan, both goldsmiths worked in Berlin and between them sold thirty-seven gold boxes to the royal court between 1743 and 1775.

Jean Louis Jordan (fl. 1743–1775), jeweller and goldsmith
Brother of André Jordan, the boxes they supplied to Frederick the Great in 1775 were amongst the most expensive at 12,000 thalers each. One was described as 'tabatière émaillée bleu transparent sujet d'or relevé sur dessin choisi, riche en brilliants, commandee' and 'tabatière de crisoprase, riche en brillants'.

Jean Guillaume George Krüger (1728–1791) chaser, engraver and painter in enamels
Born in London in 1728, he later settled and worked in Paris. Krüger was self taught as a chaser, engraver and painter in enamels. His contemporary, Jean François Reclam, noted of his stay in Paris 'Il n'y travailla sous aucune Maitre, mais sachant superieurement le dessin et ayant un talent naturel très décidé pour la peinture, il se former lui-meme'. By 1753 he was in Berlin where he married Marie Ann Arnal. Thirteen designs for boxes by Krüger are in the Kupferstichkabinett, Berlin. Krüger was the principal designer of gold boxes for Frederick the Great, although as patron, Frederick also contributed to the design process.
In Berlin Krüger worked closely with the jeweller goldsmith Charles Benjamin Lefevre (1708–1756). He returned to Paris briefly in 1774, when he exhibited at the Academy of St Luke as a painter of enamels. Krüger died in Berlin.

Martin Laignier, jeweller and goldsmith
He sold Frederick the Great one coloured gold box in 1753.

Pierre Lautier the Elder, jeweller and goldsmith
He sold Frederick the Great three boxes in 1755.

Charles Benjamin Lefevre (1708–1756) chaser
Specialist in chasing gold plaques.

Jean Oudel, jeweller and goldsmith
He sold Frederick the Great two boxes in 1754

Jean Reclam (d. 1754) jeweller
Born in Dublin, the son of Balthasar Reclam (1666–1744) who came to Ireland from Geneva, and later settled in Bremen. His son Jean came to Berlin via Magdeburg in 1739. He built a house in Jägerstrasse. He became court jeweller to Frederick the Great.

Jean François Reclam (1732–1817) jeweller and goldsmith
Studied under the Huguenot painter Antoine Pesne (1683–1757) and succeeded his father as principal goldsmith to Frederick the Great.

Louis Rollin (1674–1731) goldsmith
Born in Metz, where his father worked as a wine merchant. He joined the workshop of Johann Christian Perti in Cassel, and witnessed his master's marriage in 1682, and stood godfather to his son in 1703. Rollin became a master goldsmith in 1699 and married the daughter of a local goldsmith. In that year he took on his first apprentice, the Huguenot Pierre Baudouin. Rollin introduced French silver forms into the repertoire of Cassel silver, including the chocolate pot.

APPENDIX **4**

Huguenot goldsmiths in New York and Philadelphia

Caroline Rainey

New York

Bartholomew LeRoux I (*c.* 1665–1713) arrived in New York City sometime before 1687 as he was made a goldsmith freeman that year. It is not known where he was born or where he trained although he probably came to New York via London. He was the first goldsmith of non-Dutch ancestry to work in New York City, paving the way for other immigrant Huguenots. He introduced the cosmopolitan Baroque style when the simple provincial Dutch style was in fashion. In 1688, he married Gertrude Van Rollegom; two of their children, Charles and John, became goldsmiths. He became an assistant alderman on the Common Council. He died in New York City in 1713.

REFERENCE: Deborah Dependahl Waters, ed., *Elegant Plate: Three Centuries of Precious Metals in New York City*, Vol. 1, New York 2000, pp. 152–53 (hereafter Waters).

Charles LeRoux (1689–1745) was born in New York City, and baptized in 1689, the son of Bartholomew LeRoux I, a famous New York Huguenot goldsmith, and Gertrude Van Rollegom. He was probably trained by his father. On February 16, 1724/1725, he became a goldsmith freeman in New York City. Charles LeRoux married Catherine Beekman in 1715; their son, Bartholomew LeRoux II was born in 1717; he would later succeed his father in the goldsmithing trade. Charles LeRoux held the title of official silversmith to the New York City Common Council. He also served in the city militia as a captain. Nearly all of his surviving work is in the 'Huguenot' Anglo-Continental style of the 1720s. He also made pieces in the local New York-provincial Dutch style for his clients of Dutch descent, although very little of this work survives. Peter Quintard, Jacob Ten Eyck, and his son, Bartholomew LeRoux II were trained in his workshop. He made nine gold or silver freedom boxes for the New York City Common Council, including one for Alexander Hamilton in 1735. In 1745, the April 1ˢᵗ edition of the *New-York Weekly Post-Boy* reported the death of Charles LeRoux.

REFERENCE: Waters, pp. 155–59.

Bartholomew LeRoux II (1717–1763) born in New York City, and baptized in 1717, the son of Charles LeRoux, a New York Huguenot goldsmith, and Catherine Beekman. He became a goldsmith freeman in New York City in 1739. He took over the family business by the mid-1740s. However, he was less influ-

ential than his father or Simeon Soumaine. He never married. On his death in 1763, his estate was left to his siblings.

REFERENCE: Waters, pp. 153–55.

Simeon Soumaine (1685–*c*. 1750) was baptized in London in 1685, the son of Simeon and Jeanne Piaud Soumaine. His parents settled in London, before moving to New York City sometime prior to 1689. Little is known about Simeon's early training or practice but he was known as a master by 1719, when he registered his first apprentice. His personal life is also a mystery. Two of his most famous apprentices are Elias Pelletreau and Elias Boudinot. His silver shows superior technical skill and is in the cosmopolitan style. Soumaine's cosmopolitan style influenced the work of Philadelphia goldsmiths. He died about 1750.

REFERENCE: Waters, pp. 188–96.

Peter Quintard (*c*. 1699/1700–172) was born in either New York City or Bristol, England in 1699/1700 to Isaac and Jeanne Fume Quintard. He registered as a goldsmith in New York City in 1731, though he later worked as a ship owner and innkeeper. He was married twice, first to Jeanne Baillereau who died in 1757, then to Deborah Knapp. He was apprenticed to Charles LeRoux and upon becoming a master, took on Peter David as his apprentice in 1722. He moved to Norwalk, Connecticut in 1737 where he farmed and continued his goldsmithing business. He died in 1762.

REFERENCES: Henry N. Flynt, *The Heritage Foundation Collection of Silver*, Old Deerfield, Massachusetts, 1968, p. 307 (hereafter Flynt).

Elias Pelletreau (1726–1810) was born in Southampton, New York County in 1726 to Francis Pelletreau, a merchant, and Jane Osborne. He was apprenticed to Simeon Soumaine in 1741/1742. He became a goldsmith freeman in 1751 in New York City. His mother died and his father married Mary King in 1734. When Elias' father died that same year, his stepmother married a Hugh Gelston, a family friend in 1737. In 1748, Elias married his stepsister Sarah Gelston. He remarried twice. Elias and his family moved back to Southampton, New York County in the early 1750s where Elias started a goldsmithing business. The family fled to Connecticut when Southampton came under British occupation in 1776 but returned in 1782 towards the end of the American Revolutionary war. Records show that his clientele was local to Southampton. Because of his largely English-Quaker clients, he created relatively modest objects which were more in keeping with their tastes. Upon Elias' death in 1810, his son John inherited the family goldsmithing business.

REFERENCES: Flynt, pp. 296; Waters, pp. 174–78.

Otto de Parisien (w. 1756–1797) arrived in New York in 1756. He worked from 1756 to 1797 as a goldsmith. His advertisements state that he was "from Berlin". He stood godfather to fellow goldsmith Elisha Gallaudet's son. In 1769 he paid a Freemanship fee to be listed as a goldsmith because he had served his apprentice-

ship outside of New York City. He specialized in chasing and also worked in metal refining, and may have been associated with the renowned Jewish goldsmith Myer Myers. Interestingly, though European in origin, his work shows no affinity to the styles of Continental Europe but instead resembles the work of non-immigrant and non-Huguenot goldsmiths in New York.

REFERENCE: David L. Barquist, *Myer Myers: Jewish Silversmith in Colonial New York*, New Haven, Connecticut 2001, pp. 46, 53 (hereafter Barquist 2).

Philadelphia

Cesar Ghiselin (*c.* 1663–1733) was born in 1663 in Rouen, France to Nicholas Ghiselin and Ann Gontier. He may have been trained in England, where he immigrated as a teenager before leaving for the American Colonies. In 1681, he went to Chester, Pennsylvania before moving to Philadelphia in 1682. He was Philadelphia's first goldsmith and 'the earliest Huguenot silversmith working in the mid-Atlantic region'. His pieces were more in the style of English silver than the fashionable Continental European styles. He married Catherine Reverdy by 1693 and they had three children. However, his grandson William was the only one in the family to take up the goldsmithing trade. In 1726, his wife Catherine died. He then moved back to Philadelphia where he opened a goldsmithing business and where he died in 1733.

REFERENCE: *Philadelphia: Three Centuries of American Art*, Philadelphia 1976, pp. 5–7 (hereafter Philadelphia).

John Nys (1671–1734) is presumed to have been born in New York City in 1671 to Huguenot parents who had fled Holland as a result of the persecution preceding the revocation of the Edict of Nantes. He is believed to have been trained in New York City though his master is unknown. John Nys moved to Philadelphia around 1695 where he became the city's second goldsmith. He was married in 1693 to Margrietie Keteltas. Throughout his career in Philadelphia, he was known as a superior goldsmith, rivalled only by Cesar Ghiselin. His famous clientele included Andrew Hamilton, Francis Knowles, and Anthony Morris. In 1723, he retired to Kent County, Delaware where he died in 1734.

REFERENCE: Philadelphia, pp. 7–8.

Peter David (1707–1755) founded the David goldsmithing dynasty. He was born in 1707 in New York City. He was trained in New York by Peter Quintard. The date of his marriage to Jane is unknown though their first child named John was baptized in 1736 in Philadelphia, recording the family's move from New York City. His first wife died in 1752 and Peter remarried Margaret Swanson Parham in 1753. His son John took up goldsmithing as well as his grandson, John Jr. His work shows the influence of New York Huguenot goldsmiths long before the other Philadelphia goldsmiths. Peter David died in 1755. His son John Sr. inherited the shop and according to the *Pennsylvania Gazette*, sold a variety of gold and silver as well as imported paste jewellery, buckles and buttons. John David Sr. died

in 1793. John David Jr. was born in Philadelphia in 1772. He later formed a partnership with his uncle, Daniel Dupuy Sr. from 1792 to 1805. John Jr. died in 1809.

REFERENCES: Collected by Alfred Coxe Prime, *The Arts and Crafts in Philadelphia, Maryland and South Carolina; Gleaning from Newspapers,* Topsfield, Massachusetts, 1929–33, p. 57 (hereafter Prime); Philadelphia, pp. 44–46, 161.

William Vilant (w. 1725) is believed to have been born in New York, the son of David Vilant, a merchant. He was born some time before 1707, when he is listed in his father's will. Very little information is known about Vilant other than he worked for a time in Philadelphia and advertised there in 1725, the only documentary evidence for him. Vliant's tankard was engraved in 1750 by Joseph Leddel.

REFERENCE: Prime, p. 94.

Daniel Dupuy Sr. (1719–1807) was born in New York City in 1719 to Daniel Dupuy Sr. He studied under Peter David who was also his brother-in-law. In 1746, Daniel married Eleanor Dylander. Two of their sons, John and Daniel Jr. were trained as silversmiths, though John became a watchmaker. He moved to Philadelphia possibly with Peter David by 1738. Dupuy Sr. later trained his son Daniel Dupuy Jr. While he made silver in Philadelphia, his shop also sold silver imported from England. He worked with his two sons and then later likely went into business with his nephew, John David from 1792 to 1805. He died in 1807.

REFERENCE: Philadelphia, p. 161.

Daniel Dupuy Jr. (1753–1826) was born in Philadelphia in 1753 to Daniel Dupuy Sr., a goldsmith, and Eleanor Dylander. He was trained in the art of goldsmithing by his father and worked on and off for several years with his father and brother. He moved to Reading, Pennsylvania in 1777 to start his own business. He would later move home to Philadelphia in 1782 and open his own goldsmithing shop with his brother John. In 1784, Daniel and John joined their father's business but by 1785 both of the brothers went back to working at their previous business. He died in 1826.

REFERENCE: Philadelphia, p. 161.

Allied Craftsmen mentioned

Joseph Leddel Sr. (*c.* 1690–1754) was born in or before 1690 and immigrated from Hampshire, England to New York City. Interestingly, he was famous for his work as Huguenot pewterer as opposed to being a goldsmith. In 1711, Joseph married Marie Vincent; they had a son, Joseph Jr. who would succeed his father in business as a pewterer as well as three other children. In 1752 he was married again to Mary Patterson with whom he had a daughter. Joseph Leddel Sr. was best known for his engraving. His most famous engravings, made in 1750, were allegorical allusions to the Stuart attempt to retake the throne during the Jacobite

Rebellion. These and other of his engravings were strongly anti-Catholic and illustrated religious persecution, the reason why many Huguenots left France. He died in 1754.

REFERENCE: Waters, pp. 151–52.

Elisha Gallaudet (*c.* 1730–1805) was born in New Rochelle, Long Island in 1730. He was active in 1756 and may have worked as an engraver for the goldsmiths Myers, Pelletreau, and others. He started his career by engraving plates for counterfeiters before working for legitimate clients. His one documented commission was in 1767, when he engraved four medals for the Literary Society in New York at King's College. Gallaudet died in 1805.

REFERENCE: Barquist 2, pp. 38–39.

Huguenot goldsmiths in Boston and Charleston

Beth Carver Wees

Nicolas De Longuemare Jr. was born in Dieppe, France, around 1672, the son of Nicolas De Longuemare Sr, a watchmaker, and Anne Le Roy. He emigrated to South Carolina with his father in about 1685 and was working as a goldsmith in Charleston, by 1702. He married his first wife, Marie Bonneau (d. 1699) sometime before September 1695; they had three children: Alexandre, Marie, and Floride. His second wife was Marie Aunant, whom he married in Charleston in about 1707. De Longuemare's surviving account book (1703–11) itemizes a good deal of silver, including spoons, knives and forks, and seals, as well as mending of watches and clocks. He also dealt in silks. No objects are known today. According to the Register of St. Thomas and St. Denis Parish, Nicolas De Longuemare Jr was buried in Charleston on 15 January 1711/2.

REFERENCES: E. Milby Burton, *South Carolina Silversmiths, 1690–1860*, 1968, reprinted Savannah, Georgia, 1998, pp. 47–48 (hereafter Burton); and Samuel Gaillard Stoney, 'Nicholas De Longuemare: Huguenot Goldsmith and Silk Dealer in Colonial South Carolina', *Transactions of the Huguenot Society of South Carolina* No. 55, Charleston 1950, pp. 38–65.

Peter Feurt, son of Bartholomew Feurt and Madelaine (Peiret) Feurt, was baptized in the French Church in New York on 19 December 1703; his godparents were Pierre Peiret and Susanne Lambert. By the spring of 1727 he was living in Boston, where he was granted "Liberty . . . to Reside in this Town to open A Shop and Exercise his Calling . . ." He married Susanna Gray (b. 1703) on 23 April 1728 at Christ Church, Boston. No children are recorded. Feurt's one identified mark is PF crowned, lozenge below, in shaped surround. His extant work includes one cann; one two–handled cup and cover (now at the Yale University Art Gallery); and two serving spoons (one now at Historic Deerfield). The two–handled cup was owned by Henry Hope and/or Edward Mills, Jr. Peter Feurt died in Boston in August 1737.

REFERENCE: Patricia E. Kane, ed., *Colonial Massachusetts Silversmiths and Jewelers,* New Haven 1998, pp. 478–80 (hereafter Kane).

René Grignon, born *circa* 1652, immigrated to Boston from London in the mid–1680s in the entourage of the Huguenot merchant Gabriel Bernon (1644–1736). His wife, Mary, predeceased him, and no children are mentioned in his will. Grignon had at least two apprentices: Joseph Soames (1680/1–1705) and Daniel Deshon (*circa* 1698–1781). Sometime after 1704 he moved to Norwich, Connecticut, where he is listed as master of a ship and a merchant. His mark, RG

crowned in a shaped surround, has been found on only on two porringers, one belonging to the Yale University Art Gallery, which was made for James and Elizabeth (Andrews) Rayner. The Yale porringer is also marked by Boston silversmith Jeremiah Dummer (1645–1718). René Grignon died in Norwich, Connecticut; his will, dated 20 March 1714/5, was proved 12 April 1715.

REFERENCE: Kane, pp. 518–21.

John Paul Grimke, jeweller and smallworker, was born in 1713, possibly in Alsace–Lorraine. He was apprenticed in London to John Brown, citizen & jeweller, in 1731. By 1740 he was working as a jeweller and smallworker in Charleston, South Carolina. His first wife, whom he married in Charleston on 20 June 1744, was Ann Grimball (d. 1747); they had one child, Providence (b. March 1745/6). In about 1749 he married Mary Faucheraud (born *circa* 1725), again in Charleston. Their three children were John Faucheraud (1752–1819); Ann (b. *circa* 1754); and Mary. No objects survive marked by Grimke, who retired *circa* 1772. He died on 9 January 1791, and is buried in St. Michael's Episcopal Churchyard in Charleston.

REFERENCE: Burton, pp. 73–78.

Francis Légaré (formerly L'égaré) was born around 1636. With his wife Ann and their three children, Francis Solomon (*circa* 1674–1760); Daniel James (1689–1724/5); and Stephen John, he emigrated to England, where he was naturalized in March 1682. His name first occurs in the Boston tax list in 1687, and he is identified as a goldsmith of Boston in a real estate transaction in 1693. Although no silver or jewellery by him has been located, his estate inventory suggests that he sold jewellery and small hollow ware items. Légaré died in Braintree, Massachusetts, on 30 December 1711.

REFERENCE: Kane, pp. 651–52.

[Francis] Solomon Légaré, known as Solomon, was born in France around 1674 and immigrated with his father Francis, his mother Ann, and two brothers to England, where they were all naturalized. The family moved to Massachusetts by February 1691. Solomon was probably apprenticed to his father, at least until 1693, when he married against the older man's wishes and relocated to Charleston around 1696. Solomon and his wife Sarah had two children while in Boston: Solomon (born 17 September 1693) and Sarah (born 18 July 1695). Their third child, Mary, was born in Charleston around 1697. After Sarah's death in 1702, he married Keltie Carter, with whom he had four children: Solomon (1703–74); Daniel (1711–91); Mary (d. by 1797); and Hannah (d. 1751). He married his third wife, Ann Jones (d. 1736), in Charleston ca. 1714. They had two children: Thomas (born 1714 or 1715–78) and John. No mark is recorded for Solomon Légaré, nor is any surviving silver known. He died in Charleston on 8 May 1760. His estate inventory listed 68 oz. 16 dwts. of old silver and gold.

REFERENCES: Kane, p. 653, and Burton, pp. 105–10.

Samuel Prioleau, son of the Rev. Elias or Elie and Jeanne (Burgeaud) Prioleau, was born in Charleston, South Carolina in 1690. He is recorded as a jeweller in Charleston by October 18, 1721. He was married by that date to Mary Magdalen Gendron. By 1732 Prioleau had become Colonel of the Troop of Horse Guards. No silver or jewellery has been firmly identified as his. He died in Charleston and was buried on 30 April 1752.

Reference: Burton, pp. 152–53.

Apollos Rivoire (Paul Revere Sr) was born on 13 November 1702, the son of Isaac Rivoire and Serenne Lambert. He was baptized at Riocaud in south western France, where his grandparents lived. Rivoire immigrated to Boston in 1716 and was apprenticed to John Coney (1655/6–1722). He married Deborah Hichborn (1703/4–77) on 19 June 1729. Their nine children were all baptized in Boston's New Brick Church: Deborah (1731/32); Paul (1734); Frances (1736); Thomas (1738); Thomas again (1739/40); John (1741); Mary and Elizabeth (1743); and Elizabeth again (1744/5). Six marks are associated with Revere: PR in a shaped shield; PR in a rectangle (two sizes); P[pellet]Revere script within a plain rectangle; P[pellet]Revere script in a shaped rectangle; P[pellet]REVERE in a scalloped rectangle; P[pellet]REVERE in a plain rectangle. Kane identified over 60 objects marked by Revere Sr and made for private individuals in New England as well as for some churches. Surviving objects include canns, casters, a chafing dish, cream-pots, pepper boxes, porringers, salts, one sugar bowl, tea- and tablespoons, tankards, and teapots. Many examples are owned by the Museum of Fine Arts, Boston; others are at The Metropolitan Museum of Art, Yale University Art Gallery, Worcester Art Museum, and other American Museums. His best known apprentice was his son, Paul Revere Jr (1734–1818, back cover). Revere died intestate on 22 July 1754 and was buried in the Granary Burying Ground in Boston.

Reference: Kane, pp. 848–52.

Jonathan Sarrazin (birth date unknown), the son of Moreau Sarrazin (1710–61), was working with his father in Charleston, South Carolina, by 1754. He married three times, each time in Charleston: in 1757 to Charlotte Banbury (d. 1762); in 1765 to Lucy Lance; and in June 1770 to Sarah Prioleau. In 1760 Sarrazin became a member of the South Carolina Society, a social and philanthropic organization established by local Huguenots to help preserve their identity. He worked as a jeweller and a merchant, advertising in the 1760s extensive imports of silver and jewellery. In 1765 he purchased the stock of retiring silversmith Alexander Petrie (1707–68), and after Petrie's death in 1768, Sarrazin purchased his 'negro silversmith' Abraham. Jonathan Sarrazin died in Charleston on 9 February 1811.

Reference: Burton, pp. 163–66.

Moreau Sarrazin was born in Charleston, South Carolina in 1710, probably the son of Stephen Sarrazin. He appears to have been in business as a jeweller by 1734, and he also worked as an engraver. In 1737 he joined the South Carolina Society,

a Huguenot group. Sometime after June 1745 he established a short-lived partnership with William Wright (active *circa* 1740–51), which was dissolved by the end of 1746. His son Jonathan (d. 1811) worked with him from about 1754. Moreau Sarrazin's one identified mark is MS in a rectangle. Of his surviving work, there is one large serving spoon, engraved on the handle with the emblem and motto (*Posteritati*) of the South Carolina Society, now at the Charleston Museum; a punch ladle with wooden handle; and a chocolate pot marked both MS and AA [information provided by Brandy Culp, Curator, Historic Charleston]. Moreau Sarrazin died in Charleston on 4 February 1761 and was buried in the west cemetery of St. Philip's Church.

REFERENCE: Burton, pp. 166–69.

APPENDIX **6**

Names of known, believed or possible Huguenot goldsmiths of Cork

John Bowen

Peter Ardouin

He was the son of Mathurin Ardouin whose freedom was granted in July 1699, as one of the group which included Adam Billon. He received his freedom in 1730. He may be the same Peter Ardouin who was apprenticed in 1719 to Daniel Pineau, a Dublin Huguenot goldsmith, though if so, it appears that he confined his professional activities to the capital.[1] The name Peter Ardouin is mentioned as a witness at a Hardy/Perdrian marriage in 1760 in Cork.[2]

Charles Begheagle

Begheagle is believed to be of Flemish origin. He was warden of the Cork Company in 1693. Noted as a chaser, he worked on the chasing of the head of the mace of the trade guilds of Cork,[3] but fell ill in 1696 before its completion. He died the following year. He was responsible for the beautiful mug chased with accomplished depictions of the Four Seasons, now in the collection of the National Museum of Ireland.[4]

Adam Billon

Billon arrived in Cork as a refugee in 1699 and was supported by the Anglican bishop, Dive Downes. He was admitted a freeman on the bishop's sponsorship and took the oaths of allegiance and supremacy, thereby effecting his naturalisation, at the Cork assizes, in August the following year, unusually therefore, becoming a freeman of the city before naturalisation. He was an accomplished goldsmith, a fact attested to by the surviving examples of his work.

Simon Peter Codier

Codier was apprenticed to James Foucault, becoming free in 1725. He is believed to have died *circa* 1759.

James Foucault

Foucault was apparently the son of Peter Foucault, surgeon of Dublin. He was apprenticed in 1700 to the Dublin goldsmith John Harris. He is first noted in Cork in 1714 where on 6 December he is noted in the Council Book as James Foucauld, jeweller, and that he received his freedom 'during residence' paying 20s. An entry in the Council Book dated 9 July 1729, directed: 'That £8 6s. be paid the Widow Foucault for seven silver boxes given with freedoms.' He served on the council of the Corporation during the 1720s and was sheriff in 1721.[5]

Phineas Garde

The surname Garde is presumed to be of Huguenot origin. Phineas Garde was noted by Bennett as active in the period 1812-45.[6] His surviving work, mostly flatware, is of good quality.

Richard Garde

Richard Garde is noted by Bennett as being of 18 Broad Lane in 1824, and as having registered in 1827.[7] His period of prominence as a goldsmith was in the 1820s and he is the maker of the silver-gilt freedom box presented in 1822 to Viscount Bearhaven.[8]

Edward Gillett

In 1705 Edward Gillett obtained his freedom of the Corporation of Youghal. He was a leading goldsmith and a prominent member of the local community, being elected a common councilman in 1712, and serving as mayor in 1721. He was noted as "still living" in 1740.[9] Much of his surviving work was wrought for church use in the immediate vicinity of Youghal.

John Gillett

Lee notes that John Gillett, possibly the son of Edward, was a goldsmith in Youghal in 1749.[10]

Robert Goble

Lee and others assert that the Goble family is of Huguenot origin, though little direct evidence is available to support that assertion. Nonetheless Edward Goble and Robert Goble, braziers, were trustees of the Cork Company upon its foundation in 1656. Their relative Robert Goble, see main text, was first mentioned as a goldsmith in 1676. Robert Goble was warden of the Cork Company in 1672, and served as master of the Company in 1677, 1694 and 1695. Bennett asserts he died in 1719 and was buried at the Huguenot cemetery, French Church Street in Cork.[11]

Robert Goble II

The *Council Book* records 10 September 1694: '*Ordered that Robert Goble, on his petition, be admitted a freeman gratis, at the Mayor's pleasur*e.'[12] This is likely to be a reference to a son of the former, admitted by virtue of being the son of a freeman. He served as warden of the Cork Company in 1719 and died in 1737.

Reuben Millard

He was free by service to William Clarke, goldsmith, 16 October 1723. He died in 1737.[13]

Samuel Pantaine

Samuel Pantaine is first noted as warden of the Cork Company in 1678. He was master the following year, and again in 1686. He died in 1689.

Perdrian family

Lee and St. Leger both refer to some members of this Huguenot family being jewellers in Cork. Their ancestor was Daniel Perdrian, a prominent figure in the Cork sailcloth industry and a very involved member of the council, sheriff of Cork in 1704 and mayor in 1712.[14]

John Ricketts

His name is possibly a corruption of the Huguenot Ricards. First mentioned in 1721, he obtained his freedom in 1727. His will was probated 1737.[15]

Thomas Robinette

Robinette came to Cork apparently from Tallow, Co. Waterford, in 1791 to take up an apprenticeship with the distinguished Cork goldsmith, Carden Terry. Little else is known of him, though Lee asserts that he may be the son of Roger Robinette of that county who was dead by 1781.[16]

John Sebille

Evans notes this man as 'A French refugee'; she further notes that he was admitted a Freeman of the Cork Goldsmiths' Company in 1685.[17] In fact, this appears to be an erroneous transposition of part of the original Woods details for Anthony Semirot.[18] Thus there is no evidence for Sebille being a Cork goldsmith.

Anthony Semirot

Semirot, as noted already, experienced difficulty in being admitted to practise his craft in Cork, only achieving same by the apparent intervention of the mayor, William Hovell. He was warden of the Company in 1710 and master two years later. He died in 1743 but left a son, also Anthony, to continue his name and craft, having been apprenticed to the Dublin goldsmith Thomas Dean in 1716. He was a goldsmith of considerable ability as attested to by his surviving work.

William Teulon

William Teulon is listed amongst Cork's goldsmiths in 1791. The first note of the family in Cork was the naturalisation of Antoine Teulon in 1708. The family included merchants, distillers, and Captain Charles Teulon of 28th Regiment of Foot, who was granted the freedom of the City for his service at Waterloo. William Teulon is noted as 'still living' in 1844. The firm of S. & E. C. A. Teulon is noted as a firm of silversmiths etc. at 58 Patrick's Street in the mid-nineteenth century.

John Toleken

John Toleken was first noted in Cork in 1768 where he was naturalised as a foreign merchant 'now of the City of Cork'. The silversmith John Toleken is probably a son of the former. He registered in 1798 and worked as a silversmith until 1836.[19]

Verdaille family

On 4 August 1707 James Verdille 'clothier' was admitted 'free upon the Act'.[20] On

24 July 1723 James Verdille was admitted a freeman upon paying £5. The latter was most likely a son of the former.[21] Lee notes (reference Sir Charles Jackson) that the Verdailles had become jewellers by 1754.[22]

NOTES

1 Grace Lawless Lee, *The Huguenot settlements in Ireland*, London 1936, pp. 33–34.
2 Lee 1936 (as note 1), p 54.
3 Charles J. Jackson *English goldsmiths and their marks*, 2nd edn 1921, pp. 682–85.
4 J. R. Bowen and C. O'Brien, *Cork silver and gold: four centuries of craftsmanship*, Cork 2005, p. 57.
5 Bowen & O'Brien 2005 (as note 4), p. 181.
6 Douglas Bennett, *Collecting Irish Silver, 1637–1900*, London 1984, p. 185.
7 Bennett 1984 (as note 6), p. 185.
8 Bowen & O'Brien 2005 (as note 4), p 165.
9 Lee 1936 (as note 1), p. 71.
10 Lee 1936 (as note 1), p. 71.
11 Bennett 1984 (as note 6), p. 185.
12 Richard Caulfield, ed., *Council Book of the Corporation of the City of Cork,* Guildford 1876, p. 236
13 Bowen & O'Brien 2005 (as note 4), p. 184.
14 Alicia St. Leger, *Silver, Sails and Silk: Huguenots in Cork, 1685–1850*, Cork 1991, p 26.
15 Bowen & O'Brien 2005 (as note 4), p. 185.
16 Lee 1936 (as note 1), p. 49.
17 Evans 1933 (as note 14), p. 552.
18 Correspondence by Conor O'Brien with the writer December 2006.
19 Bennett 1984 (as note 20), p187.
20 Caulfield 1876 (as note 12), p. 326.
21 Caulfield 1876 (as note 12), p. 431.
22 Lee 1936 (as note 1), p. 65.

Names of known, believed or possible Huguenot goldsmiths of Dublin

Tessa Murdoch and Thomas Sinsteden

Abbreviations

A: Apprenticed.

QB: Quarter Brother. Quarter Brothers were either foreigners (i.e. living outside the walls of Dublin) or craftsmen of different religious preference to the Protestant established Church. They were required to strike their mark after completing their seven years' apprenticeship.

F: Freeman.

Fl.(fl.): Working dates.

AP: Act of Parliament 1661.

Sources

Joan Evans, Huguenot Goldsmiths in England and Ireland, *Proceedings of the Huguenot Society*, XIV, 1933, pp. 496–554.

Charles Jackson, *English Goldsmiths and Their Marks*, 1921.

Thomas Sinsteden, Surviving Dublin Assay records, Part II, *Journal of the Silver Society*, 16, 2004, pp. 87–101. (TS)

The Archives of The Dublin Assay Office. (ADGC)

Freemen Rolls of City of Dublin, Gertrude Thrift, 1919, Archives City of Dublin. (FR)

Proceedings of the Huguenot Society of Great Britain & Ireland. (PHS)

William Galland Stuart, *Watch & Clockmakers in Ireland*, Dublin 2000. (W&CM)

Huguenot Goldsmiths in Dublin

Audouin, Peter [A]: 1719 Daniel Pineau. (FR)

Augier, Robinson [A]: 1714 to Daniel Pineau. (PHS, 1933)

Balaquier, James, son of Bartholomew Balaquier of Dublin [A]: 1707 to Daniel Pineau

Barboult, Abraham: watchmaker [F]: by redemption 1703; mark entered 1706–7, died 1751. Submitted small items for assay 1720s and 1730s. A tankard and beer jug attributed to him with mark AB survives, however it is doubtful that these are by Barboult.

Barboult, Solomon: watchmaker, fl. 1720, died 1758. (W&CM)

Barnard, John [QB]: 1679 [F]: 1680.

Barnard, William [QB]: 1670.

Baullier, Peter: Jeweller, fl. 1701–25. (PHS, 1933)

Beauvais, Benjamin, fl. 1717.

Baskett, Johes: Free by service of apprenticeship to Abraham Voisin 1673 and fine 1682. (ADGC and Petra Coffey, *Huguenot Freemen of City of Dublin*, PHS, Vol. XXVI, No. 5, 1997, p. 637.

Beringuier, Daniel [A]: 1726 son of Stephen Beringuier of Dublin, Merchant [QB]: 1734.

Bezieres, Henry; [AP]: 1685. No apprentice record. Admitted to city franchise 2 July 1686.

Blanchard, Abraham (Senior) [QB]: 1677, A: John Isaac 1669. (ADGC)

Blanchard, James [QB]: 1704 [A]: Joseph Walker 1699, son of Samuel Blanchard, Dublin, farrier.

Blundell, Thomas, the elder [QB]: 1733, Warden 1744–47, Master 1747–48. Died 1774. Long case clock for Goldsmiths Company. Son of Joseph Blundell. In 1751 shop was located at 7 Excise, south end of Essex Bridge.

Blundell, Joseph, clockmaker [F]: 1704, installed St. Werburgh's Church steeple clock in 1732.

Blundell, Thomas the younger, fl. 1774–1824. (W&CM) Note his descendants worked in Limerick.

Blundell, Thomas Limerick, fl. 1848–65. (W&CM); Blundell, William Limerick Fl.: 1838–1858. (W&CM)

Boileau, John, son of Charles Boileau, late of Dublin, Gent. A: 1737.

Boillot, John [QB]: 1674.

Bollegne, James [QB]: 1718 [F]: 1719.

Bovet, Francis, apprentice to Adam Sorett 1681 Watchmaker son of Elias Bovet, Rochelle, merchant. Also spelled Bove.

Boove, Benjamin [QB]: 1713 [A]: to Francis Girard 1707. (ADGC)

Boucher, Charles, son of Peter Boucher of Rochelle, merchant [A]: to Alexander Brown 1727.

Bouchett, Richard [QB]: 1700.

Breviter, Benjamin, apprentice to Abraham Voisin 1676, son of Richard Breviter, Norwich. (ADGC)

Bringy, Daniel, fl. 1744. (HSP, 1933)

Chabenor, Henry watchmaker [A]: 1678 to George Southicke, died 1707; watch and clock known. (W&CM)

Champion, James jeweller [QB]: 1700 [F]: 1715–19.

Champion, James Jnr. Jeweller [A]: to Henry Wilme 1723; [QB]: 1731.

Champion, Eleanor 1775–1784, 30 Grafton Street, as Champion and Keen, Jewellers, 3 College Green 1780–3; recorded until 1792.

Charles, James silversmith 1717. (FR) Not in ADGC

Chauvin, John, son of John Chauvin of Dublin, wigmaker [A]: 1719 to Peter Gervais.

Correge, John [QB]: 1751.

Correges, Benjamin, son of Elizabeth Correges of Dublin, widow [A]: 1714 to Peter Gervais [QB]: 1724 [F]: 1724–5, died 1728.

Correges, James [A]: 1712 to Daniel Pineau [QB]: 1724–5.

Coudart, Salomon, goldsmith and watchmaker [F]: 1707.

Coudert, John, son of Bernard Coudert of Dublin, Gent. [A]: 1707 to Murtagh Dowling.

Court, Thomas [QB]: 1700.

Cousin, Isaac [QB]: 1698.

Cuisset, James Joseph, manufacturing jeweller, 56 Marlborough Street, 1819.

Daffron, Joseph goldsmith, 2 Little Ship Street South Side till 1819. Flatware assayed in 1787–89, mainly sugar tongs and salt spoons. Many survive. (TS)

Darousseau, Mathew [F]: 1713.

Darquier, Lawrence, brother of William Darquier of Dublin, Gent. [A]: 1731.

De Glatigny, Philip, son of Adam de Glatigny, Dublin, Gent., a Lieutenant in La Meloniere's Regiment, pensioned after the Peace of Ryswick [A]: 1728 to George Parker.

De La Main, Charles [QB]: 1680–1.

Delamain, Nicholas [QB]: 1683.

Delandre, Bartholomew son of William Delandre [A]: 1759 to Thomas Burton [F]: 1770; registered mark 1784, Elected Warden 1785–8; Master 1788–9; Member of the Common Council of the City 1789–1798. Fl. until 1825. (PHS, 1933)

Delasale, James [QB]: 1738.

Delaune, William, son of Gideon De Laune of Dublin, Gent decd. [A]: 1733 to Arthur Weldon.

Delesart, Alfred, jeweller [F]: 1802.

Delile, Stephen [A]: 1716 to Daniel Pinsane.

Delimarest, Thomas [A]: 1726 to Martin Billing [QB]: 1736 [F]: 1738–46, recorded as Jeweller in 1738, Warden 1743–6. Plate assayed 1745–48. Makers mark not recorded.

De Lorthe, Esaias, son of Esaias De Lorthe [A]: 1719 to James Balaquier.

Dennard, Peter [A]: 1723 to John Sterne.

Desinards, Peter, son of Lamotte Desinards of Dublin, merchant [A]: 1723 to John Sterne [QB]: 1734, [F]: 1734–5.

Deserett, Samuel [QB]: 1715.

Destaches, John [F]: 1672–99.

Devin, Peter [QB]: 1685 [F]: 1686.

Dezouche, Isaiah, son of Isaac Dezouche of Dublin, silk weaver [A]: 732 to Daniel Pineau.

D'Olier, Isaac goldsmith [A]: 1721 to John Williamson, son of Isaac D'Olier, merchant [F]: 731. Plate assayed 1731–1760s. Warden 1739–41, Master 1752–53, member Common Council City of Dublin 1755. Workshop and retail shop at the Bear and Hammer on 87 Dame Street. Died 1779.

Isaac D'Olier and Son, 87 Dame Street, 1754–67; Warden 1739–42; Master 1752–3; died 1779.

D'Olier, Isaac (junior, son of the above) [A]: 1747 to Robert Billing, partnership with his father from 1754; [F]; 1763; jeweller in Dublin 1763.

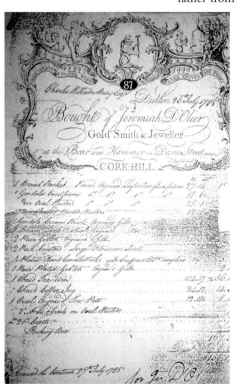

D'Olier, Jeremiah (1747–1816) [F]: 770 Goldsmith & Jeweller. Master 1781. One of the founders of the Bank of Ireland – D'Olier Street is named after him. Made the new chain for the Lord Mayor of Dublin, 1784. Member Common Council City of Dublin 1782. Sheriff's Peer 1790. No plate assayed 1788 so mainly retailer. (TS) Bill head of 1785 survives.

D'Olier, Richard, son of Isaac D'Olier [A]: 1753 to his father; moved to 8 Parliament Street, 1780 as Jeweller and Goldsmith.

Donoe, Gedeon [QB]: 1698 No apprentice record, no plate assayed. (TS)

Donoe, Anthony 1698: [F]:1700 also spelled Dunow or Duno or Dunno. No apprentice record, no plate assayed. (TS) Bracket Clock, ebonized, 8" sq. dial, c. 1715 (C&WM)

Doutoung, John [QB]: 1694.

Dufour, John Moses, son of Isaac Dufour of Dublin, weaver [A]: 1748 to James Vidouze, jeweller [F]: 1768; fl. as jeweller in Dublin until 1803. (C&WM)

Dumain, Peter [QB]: 1747.

Duplessy, Charles [QB]: 1717, fl. until 1725.

Dupuy, Lambert A: 1760.

Duruson, Mathew [QB]: 1719.

Durousseau. Mathew [F]: of the London Goldsmiths' Company 1704; recorded in the Dublin Company 1713–1719.

Dycosseau, Michael [F]: 1714.

Faure, Peter son of Elizabeth Faure of Dublin, widow [A]: 1726

Ffrench, Rt Hon Humphrey (Lord Mayor) [F]: 1733 as a courtesy (not a trained goldsmith).

Folliot, Lewis [F]: 1737.

Foucault, Jacques, son of Peter Foucault of Dublin, Surgeon [A]: 1700 to John Harris [QB]: 1707, recorded as jeweller at Cork 1714, d. 1729.

Fourreau, John son of Aymé Fourreau of Dublin, gent. [A]: 1705.

Fraigneau, Adam, lapidary [QB]: 1754; [F]: 1761 died 1779.

Fraigneau, Isaac son of Isaac Fraigneau [A]: 1763 to Adam Fraigneau [F]: 1771, died 1786.

Franaux, Peter [QB]: 1712.

Freboul, John [F]: 1722. Son of Peter Freboul of Kilkenny, Merchant. A; Dublin 1741 to James Vidouze. Had small quantities of plate assayed 1726–1733. (TS) Some fine silver survives from mid thirties with an IF under crown mark, some over striking John Hamilton's mark. This could also be the mark of John Freeze F: 1718 and Master Warden 1745. He also had small quantities of plate assayed 1725–28.

Gerrard, John also spelled Garrett [A]: John Dixon, 1688 [F]: 1695 by redemption according to an order of the Lord Mayor & Court of Aldermen which suggests that he had completed his training in France. Had plate assayed 1696–1700. (TS) A tankard survives from 1704 to 1705.

Gerard, Francis [F]: 1704; Warden 1710; died 2 February 1710. Also spelled Girard. Business continued by his widow Mary using his mark into late teens. Had small quantities of plate

assayed 1711–1713. (TS) A fine tea pot of 1715–16 survives. Oliver St George commissioned silver from Mary Gerard. See invoice. (Oliver St. George passion for Plate; Alison Fitzgerald, Silver Studies, *Journal of the Silver Society*, No. 22, 2007.)

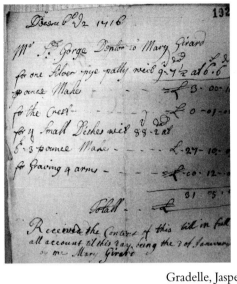

Girard, Anthony, fl. 1701.

Girard, Francis [A]: Mary Girard, 1714.

Gervais, Francis, fl. 1768–86.

Gervais, Peter [QB]: 1712; [F]: 1714 Workshop and retail shop at the Jolly Shepherd (see St George invoice), Dame Street. Both Francis Girard and Peter Gervais used a maker's mark of a shepherd attending his flock above their initials. Had plate assayed till 1730. A merchant Peter Gervais left a will in 1730.

Gillois, Pierre [QB]: 1753 in Dublin; mark entered in London, 1754 recorded as working in Wardour Street.

Girard, Anthony [QB]: 1701 .

Godfrey, Edmund [QB]: 1677.

Godfrey, Thomas [QB]: 1662; [F]: 1669–82.

Goodeau, Samuel, son of John Goodeau, merchant [A]: 1728 to Peter Gervais. Left will 1757. No record of plate assayed.

Gouy, Charles, son of William Gouy of Dublin, mariner [A]: 1721 to Noah Vialas.

Gradelle, Jasper [QB]: 1718; [F]: 1725–33. Watchmaker. (C&WM)

Guppy, William [QB]: 1736.

Hagne, Joshua [QB]: 1731.

Hainon, Daniel [QB]: 1734.

Heyvin, Timothy [QB]: 1683; died 1708. One of just a few quarter brothers who had to pay 5/- instead of 2/6d a quarter. Has small quantities of plate assayed 1694–1700. (TS)

Hubert, David [QB]: 1752.

Hulbert, Joel [QB]: 1719.

Ince, Robert [QB]: 1692; [F]: 1694–1712. Had 247 oz plate assayed in 1696 otherwise little more. (TS)

Ince, Silvester [A]: to Peter Gervais 1724; [QB]: 1734, had 6 oz of silver assayed in 1753. Son of Randolph Ince, apothecary.

Jacob, Edward [F]: 1718. (PHS)

Jesson, John A: 1722 to John Freeze [QB]: 1730 Submitted silver for assay 1729 and 1730 but after that very little.

Jonquer, David [QB]: 1761 registered as jeweller 1784 in Directories from 1788–98 at 36 Great Ship Street East.

Jonquier, James, son of James Jonquier [A]: 1761.

Labase, John [QB]: 1717.

Lacoste, Peter, son of Hercules Lacoste of Portarlington, gent. [A]: 1723 to Mark Martin [QB]: 1732

Lamie, James, son of Oliver Lamie [A]: 1752.

Lapier, George.

La Roche, Matthew [QB]: 1675 [F]: 1680, fl. until 1697. Had small quantities of silver assayed 1694 and 1695. Fl. until 1697. (PHS, 1933)

Lasalle(s), James, son of Mark Lasalle of Dublin gent. [A]: 1717 to Daniel Pineau.

La Trobe, Henry [QB]: 1750–76.

Lavell, Jasper [QB]: 1692.

Le Bas, James (1772–1845) [A]: William Le Bas (*c.* 1757–1827) in London 1788; [F]: in Dublin 1824, Warden of Dublin Goldsmiths' Company 1835.

Le Bas, Samuel (1836–1909) [F]: 1869–1909 [A]: 1851 to John Smyth. Warden 1874 and 1890–02. Assay master 1880–1890. Died 1909. Son of William Robert Le Bas (1802–1863).

Le Bas (Albert) Alexander (1888–1941), great-grandson of James Le Bas (1772–1845), Alexander was Dublin Assay Master 1905–1941, father of Ronald Le Bas (b. 1923), present Assay Master. See article by Douglas Bennett in the *Antique Collector*, August 1974.

LeFebure, Anthony, son of Jacob Lefebure of Dublin, merchant [A]: 1725 to Mrs Mary Barrett; [F]: 1731–37. Submitted considerable amount of plate for assay in 1730s. Some silver survives. Fell foul of the Goldsmiths Company in late 1730's and his widow was denied a pension in early 1740s.

LeFevre, Thomas, 62 South Gt George's Street, registered 1797.

Lemaistre, Charles [QB]: 1720 [F]: 1736–1743, fl. until 1752. (HSP, 1933)

Lemaistre, Henry, watchmaker, 71 Kevin Street in Directories 1788–1809.

Lemaistre, Matthew 1759–1764. (HSP, 1933)

Lemaistre, Michael, son of Elizabeth Lemaistre of Carlew, widow A: 1739 to Charles Lemaistre.

Lemaistre, Nicholas A: 1739 to Charles Lemaistre; [QB]: 1749, [F]: 1751–55. Had 5 oz of silver hallmarked 1752.

Lemaistre, Peter, watchmaker [QB]: 1698; [F]: 1708–1719.

Lemaistre, Peter, watchmaker, registered 1789 Directories 1789–96.

Lemaistre, William registered 1784, d. 1785.

Lemesier, Peter [QB]: 1698.

Lemesier, Samuel [QB]: 1700.

Leroy, Peter [QB]: 1698.

Letablere, John La Douespe, lapidary and goldsmith, son of Rene la Douespe late of Dublin Esq. A: 1726 to William Streeter; [F]: 1737 Warden 1750–1, died 1754. Had no plate hall-marked yet appears to have supplied Trinity College with plate. Probably acted as retailer, possibly running a Toy Shop. (Douglas Bennett, *Silver Collection*, Trinity College Dublin, TCD Press 1988.)

Letablere, René, son of René Letablere of Dublin, Gent. [A]: 1729 to Daniel Pineau.

Manjoy, Benjamin [QB]: 1702: [F]: 1707. His first plate assayed 1713.

Manjoy, Dorothy widow of Benjamin, fl. 1715–31. Had about 200 oz of plate hallmarked from 1726–1731. Dorothy was one of three active Dublin women goldsmiths during the 1720s. A silver washball box is in the Untermyer Collection.

Marchant, Samuel [QB]: 1719.

Mestayer, John, jeweller [A]: To David Bomes 1764; 151 Capel Street, West Side, 1783–92.

Molier, Henry [QB]: 1752. First plate assayed 1752–3.

Mondet, Abraham, son of Lodowick Mondet of Dublin, merchant [A]: 1722 to Arthur Weldon; [QB]: 1734–5.

Mosse, Bartholomew A: William Williamson, 1726, [F]; 1734, Warden 1749 died 1751. Had considerable amount of plate assayed in 1740s. Plate survives.

Moussoult, James [A]: 1681 to Abraham Voisin.

Onge, Daniel, Jeweller [A]: 1727 to William Sinclare; [F]: 1735 Warden 1748, Master 51 died 1752. He and his widow had 111 oz each hallmarked during 1752–3. Daniel had small quantities of small silver items hallmarked, his best total for a year was 435 oz for 1747–48.

Pallet, John Warden 1712–1714; Master 1716–1717.

Pantain, Nicholas [QB]: 1682, [F]: 1693, Master 1698 (born in Rouen, father of Samuel Pantaine who worked in Cork & became Warden there in 1768).

Paturle, John, jeweller, served his apprenticeship in France [QB]: 1700; [F]; 1704, died 1721.

Pineau, Daniel, jeweller and watchmaker [F]: 1707–1752.

Pomerede, Daniel [QB]: 1744, fl. until 1761. Engraver. Engraved a map of Waterford in 1746, and the County of Kildare, this includes the scene which Pomerede engraved on the silver racing punch bowl by Dublin goldsmith William Williamson of the famous match run between Sir Ralph Gore's Black and All Black and the Earl of March's (Old Q) Bajazet in 1751, now in the Museum of Fine Arts, Boston.

Portall, Philip A: Simon Young, 1727 [QB]:1734, [F]: 1738 A few small items with his mark have survived.

Racine, Benjamin, jeweller [F]: 1699; Warden, 1705, Master, 1710; fl. until 1723.

Racine, Peter (senior) [QB]: 1670.

Racine, Peter (junior) [A]: to Peter Racine, his father 1718, fl. until 1729.

Racine, Thomas [QB]: 1704.

Rieusset, David, son of Peter Rieusset of Dublin, merchant decd. [A]: 1734. (HSP, 1933)

Rieusset, Peter son of Peter Rieusset of Dublin, merchant, decd. [A] : 1738. (HSP, 1933)

Rousseau, Andrew [QB]: 1675.

Ruchant, Samuel A :1693 to Matthew La Roche. (HSP, 1933)

Rummieu, David [QB]: 1697 [F]: 1706; died 1729. Brass ink stand in Dublin Goldsmiths Hall has his mark. Submitted silver for hallmarking from 1698 to at least 1713, although quantities were small after 1710. Two wine goblets, one in the National Museum of Ireland and one in San Antonio Museum of Art are examples of his work.

Rummieu, Paul, 1704–5. Appears to have been in business with his brother but no silver hallmarked for him is recorded. See Alison Fitzgerald, *JSS*, No. 22, 2007.

Sebille, John goldsmith working with John Langford, 1766–1771.

Semirot, Anthony, goldsmith at Cork, admitted to Dublin Goldsmiths' Company 1685; in Cork Warden in 1710, Master 1712, died 1743.

Semirot, Anthony (Junior) [A]: to Thomas Dean 1716, son of Anthony Semirot, goldsmith of Cork.

Soret, Abraham, watchmaker [QB]: 1685; [F]: 1690; Warden 1702–5, d. 1715.

Soret, Abraham there were goldsmiths of other generations of the same name as it appears in the records into the second half of the 18th century.

Soret. Adam [F]: 1675; Warden 1680–3; Master 1685–6 & 1691–2, died 1723.

Soret, Andrew, watchmaker, 1685–6, Warden 1702–5.

Soubiran, William, son of Capt. John Soubiran of Dublin [A]: 1740.

Souder, Francis [QB]: 1674.

Talibart, Louis watchmaker and jeweller, 4 St. Stephen's Green, 1833–61.

Thibault/Thiboe, James, clockmaker [QB]: 1724–5.

Touques, Gilbert [F]: 1637, Warden 1644, Master 1647, fl. 1644–8.

Touch, Jacob [QB]: 1711 died 1723.

Tubin, Peter [F]; 1686.

Tuite, John [A]: John Mathews 1703; worked in Dubin 1710–20 when he moved to London and used the same punch. Died 1740. John Tuite is a good example of a 'foreign' goldsmith who became a "Quarter Brother" having completed his training but failed to be elected as a free brother of the Corporation. He was frequently fined for substandard work and by the early 1720 transferred to London where he became a successful large plate worker specialising in salvers. A fine example can be found at the Clark Institute in Williamstown Massachusetts. Some of his Dublin silver also survives.

Verdon, Peter Freeman: 1732, fl. until 1754.

Vialas, Noah [QB]: 1713; F: 1717; Warden 1730–3; Master, 1741, fl. until 1774.

Vidouze, Francis, 1784 17, Fownes Street registered 1783–1804.

Vidouze, James, son of James Vidouze, gent., [A]: 1726 to David Pineau [QB]: 1737; [F]: 1739 Master 1759–60; 1737–81 Jeweller of Fownes Street.

Vigne, Henry, fl. 1827–31.

Vigne, James registered 1776; Directories 1776–1800, 7 Eustace Street, W. Side and 27 College Green, South Side, died 1800.

Vizier, Barnaby, fl. 1765–6.

Vizier, Barnaby, registered 1802 in Directories 1784–1819.

Vizard, Ralph [QB]: 1727.

Voisin, Abel, fl. 1676.

Voisin, Abraham, fl. 1661–1704. He was prosecuted by the Dublin Goldsmiths' Guild for working bad silver.

Vordoon, Peter [F]: 1729.

Vyse, Henry [QB]: 1701.

Wilme, George Freeman 1761, fl. until 1780.

Wilme, Henry (senior) [F]: 1723, fl: 1730.

Wilme, Henry (junior) [A]; to his father William Wilme 1774 [F]: 1785 Warden, 1792, Master 1797, 2 Skinner Row, South Side, 1779–1788; 31 Dame Street, 1789–96; 14 Great Ship Street, 1796.

Wilme, John [A]; John Palet, 1709; [QB]: 1718; [F]: 1732; Warden 1736; Master 1739; Assay Master 1751–4, 5 Hoeys Court.

Wilme, William [A]: to his father Henry Wilme 1738 [QB]: 1745; [F]: 1752, Warden 1762, Master 1766.

Goldsmiths, designers, engravers, modellers and sculptors in Paul de Lamerie's circle

Tessa Murdoch

Designers

William de la Cour (fl. in London 1740), designer, drawing master, decorative painter

De la Cour probably came to London from Ireland. When he first arrived he worked as a scenery painter at the King's Theatre and is later recorded painting scenery in Edinburgh in 1757, and murals for Scottish interiors designed by architect Robert Adam in Edinburgh and at Yester House, East Lothian. In London in the 1740s de la Cour published eight different books of ornament. His trade card which advertises his shop at the sign of the Golden Head, Katherine Street in the Strand where he sold artists' materials, notes that 'He also Designs for all Sorts of Trades' (Plate 62).

Hubert François Bourguinon 'Gravelot' (1699–1773), designer, draughtsman and painter

Came to England from Paris in about 1733 and set up his own drawing school at the sign of the Pestle and Mortar in Covent Garden. He also taught at the St Martin's Lane Academy. Gravelot designed for a wide range of decorative objects. Gravelot returned to France in about 1745.

Daniel Marot (1661–1752), architect, designer and print-maker

Born in Paris to Jean Marot and his wife Charlotte Garbrand, Daniel trained under Jean Berain, designer to Louis XIV. Marot left France in 1685 to join his mother's relatives in the Netherlands. His designs for interiors for William of Orange at Het Loo included garden vases which lent themselves to interpretation in silver as well as marble or lead. Daniel spent two years in London from 1694 to 1696, but his younger brother Isaac settled there. Marot's designs were published after William's death and remained influential in England through the 1720s during Paul de Lamerie's formative years. Daniel Marot died after de Lamerie in 1752.

Draughtsmen

Mr. Siste

Mentioned by George Vertue in 1749 as principal workman with Mr Roubillac sculptor who 'draws very well'.

REFERENCE: George Vertue, *Note Books*, III, pp. 143, 154.

Engravers

Ellis Gamble (fl. 1713–1728)

Operated at the sign of the Golden Angel off Cranbourn Street in Leicester Square, as demonstrated by his trade card which was engraved in about 1723 by his former apprentice William Hogarth. In that year Gamble formed a partnership with the goldsmith Paul de Lamerie which lasted for five years. Gamble presumably obtained for Hogarth the commission to engrave the seal salver for Sir Robert Walpole in 1727–8 (Plate 60) which was retailed by Paul de Lamerie.

Charles Grignion (1721–1810)

The son of the Huguenot watchmaker Daniel Grignion, Charles studied in Paris under J. P. Le Bas and then at Gravelot's Drawing School in Convent Garden where Thomas Gainsborough was a fellow pupil. Grignion worked closely with Gravelot, engraving his master's designs. By the late 18th century, the Italian engravers Cipriani and Bartolozzi regarded Grignion as 'The Father and Founder of the English School of Engraving'.

William Hogarth (1697–1764)

Apprenticed in 1714 to the Westminster-based silver plate engraver Ellis Gamble, he did not complete his apprenticeship and set up his own shop as an engraver in 1720. Hogarth is best remembered for his outstanding career as a painter and engraver of modern moral subjects.

George Vertue (1684–1756) engraver

He worked with a French engraver probably Blaise Gentot who returned to France about 1700. He then served an apprenticeship with Michael Vandergucht. He studied drawing at the Academy in Great Queen Street founded by Sir Godfrey Kneller in 1711. In 1714 the Lord Mayor of London commissioned a print of 'The View of the Charity Children in the Strand'. In 1717 he was appointed official engraver to the Society of Antiquaries, and he attended the sale of John Talman's collection as the Society's agent in 1727. He was elected a Fellow of that Society. Vertue was appointed engraver to the University of Oxford in 1727.

In addition to his knowledge of art history, he wrote copious notes on contemporary artists and craftsmen, collectors, patrons and antiquaries which are a mine of not always reliable information.

Goldsmiths

Paul Crespin (1694–1770, front cover)

Apprenticed to the Huguenot Jean Pons in 1713, he registered his first mark in 1721. He worked with Nicholas Sprimont on the Neptune centrepiece and associated dishes, salts and sauceboats in 1742–43 thought to have been commissioned for Frederick, Prince of Wales. Crespin's elder daughter Magdalen married the Huguenot clockmaker Francis-Gabriel Barraud. Crespin retired to Southampton where he died.

REFERENCES: Grimwade, 1990, pp. 478–79; Murdoch in *DNB*, 2004.

Phillips Garden

Apprenticed to Gawen Nash in 1730; entered his mark as a smallworker 12 June 1738 when he was based in Gutter Lane. By the time he entered his third mark in 1744, he was working in St. Paul's Churchyard. His trade card attributed to his brother Francis Garden, shows the interior of a goldsmith's shop.

REFERENCE: Grimwade, 1990, pp. 518–19

Charles Kandler (fl. 1725–1735)

Kandler is now considered to be the brother of the famous modeller at the Meissen porcelain factory. He is first recorded in London in 1727 when he entered his mark as a large worker at Goldsmiths' Hall and giave his address as St. Martin's Lane. The signed note found at the back of the gilt bronze tabernacle that Kandler made to architect James Gibbs' designs for the 8th Duke of Norfolk in 1730 indicates that Kandler worked at the sign of the Mitre. He specialized in supplying ecclesiastical silver. Many of Kandler's English patrons were members of the Catholic nobility including the Arundells of Wardour; the Cliffords of Ugbrooke and the Petres of Ingatestone and Thorndon in Essex. By 1735 Charles Kandler was back in Dresden where he is known to have visited the Meissen porcelain factory. The business in London was carried on by his relative Frederick Kandler who continued to supply ecclesiastical silver for leading Catholic families including the 9th Duke and Duchess of Norfolk and the Welds of Lulworth.

REFERENCES: Grimwade, 1990, p. 567; Cassidy-Geiger in *Silver Society Journal*, XXII, 2007.

Frederick Knopfell

Working as a journeyman with Paul de Lamerie at the time of his death in 1751, and mentioned in de Lamerie's will. Entered his mark 11 April 1752 as at Little Windmill Street, St. James's, possibly de Lamerie's previous premises.

Probably identifiable with Frederick Klupfel, jeweller of St Martin''s Le Grand, a relative of Sigismund Godhelp Dinglinger, who worked as a jeweller at the Diamond Cross, St. Martin's Le Grand, 1749 and was related to the famous family of Dresden royal goldsmiths.

REFERENCE: Grimwade, 1990, pp. 573, 756.

Paul de Lamerie (1688–1751)

Born in Bois-le-Duc, Holland, de Lamerie came to London as an infant and settled with his parents in Berwick Street, Soho. He was apprenticed in 1703 to Pierre Platel, and entered his first mark at Goldsmiths' Hall in 1713. In 1717 he married Louise Jolliott at the French Church in Glasshouse Street. Entered second mark in 1731, by then at the Golden Ball in Windmill Street. Moved to Gerrard Street in 1738. Became Fourth Warden and then Third and Second Warden of the Goldsmiths' Company. His second daughter Susannah married the Huguenot watchmaker Joseph Debaufre.

REFERENCES: Grimwade, 1990, p. 488; P. A. S. Phillips, *Paul de Lamerie*, 1935; Ellenor Alcorn, *Beyond the Maker's Mark*, Paul de Lamerie Silver in the Cahn Collection, 2006.

Pierre Platel (1664–1719)

Recorded in London in 1688, by 1699 he had premises in fashionable Pall Mall close to St James's Palace. His clients included the Duke of Devonshire and the Earl of Portland both close to King William III. In 1703 he took on Paul de Lamerie as his apprentice.

Abraham Portal (d. 1809)

The son of a Huguenot vicar in the Church of England, Portal was apprenticed to Paul de Lamerie in 1740, He found time in his master's workshop to write poetry. He became free of the Goldsmiths Company in 1750. Portal had a second career as a dramatist and has achieved an entry in the Dictionary of National Biography largely on the strength of his literary talent.

Ernest Sieber (fl. 1746–1752)

Probably of German origin, Sieber entered his first mark as a large worker in 1746, he may have worked in London for only five years as by 1752 he is recorded in The Hague.

James Shruder (fl. 1737–1763)

Entered his first mark as a largeworker 1737 as at Wardour Street, St. Ann's Westminster. Second and third marks entered 1739. He designed his own trade card which shows his address at 'the Golden Ewer in Spur Street, Leicester Square'; from 1744 he is recorded at the corner of Hedge Lane, Leicester Square. In 1763 Mortimer's *Universal Directory* lists James Shruder as a modeller in papier maché.

REFERENCE: Grimwade, 1990, p. 658.

Nicholas Sprimont (1715–1771)

Born in Liège and apprenticed to his uncle there, Sprimont arrived in England in 1742, when he married Ann Protin at the Knightsbridge Chapel in London. In 1742–3 he collaborated with Paul Crespin on the Marine table service for Frederick Prince of Wales. In 1747 he founded the Chelsea Porcelain Manufactory.

REFERENCE: Grimwade, 1990, p. 668; Murdoch in *DNB*, 2004.

Modellers

Artari family (working 1720s–1760)

The family came from Arogno in Italy. Giuseppi Artari trained with his father and worked in Rome, Germany and Holland before coming to England, where he worked with Giovanni Bagutti for the Catholic architects James Gibbs and Giacomo Leoni at Ditchley, Oxfordshire and Clandon, Surrey. He later worked at Houghton under William Kent for Sir Robert Walpole.

Giovanni Bagutti (1681–after 1730)

Born near Lake Lugano, on the Swiss border with Italy, Bagutti was in England by 1709 and was still working at Clandon with the architect Giacomo Leoni in the 1730s.

Bartholomew Crammilion (1755–1757)

Worked as a plasterer at the Rotunda Hospital Chapel in Dublin after which he returned to his native Belgium where he worked as a sculptor.

Lafrancini brothers, Paul (1695–1770) and Philip (1702–1779)

Originally from the North of Italy, they are recorded as working in the North of England from 1731 for the architect James Gibbs and later in Ireland.

Francesco Leone Serena (working 1700–1729)

Worked at Ditchley in the 1720s with Giuseppi Artari and Giovanni Bagutti.

Charles Stanley (1703–1761)

Born in Copenhagen, he trained there with the sculptor and stuccoist J. C. Sturmberg. He studied in Amsterdam under Jan van Logteren in 1727 then left for England where he joined the workshop of the sculptors Peter Scheemakers and Laurent Delvaux. He worked in England until 1746 when he returned to Denmark to take up the position of court sculptor. He worked in stucco at Langley Park Norfolk, in the Radcliffe Camera, Oxford and at Okeover, Staffordshire.

Francesco Vassalli (1724–1763)

Born in Italy near Lugano. Also worked at Ditchley with Serena, Artari and Bagutti.

Sculptors

Louis Francois Roubiliac (1702–1762)

Born in Lyons, France, Roubiliac is first recorded in England in 1730. He supplied bronze figures for the entrepreneur Charles Clay to adorn the Temple of the Monarchies advertised in 1743. Primarily active as a portrait sculptor, he taught modelling at the St. Martin's Lane Academy. In the 1740s he was associated with the goldsmith and entrepreneur Nicholas Sprimont who stood godfather to his daughter Sophie at the Huguenot Church of Spring Gardens, Charing Cross in 1744.

REFERENCE: Malcolm Baker in *DNB* 2004.

Michael Rysbrack (1694–1770)

Born in Antwerp, he trained under Michael van der Voort. In England from 1720, he worked for Lord Burlington and for William Kent at Chiswick and at Stowe for Richard Temple, 1st Viscount Cobham. He made a bronze equestrian

statue of William III for Queen's Square, Bristol which was inspected in his studio by Queen Caroline in 1735. He was made a Governor and Guardian of the Thomas Coram Foundation (The Foundling Hospital) in 1744. Business became less brisk in the 1740s. His masterpiece is arguably the statue of John Locke in Christ Church, Oxford, 1756.

REFERENCE: Katharine Eustace in *DNB* 2004.

The Contributors

David L. Barquist is The H. Richard Dietrich, Jr., Curator of American Decorative Arts at the Philadelphia Museum of Art. Prior to joining the Museum in 2004, he was employed by the Yale University Art Gallery for 23 years as Assistant, Associate, and Acting Curator of American Decorative Arts. Barquist received his A.B. from Harvard College, M.A. from the Winterthur Program in Early American Culture at the University of Delaware, and Ph.D. from Yale University. Among his publications are *American and English Pewter at the Yale University Art Gallery* (1985), *American Tables and Looking Glasses in the Mabel Brady Garvan and Other Collections at Yale University* (1992), and *Myer Myers: Jewish Silversmith in Colonial New York* (2001), which served as a catalogue for a travelling loan exhibition. He also has contributed to collection catalogues for the Concord Museum, the Albany Institute of History and Art, and the Diplomatic Reception Rooms of the U.S. Department of State.

Michèle Bimbenet-Privat was Chief Curator of National Archives. She was appointed Head Curator at the Museum of the Renaissance at the Chateau d'Ecouen in 2006. She is also Associate Professor at The Sorbonne University, Paris. Her main publications include: *Les Orfèvres parisiens de la Renaissance, 1506–1620*, Paris (1992); *L'Orfèvrerie parisienne de la Renaissance. Trésors dispersés* (Paris: Centre culturel du Panthéon (1995), *Les Orfèvres et l'orfèvrerie de Paris au XVIIe siècle*, Paris (2002), 2 vols; 'Le style "cosses de pois": l'orfèvrerie et la gravure à Paris sous Louis XIII', *Gazette des Beaux-Arts*, CXXXIX, January 2002, pp. 1–224 (with Peter Fuhring); *La collection Jourdan-Barry. Orfèvrerie française*, Paris (2005) 2 vols (with P. Fuhring and A. Kugel).

John R. Bowen is a civil engineer by profession and is Chairman and Chief Executive of The Bowen Group of Companies, a Cork headquartered, diversified enterprise involved in building, civil and mechanical contracting, and property development. Having attended school at Waterpark College, Waterford, he obtained his civil engineering degree at University College, Cork. He also holds a Masters in Business Administration from Warwick Business School. He is a Chartered Engineer, a Member of the Institution of Civil Engineers and a Fellow of the Institution of Engineers of Ireland. He has had a lifelong interest in the study of the history and achievements of Ireland's provincial silversmiths and gold-smiths. He arranged and curated the first gallery exhibition dedicated to the work of the gold and silversmiths of Cork, 'Airgeadóir' at the Crawford Gallery, Cork in 2005, and in collaboration with Conor O'Brien co-authored the first book on

the subject to coincide with that exhibition, *Cork Silver and Gold, Four Centuries of Craftsmanship*. He chaired the organizing committee for the exhibition of the work of the goldsmiths of Limerick at The Hunt Museum, Limerick (2007–8) and co-edited (with Conor O'Brien) the exhibition catalogue *A Celebration of Limerick's Silver*. He is currently planning an exhibition of the silver of Waterford and the South East of Ireland.

Philippa Glanville FSA was Senior Research Fellow from 2003 to 2007 and formerly Chief Curator of Metalwork at the Victoria and Albert Museum. She was Academic Director, Waddesdon, The Rothschild Collection. In 1987, she published *Silver in England* (reprinted 2006). She has written extensively on silver and the history of collecting, contributing in 2006 to *Britannia and Muscovy*, Yale Center for British Art/Gilbert Collection, to *Feeding Desire*, Cooper Hewitt (2005) and to *Rococo silver in England and its Colonies*, The Silver Society (2006). She co-edited with Sophie Lee, a former V&A Curator in the Metalwork Collection, *The Art of Drinking*, V&A (2007). She has contributed to *Treasures of the English Church*, published to coincide with the exhibition at Goldsmiths' Hall, London (2008).

Christopher Hartop is an independent scholar and consultant. His books include *The Huguenot Legacy: English Silver 1680–1760* (1996), which was awarded the National Huguenot Society Award in 1997; *East Anglian Silver 1550–1750* (2004), *Royal Goldsmiths: the Art of Rundell & Bridge 1797–1843* (2005), *British and Irish Silver in the Fogg Art Museum, Harvard University* (2007) and *A Noble Feast: The Jerome and Rita Gans Collection at the Virginia Museum of Fine Arts* (2007). He has also contributed to *The Grove Dictionary of Art* (1996), *The Dictionary of Art and Architecture of Latin America* (2002), and *Joséphine and the Arts of the Empire* (2005). He has also contributed to *Treasures of the English Church*, London (2008). He was Chairman of the Silver Society 2002–3.

Tessa Murdoch FSA received her Ph.D. on 'Huguenot artists, designers and craftsmen in Great Britain and Ireland 1680–1760', at the University of London, 1982. At the Museum of London from 1981 she curated the exhibition 'The Quiet Conquest: The Huguenots 1685–1985'. She joined the V&A in 1990 and worked in the Furniture and Woodwork Department and became Deputy Keeper, Sculpture, Metalwork, Ceramics and Glass in 2002. She was lead curator for the V&A's Sacred Silver and Stained Glass Galleries, 2005. Publications include, as editor, *Boughton House: The English Versailles* (1992); with Christopher Gilbert, *John Channon and English Brass Inlaid Furniture 1730–1760* (1993) and recent articles 'London Ormolu: Lighting from George II to George IV', *The Magazine Antiques*, March 2004, and 'Huguenot Goldsmiths from Metz in London and Cassel' in *Zuwanderungsland Deutschland: Die Hugenotten*, Deutsches Historisches Museum, Berlin (2005). She wrote the foreword to Ellenor Alcorn's book '*Beyond the Maker's Mark: Paul de Lamerie Silver in the Cahn Collection*' (2006). Her most recent publication is *Noble Households: Eighteenth-Century Inventories of Great English Houses: A Tribute to John Cornforth* (2006). She is currently lead

curator of the new Gilbert Galleries; this will include further examples of London-made Huguenot silver and opens at the V&A, June 2009. She has contributed to *Treasures of the English Church*, London (2008) and is currently writing with Randolph Vigne *The French Hospital in England and its Huguenot collections* (forthcoming 2008)

Professor Dr. Hans Ottomeyer studied at the Universities of Freiburg, Berlin, London, Munich and Paris from 1967 to 1976. His Ph.D. at the University of Munich was on 'Charles Percier and the Origin of the Empire Style' (1976). He worked for the Bavarian Museum of History and the Bavarian Castles and was Curator of Furniture and Deputy Director from 1983 to 1995 at the Munich Stadtmuseum. From 1995 to 2000 he was Director of the Staatliche Museen, Cassel. In 2000 he became Director General of the Deutsches Historisches Museum, Berlin. He has published extensively on the Empire and Biedermeier styles, on Munich Art Nouveau, ormolu, silver, the history of food and dining, European court ceremonial and continental furniture. He curated exhibitions on the Kings of Bavaria, Catherine of Russia, the History of Time, Design and Advertising. He recently edited with Sabine Beneke, *Zuwanderungsland Deutschland: Die Hugenotten* (2005).

Jet Pijzel-Dommisse is currently curator of the Department of Decorative Arts of the Gemeentemuseum, The Hague. She studied History of Art and specialized in the Decorative Arts at Leiden University. She has lectured at Leiden and at the Amsterdam School of Restoration and worked at different projects in various museums. She spent three years cataloguing the dolls houses in the Rijksmuseum Amsterdam. She received her doctorate in 2000 from Leiden University for her publication on these houses which are an important source of information on Dutch interior decoration in the late seventeenth and eighteenth century. She contributed to the publication of the Dutch 'edition' of Peter Thornton's *Authentic Decor: Het Nederlands interieur in beeld* (2002, ed. Prof Willemijn Fock) and organized the exhibition *De Hollanders thuis* in the Gemeentemuseum on this subject. She recently organized the exhibition *The Hague Gold and Silver* and published a book containing, in addition to silver made in The Hague, a catalogue of the museum collection: *Haags goud en zilver. Edelsmeedkunst uit de hofstad* (2005).

Caroline Gabrey Rainey is pursuing a double major in Art History and Archaeology and the Arts Management Certificate at Sweet Briar College, Virginia, USA. She interned in the Metalwork Collection, Victoria and Albert Museum in January 2008. She intends to pursue a career in the decorative arts.

Thomas Sinsteden graduated from Trinity College Dublin medical school in 1976. He began to collect Irish silver in the early 1980s, whilst with the University of Texas, which led to an interest in Irish history seen through the arts and associated trades, especially the goldsmiths' trade in Dublin. He is now an independent scholar and consultant on Irish silver. He has published two articles

on *Surviving Dublin Assay Records*, for the *Silver Society Journal* in 1999 and 2004. He is currently writing a book on The Goldsmiths of Dublin. He is a member of the Dublin Goldsmiths' Company Antique Plate Committee.

Beth Carver Wees is Curator of American Decorative Arts at The Metropolitan Museum of Art, New York, where she is responsible for the collections of American silver, jewellery, and other metals. Before joining the Metropolitan's staff in 2000, she was Curator of Decorative Arts at the Sterling and Francine Clark Art Institute in Williamstown, Massachusetts. She lectures internationally and has published numerous articles and catalogues, including *English, Irish & Scottish Silver at the Sterling and Francine Clark Art Institut,* Hudson Hills Press, New York (1997).

Beth is currently preparing a catalogue of the Metropolitan Museum's extensive collection of American silver. She has worked with Winterthur Museum on the exhibition and publication *Silversmiths to the Nation: Thomas Fletcher and Sidney Gardiner (1808–1842)*, which opened at the Metropolitan Museum of Art, New York in November 2007.

Index

Note: Colour plates are indicated by Colour Plate number, e.g. *CP VIII* and not by page number; black and white plates are indicated by page numbers in italics, e.g. *39.*

GREAT VARIETY of PLATED WORK

Charles William Bury Esq

Bought of

Gold S

at the Bear and Ha

COR